THE
JAPAN
AFFAIR

THE
JAPAN
AFFAIR

Thirty-five years of Comment
on a Changing Relationship between
Two Island Monarchies

David Howell
with a foreword by Koji Tsuruoka

GILGAMESH

The Japan Affair
Thirty-five years of Comment
on a Changing Relationship between
Two Island Monarchies

Published by Gilgamesh Publishing in 2020
Email: info@gilgamesh-publishing.co.uk
www.gilgamesh-publishing.co.uk
ISBN 978-1-908531-45-2
© David Howell 2020

Edited by Asher Kessler

With special thanks to The Japan Times for their kind permission
to include these articles, first published in their newspaper.

CIP Data: A catalogue for this book is
available from the British Library

This book is dedicated to Yoshiyuki Kasai, Chairman-Emeritus of Japan Central Railways but also a tireless champion of Japanese-British relations and cooperation, and who probably understands the interests and prospects of Britain better than many of us do ourselves.

Contents

Contents

SECTION II
Japan-UK 2000-2010 - A Normal Country?

FOREWORD

Mr Koji Tsuruoka,
Japanese Ambassador to the
United Kingdom 2016-2019

Lord Howell has contributed his thoughts to a Japanese English paper, The Japan Times, which is a quality paper for non-Japanese speakers interested in Japan. He has led the wise men group, initially called The 20th Century Group, created by two Prime Ministers, Yasuhiro Nakasone and Margaret Thatcher. The Group was designed to freely discuss the bilateral relations between Japan and the UK and present recommendations to the two Prime Ministers.

It continues today as The 21st Century Group and the work is becoming even more relevant as both nations are facing a volatile world where traditional norms cannot be taken for granted. Japan and the UK have both benefited from a stable and predictable world under US leadership based on freedom, democracy and a market economy including free trade. The US approach to world affairs is now changing course. China, the country that gained the most in the last two decades of stability and predictability based on the rule of law, is not hesitating to demonstrate her strength both politically and economically. Her actions are triggering concern not only in her own neighbourhood but also globally. This is the time for the mature democracies of Japan and the UK to work closely to keep the world stable and prosperous while also ensuring full participation in work to establish and strengthen the global order with such new powers as China.

Both Japan and the UK have statehoods which depend on world peace. Needless to say no country can survive without peace, but in the case of Japan and the UK - both successful economies with a large population under a democratic government - peace is the prerequisite for their stable and prosperous statehood. Japan in the East and UK in the West are two countries that have no ambition to dominate the world as superpowers and they are, therefore, well-placed to serve a role in strengthening peace. Indeed, it is their responsibility to do their utmost to maintain world order through diplomacy.

The articles Lord Howell has written over the last decades are consistently based on optimism backed by the intellectual quality of the English gentleman. This is the spirit that we will uphold, recognizing the progress the world has achieved since the end of World War Two and, as we enter a new world with confidence, we need to collectively work to further improve on past successes through collaboration rather than by seeking to impose the will of might. Japan and the UK are two countries that respect quality and take pride in working for world peace. We both know only too well that we cannot prosper without peace.

Our bilateral relations have seen both good and difficult days in the past. We have learned from, and have relied on, each other at times, but today, our task is to better serve the world because if Japan and UK do not, who will? Japan and the UK together can indeed make a difference for the better. The insight into Japan described by Lord Howell in his beautiful writings highlights to us the value and potential of our collaboration. From the time it opened to the world in late the 1800s, Japan has followed and learned from the UK, and it is now time for it to work with the UK for global good.

Having served as Ambassador from 2016 to 2019, I have witnessed the UK handling the difficult task of Brexit. I have always been impressed by the optimism and the determination to fight through, no matter what side of the debate one may be on. It will be a privilege for Japan to work with the UK. This book is not looking back to old days; it is indicating what we should do now and in the future.

Koji Tsuruoka
January 2020

AUTHOR'S INTRODUCTION

Windows on Japan-UK relations
1984-2020

This is a story of an evolving relationship between two island nations – a relationship which could be (and should be) of growing importance as the UK seeks to re-position itself in a totally transformed international landscape.

Modern Japan defies Western analysis. It fails to fit into the Anglo-American model of liberal democratic capitalism which used to dominate Western thinking in the 20th century but now looks shaky. It is collectivist and yet capitalist. It is closed yet open. It is democratic, yet there is something different about the way its democracy works. It is distinctly nationalist and yet very outward-looking. It is traditionalist and bureaucratic and yet breathtakingly innovative. It is centralised and unitary but yet polycentric. It is corporatist and yet overwhelmingly an economy of small businesses. Its industry, wealth and technology qualify it as a superpower and yet it has no superpower pretensions.

Altogether it is a puzzle which used to lead Westerners to shrug their shoulders, enjoy the sushi and sashimi and aspects of the culture, buy the cars and electronics but leave philosophy and politics out of it as being too remote and too foreign to be of much interest.

All that has changed. As liberal democracy in the West has been disoriented by digitally empowered populism, as the narratives and focal points of Western policy and purpose have become blurred and

contradictory (to the point where Yuval Noah Harari says we may have to prepare for a future without faiths or stories, a sort of nihilism), where do we now turn?

Could it be to the Japanese example? Could the learning flow, which in distant times past used to be from West to East, now need to be completely reversed? When it comes to governance and social coherence should what Benjamin Disraeli once described as 'all the baleful European ideologies' be discarded in favour of something different, and from the other end of the planet, now only a click away?

More immediately, Japan appears to have escaped, so far, the populist infection which has spilled onto the streets of many Western capitals and distorted Western politics. How has that come about, and why, for all its wealth and power, has Japanese society somehow flattened the glaring inequalities which so disturb Western society and so aggravate political sentiments?

These are the questions to which Western societies, the British very much included, badly need answers. A series of newspaper columns, penned every two weeks over four decades, cannot possibly provide these answers in full. And as a rule journalism makes bad books. Articles have a brief shelf life and there is nothing as dead as yesterday's newspaper.

But sometimes op-eds can have an afterlife, or least cast a beam of illumination on things as they were, or were becoming. It is striking how the recurrent themes and topics in these articles, stretching back more than three decades, dwell on precisely the issues which are considered the last word in topicality and newness today.

Again and again, from the eighties onwards, the pieces pick up the new urgency for capitalist reform and the fairer sharing of new wealth. The rise of mass protest and street power, so breathlessly commented on today, turns out to be an old story. The growing disillusion with the old European Union, the emergence of a world of new networks, the eclipse of arms control, the explosive effect of technology on conventional politics – all these emerge from these pages as the preoccupations of decades past.

Today, the same concerns are paraded as the 'hottest' new subjects for journalistic comment. Yet as the succession of articles shows, they turn out to be decades old, discussed and analysed endlessly in a UK-Japan

context for years past. Truly plus-ça-change amongst the UK's sleepy media commentariat.

Here we try simply to open windows along the way to a new kind of world, with a bit of interspersed commentary to keep things flowing. Read and judge whether it works.

From being the worst of enemies in the first half of the last century Japan and Britain have become the best of friends. Such things happen, but usually very gradually and slowly, and this has been the case with the two island states either end of the planet.

And even best friendships don't just float in mid-air. They have their setbacks, misunderstandings, cool periods,periods of neglect. They have to be worked at, rooted, nourished, cherished.

The story of the Japan-UK relationship of course goes back deep into history, with its light eras and its very dark ones. The pages in this volume pick up it up only over the last four decades. They cover, very roughly and with lots of overlaps, three stages, beginning in the 1980s, then taking us through the first decade of the present century and bringing us up to and through the second decade, just ending.

At the start of this whole period Japan had already not only recovered from the unimaginable horrors, humiliations and utter destructions of war, defeat and nuclear incineration but had incredibly re-emerged as an industrial power of the first order, rivalling every other nation and giving rise to what looks in retrospect like a slightly absurd spate of views about Japanese world dominance, Japan as a superpower and other rather stupid headlines. Mostly these emanated from the USA, where a sort of semi-hysteria had taken over, as is often the case there, giving birth to a string of alarm-filled books.

By the nineties this was then replaced by a different story, again in exaggerated form. Instead of Japan the unstoppable superpower, it became Japan the stagnating economy, how Japanese growth had come to a grinding halt etc.

Neither of these pictures were anything near the truth. Western commentators, gleefully badmouthing the once feared superpower and describing its zombie banks and paralysed finances, completely failed

15

to notice that the so-called 'lost' decade of stagnation was at a very high level of activity and living standards. The word 'consolidation' would have been a much more accurate description. If this was 'stagnation' then it would have been nice to have some of it in the Western economies.

In reality the innovative pulse of modern Japan never faltered. Growth may have slowed for a while (and there are plenty of questions to ask about how one measures growth anyway, and whether the GDP figure comes anywhere near measuring the actual pace of improvement in a society).

But today Japan stands as not only one of the world's richest nations, measured in per capita terms, but also as one of the most stable in political and social terms, despite being constantly confronted by the wrath of nature in terrible forms.

Earthquakes, tsunamis and typhoons of unimaginable destructive force all too often fill the world news headlines about Japan. The good news gets forgotten. As one of the last and most recent pieces in these pages speculates, it may be that the two conditions - relative political and social stability and coherence on the one hand and the monstrous and repeated challenges of nature on the other – are related. It may be that the resilience with which the Japanese people meet these dreadful events is the binding force which gives Japanese society its inner strength. This may be the quality which allows the Japanese to label their new era, under a new Emperor, without cynicism, Reiwa, or Beautiful Harmony. Oh for some of that in the West!

The selection of articles, from a much larger number over some 35 years of regular fortnightly appearance (with one big break after 2010), has been divided and edited to fit three episodes. The first one runs from the mid-eighties to the century's end, when British perceptions about Japan began to change, old stereotypes were wearing off and the beginning of a new friendship was planted and beginning to grow.

Japanese investment had already begun by the nineteen-eighties to pour into the UK, bringing not only jobs but a refreshing approach to industrial relations which blew many of the cobwebs out of the more archaic of trade union practices, which had been paralysing British industry.

This of course was also the time when Europe went through its biggest

change since the Second World War, with the 1989 fall of the Berlin Wall, followed by the fall of the Soviet Union and the rise of hopes, now confounded, of a new democratic Russia joining the comity of nations. Most analysis was (and continues even now to be) in Western terms, with little thought about the Asian impact or consequences.

Earlier in the decade, in 1984, Margaret Thatcher and Yasuhiro Nakasone, the two Prime Ministers at the time, had met together to take a step showing remarkable foresight. This was to set up, at the highest level of industry and politics, a kind of think-tank group which would meet at least annually and discuss with complete informality the ways in which Japan and the UK could reinforce each other.

Here were the seeds of something at a different level to the usual bilateral friendship groups that pepper the international landscape. Named originally the UK-Japan 2000 Group it recast itself as the Millennium approached as the UK-Japan 21st Century Group. It not only continues to this day in 2020 but could soon be filling an even larger role.

The second period - the first decade of the 21st century, was when Japan in Western eyes ceased being merely an industrial phenomenon and began to assume a major role on the international stage as a 'normal' country - not quite normal of course and still with a strong pacifist streak, but definitely part of the G7/8 galère and with a growing, although still carefully circumscribed, role in the wars and convulsions following the 9/11 horror.

Japan's dazzling economic expansion appeared to slow down, leading to much Western misinterpretation, but its prominence as a major part of the international financial order grew, even while the rest of the world spiralled down into the quagmire of sub-prime loans and the Lehman collapse.

The third phase, from 2010 to the present time, takes on a different tone and quality again. This has been, and continues to be, the episode when communications technology and the digitalization of everything changed the world and changed the international scene. The future is now going to be shared between the West and Asia. Dire warnings roll out – again mostly from the USA – about the clash of world systems, but the strong hope must be that the two hemispheres can work together, perhaps with the Japan-UK linkage showing the way. Who knows? At least that is the thread of hope running through many of the columns reprinted here.

One new difficulty that also emerges in the most recent phase, requiring delicate diplomacy, has been the task of striking a balance in the UK between relations with China alongside those with Japan. Japan, which over the years has come to see itself as the UK's 'best friend' in booming Asia, was visibly upset when in 2015 the British and Chinese together declared a new golden era of togetherness. Suddenly, there was the UK taking the lead in supporting China's new development bank, the AIIB, welcoming Chinese involvement in its nuclear power plant replacement programme and inviting cooperation in building and operating high-speed trains - an area where Japan had been far in advance and regarded Chinese technology as weak and potentially dangerous (as one sickening crash between high speed trains indeed proved it to be).

Even more tricky is the fact that this most recent decade has been the age of Brexit, over which Japanese industry and government at first expressed very strong dismay. Some argued that the Japanese would now 'go elsewhere' having invested heavily in the UK on the assumption that it was the ideal base for entering European markets.

Worries have now been assuaged by the prospect of a sensible and orderly exit from the EU, with a proper transition period (although not without one last desperate cry from 'Remainers' that there could still be a No Deal exit at the end of 2020 – very unlikely). Time has also allowed calmer analysis of the much bigger forces changing the nature of world trade and the fundamental shape of key industries, not least the motor industry. But many questions remain unresolved. The kaleidoscope of changing perspectives continues.

So when reading these columns, think and feel you are on an Underground escalator, gliding past all those framed pictures besides you – some sequential, some moving, some just advertising the latest West End show. Each article here is a framed window into a constantly changing scene. This is the 'up' escalator and as with the real thing it is running continuously. So also with the relationship between the two island monarchies – always upwards, always evolving, always positive.

It has led quite a way already. Who knows where it could take us now.

David Howell
London, March 2020

SECTION I

Mid-1980s to the Millennium.
Japan a New Friend?

OPENING COMMENTS
Mid-1980s to the Millennium.
Japan a New Friend?

By the mid nineteen-eighties, when these columns begin, Japan was already heavily invested in Britain, notably in the Welsh valleys. Akio (Sony) Morita's big investment at Bridgend had led the way and Japanese approaches to Britain's trade unions was bringing a much fresh breeze into the country's archaic industrial relations.

Japan was still viewed through the economic lens but perceptions were changing. It was beginning to be accepted that economic power led inevitably back to political influence and power. This went along with a rising note of criticism (so-called Japan-Bashing) that the new giant was not pulling its weight on the world stage.

For instance, where was Japan in the First Gulf War, given how much of Japan's oil and gas came from the region? (This was actually unfair given Japan's massive back-seat role in installing and financing the vital pan-Gulf surveillance systems which played a key part in driving Saddam out of Kuwait). And where did Japan stand on the central drama of this period gripping the West – the unfolding collapse of the Soviet Union? One of the most frequent comments of Western diplomats in those days was about the silence of the Japanese. Their Ministers and delegates duly turned up at global gatherings and summits but said very little - often nothing.

This first decade begins with a bit of opinion prophesy - a forecast

that the Japan of the twenty-first century would come to be seen and behave differently in the emerging new world ahead, and that there were new lessons to be learnt from Japan's progress. The silences would end. And so it was to prove.

2 NOVEMBER, 1985

Lessons from Japan

There can be no doubt that British perceptions about Japan have been undergoing an enormous change in recent times.

This is not just because of developments in Japanese policies and outlook, although these have been most significant. It is also because of developments and changing attitudes in Britain as well.

For many people in Britain, Japan has today become not just the feared international competitor but also the model for the future.

This may sound contradictory. But of course fear and admiration can easily go together. There is nothing paradoxical about a viewpoint which simultaneously regards the Japanese trade offensive with grave apprehension yet accepts that we in the West have enormous lessons to learn from the Japanese example.

Indeed, this mixture of views actually helps to get the economic issues into better focus that too much concentration on matters such as Japan's enormous trade surplus can lead to some serious errors and could have catastrophic consequences tor the world economy.

Frontal attacks on the problem of the trade imbalance, without a sound understanding of the much deeper factors involved, will in the first place almost certainly fail to produce results, and in the second place and in consequence, lead to bitterness, frustration and pointless retaliation.

Basic economic reasoning alone should warn us against overreacting to the simple trade statistics. Japan is in "surplus" because its domestic savings far exceed investment. Japan therefore exports enormous sums of capital around the world. A trade surplus is the inescapable companion of this great capital flow.

Gains and Losses

If this was curbed, the Americans would be in much worse trouble with their gigantic trade and budget deficits. At the same time, all America's suppliers, or those who export to countries in turn supplying the U.S. — which certainly includes Britain — would also be in deeper difficulties. There would be gainers and losers. We might sell more to Japan but less to, say, Brazil or the United States itself. And after a good deal of painful readjustment, these switches would just about cancel each other out.

Not that I am for a moment belittling Japan's undoubtedly impressive determination to improve market access. It is clear that Japan means business in aiming for a degree of openness which surpasses international standards. I trust that overseas businesses, including British ones, will really seize the new opportunities opening up. I, for one, am particularly impressed by the market-opening package if it actually leads to Japanese public procurement contracts being awarded overseas. In most countries this is invariably the last bastion of nationalist protectionism. If Japan breaks that mould, then it will indeed be able to claim, without contradiction, that it is exceeding international standards.

Similarly, we await with eagerness the first steps this autumn toward liberalization of Japanese interest rates and the development and opening of financial and capital markets.

But if anyone thinks that these moves, excellent in themselves, will solve the alleged "problem" of Japanese trade superiority, they are living in a cloud of illusion. The reality is that Japan is the second richest nation on earth producing goods of the very highest quality and competitiveness, with a very high domestic savings ratio.

If Japan imports more, as I hope it will, it will also produce and sell more abroad. That is good. It will add to world trade and prosperity.

But it will not solve the famous imbalance because the roots of that lie far deeper than anything which can be touched merely by trade reform.

Growing International Forces

The heart of the matter lies in Japan's emerging role as a great international force, a role which in the West we increasingly expect it to play and which I understand it is now edging toward.

This process shows up in the lively debate here on the defence spending ceiling, which seems bound to rise as new responsibilities for world peacekeeping are shouldered. And it shows up, too, in Japan's increasing commitment to assist the economic development of the low-income countries — although I believe we all have a lot to learn about the help, and the damage, that wrongly directed transfers of aid resources to the governments of poorer countries can produce.

So this is the second aspect of our changed perception of Japan — that we now look to Japan not as a polite but low-key participant in world economic and security cooperation, but as a global power taking a forward and dynamic role in world affairs.

Greater Understanding

The third big change in our British view of Japan is a little different. It may even contradict the other two. It is that what we believe to be the Japanese social and economic formula appears to be particularly well-suited to cope with the problems and stresses of the information revolution and the much more atomized and diffused kind of society which lies immediately ahead in the post-industrial age.

That is to say, we are now beginning to understand in Britain that Japan's economic vitality is not just a matter of huge trading and manufacturing houses, jobs for life, and good industrial discipline. We see now, or we think we see, elements in Japanese business relations which give this society its remarkable qualities of unity with variety, cohesion with flexibility, and freedom to innovate.

I have in mind especially the sense of obligation in commercial dealings in Japan which seems to temper the normal arms-length business transaction about which Professor Ronald Dore of the

Technical Change Centre in London has written so perceptively in his studies of the Japanese textile industry.

This is a reminder that the less visible part of the Japanese economy, the great sea of subcontractors and family and small business suppliers, is also possibly the most important part. It gives Japan's economy the suppleness and resilience which big business alone could not provide, and which is vital as the old concentrations of heavy traditional industry dissolve and the new "soft" economy of small industries and services replaces it.

This is certainly the path we want to follow in Britain. Not long ago the Daily Telegraph in London — hardly a socialist organ — had this to say about our society: "British companies and British unions, for all their crocodile tears about the unemployed, are, with only a few honourable exceptions utterly indifferent to social obligations which their counterparts in Germany and Japan willingly accept."

Perhaps that is putting it a little harshly. But the message is clear. If we want to travel along the road of super-competitiveness and maximum flexibility and efficiency in the microelectronic age, while at the same time providing good and satisfying occupations for nearly all, some new qualities are needed. Perhaps we can find them here.

Final Questions
Finally, there is one major question to be asked about this whole analysis and argument. Are we seeing the true Japan of today or is this a fading image? Are we trying to emulate this subtle mixture of large and small enterprises working together in harmony, just at the very moment when it is altering in Japan?

I see Nomura forecasting an entirely different economic and social landscape in Japan over the coming decade. Their expectation is that domestic demand will take over from exports as the growth engine. The yen rises, the export surplus falls and Japan begins to face the very problem we have in Europe — demand which is high but which does not generate jobs.

Could Japan then find itself saddled with rising social security payments and the trappings and attitudes of the centralized bureaucratic welfare state at the very moment when we in Europe are struggling to

break out of this pattern and create the new and modern "soft" economy relying on much greater decentralized independence and enterprise?

Ships in the Night

That would be a sad irony, if our two societies, on opposite sides of the planet, far from converging, just met like two ships in the night and then headed on in opposite directions.

I very much hope this prospect is a false one and that the qualities we in Britain now see and admire in Japan will endure and indeed flourish. Perhaps we can offer you some advice from our past on the dangers and pitfalls, the ways not to go.

In the meantime, I conclude by repeating my belief that the changed British attitudes I have described toward Japan today are helpful and good and should be encouraged. They will enable us to see more clearly that the surface economic problems, such as the export surplus, hide much deeper issues and that some of the superficial remedies being called for would be far worse than the disease. If we can all grasp that point alone, then the world will be a better, more stable and more prosperous place.

10 JANUARY 1986

'Long' View
Envisages Joint European, Asian Economic Growth

That the twenty first century is going to belong to the nations ringing the Pacific, and that Western Europe is locked in a pattern of progressive sclerosis and decline, has become something of a cliché in the circles where wise men gather together and informed opinion is supposedly conceived.

And undoubtedly there has been plenty of evidence to support this view of affairs over the last decade. European growth has been slow, industry reluctant to seize and exploit new technologies, welfare benefits large, and latterly, registered unemployment throughout the European continent intolerably high. No wonder that speech after speech in almost every European forum has warned of the need to halt the slide, bemoaned the threat of ever-rising Asian imports (and of ever higher quality) and described how America is turning away toward the virile Pacific powers.

Yet as time goes by and we pass the midpoint of the decade, it could be that this standard picture of the future is beginning to need a little revision.

First, what is really meant by the claim that America is 'turning away from Europe'? It may well be true that the West Coast is richer and faster-growing than the East and that it has supplied the world with Ronald Reagan.

But America also has an Atlantic sea board, and this is not going to disappear. Psychologically, culturally, economically, and militarily the United States remains inextricably tied to the European continent. If anything, the links are getting more intimate across the Atlantic Ocean.

It could be that those who talk of the United States turning away are confusing what they see with something quite different. That something different is the determination of all the NATO allies, both European and American, to involve the biggest Pacific power of all, Japan, much more closely in the global order, and in particular in the world tasks of security and economic stability.

If this is what lies behind growing American interest in its Pacific flank, then it is a concern which has whole-hearted European support. Encouraged by the apparent outward-looking emphasis of Mr. Nakasone's premiership, the Europeans would be only too happy to see Japan come right to the fore on the world stage.

With technology now sending defence systems into space, the feeling that Japan lies somehow outside the world security theatre is fast giving way to the view that Japan is now as much a vital link in the free world security system as France, West Germany or the UK, and that this should be fully reflected in its defence commitments.

As for Japan's contribution to economic stability, the efforts being made from within Japan to improve market access and increase imports are seen as the very minimum consistent with Japan's obviously central role in the world economic system. In fact it would be true to say that they still continue to disappoint as something less than the minimum.

The members of the European Commission delegation who recently found that they could get no change in Tokyo for the idea that Japan should adopt import targets, were greeted on their return by a chorus of "we told you so" from those who remain convinced that even now the Japanese could and should do much more to correct the trade imbalance.

It is probably fair to say in this context that, for all the wonders of telecommunications, news travels slowly from one end of the planet to the other and the sheer extent of efforts so far in Tokyo to open markets, and more significantly, to strengthen the yen, have not been fully appreciated in Europe. Even so, it would be wrong not to report

that more positive results are awaited with ever-growing impatience, and that the expectations aroused by Mr. Nakasone's high profile stance on the world stage at successive summits have not yet been fulfilled.

Nor can one entirely blame the cynics and those who doubt whether Japan will ever take really decisive action. The statistics tell us that Japan's exports are at the highest levels ever and that the trade imbalance with the E.C. continues to expand (although this actually disguises a decline in trade both ways, European exports having dropped faster than Japanese imports).

There is perhaps another sense in which more reflective European views about Japan and the Asian 'miracle' are undergoing some mild revision. The nations of Europe are very old and they have seen countless ups and downs. A 'long' European view of the frenetic rise of Asian prosperity might be that what goes up very often comes down and that not all of the fantastic expansion of modern Asia is soundly based.

The Singapore stock market 'hiccup' of recent weeks is taken as confirmation of this view of the transience of Asian miracle growth while Hong Kong's lustre is now seen (regrettably) as shaky. Taiwan can hardly be depicted as a rock of political stability, while China remains for all the bold talk of liberalization and development, a shambling and patchy empire with many aspirations but not much ready cash to meet them.

This is not to suggest that these doubts extend to the ancient and powerful Japanese nation. But recognizing Japan's enormous strength is not quite the same as saying that all the action has passed, or is about to pass, to the Pacific countries. Meanwhile, the undoubted 'bread-and-butter' problems of trade friction remain and will continue to provoke the usual outcries from the various producer lobbies who feel themselves threatened and whose interests are well and noisily represented within the political systems of most European nations (in contrast to those of the consumer).

They are not going to disappear, although they can undoubtedly be eased if the two sides involved think and act carefully toward each other, keep in constant contact and never cease trying to grasp each other's viewpoint. This means raising curtains and barriers between Japan and Europe, not pulling them down. It means welcoming the

two-way flow of both capital and direct physical investment. It means, on the European side, a readiness to learn and imitate Japanese methods and technology by the most intense application, rather than giving up on the grounds that the trade contest is hopelessly unequal and unfair.

In sum, the message the Europeans would most like to hear from Japan is that this amazing and rich nation has now decided unequivocally to play its full part on the world stage that it is a fully committed world power and not just an incredible industrial and electronic machine.

Perhaps the message in return that the Europeans need to convey to Japan is that they are not yet finished, do not all regard themselves as decadent and declining and have just as vital a role to play in the future as the Asian wonder-nations.

If Japan and Europe can set out into 1986 with these two thoughts firmly in mind, then we could well see relations improve and prosper. The only thing that could work the other way is a simple failure by the two sides to understand each other's position. And for that there is now really no excuse at all.

12 SEPTEMBER 1986

Ageing Japan could be Source of New Dynamism

This week, amidst a great fanfare the new Nissan motor plant on Tyneside was opened with a welcome of unqualified warmth by the British prime minister, Mrs. Margaret Thatcher. Most newspapers carried front page pictures and stories. Mrs. Thatcher's general welcome was reflected throughout almost the entire press, with hardly a critical or warning word anywhere about the Japanese threat.

This makes a remarkable change from opinions quite widely only a few years ago that Japanese investment in Britain was a two-edged sword. In part I think this is because experience has proved the fear unfounded but in part it comes from something deeper. The reality is that public opinion has both become infinitely better acquainted with things Japanese and, as is often the way on closer acquaintance, has changed fairly radically.

Indeed, the interest of the Western press and public opinion these days in the inner state of Japanese society has reached almost obsessional levels.

The coverage is enormous. Prompted by the nature of Japan's role at the epicentre of world economic upheaval, by stories Japan is under strain as the yen soars, and by the growing world pressure for the Japanese to shake off ancient and frugal ways and join the big spenders, features and "in depth" analyses have been pouring out of the press and

are eagerly digested, all purporting to reveal the true nature of modern Japan, what makes it tick and how it is changing.

Illusions Crumbling

In the process some well established illusions are crumbling. For example, it has long been the view of less well-informed sections of British public opinion that the Japanese are prosperous but miserable. They work hard but live a life restricted by excessively rigid tram-line discipline and conformity.

Not so, says a recent survey. Japanese workers are a happy lot. They like their life style and society and find it fulfilling. They do not find their work ethic oppressive.

A second myth — although admittedly one that has been on the wane for some while — is that low Japanese pay rates allow Japanese imports to undercut home-products. Now this is seen to be totally out of date and completely wrong. With the ever-rising yen it appears that Japanese workers' wages are some of the world's highest. In nominal terms, at least, higher than the United States. So much for the cheap labour alibi about Japanese competition.

Yet another myth used to be that Japanese managers were profit-driven tyrants arriving in Britain to brow-beat insubordinate British labour into shape. Not so, we learn. A survey reveals that hardly any of the numerous Japanese firms in South Wales, for example, have so far proved to be money spinners at all. If profitable operation is the aim, then it appears to be a very long term one indeed. Meanwhile labour relations are now excellent. Amidst all the comment on the new Nissan project no voice has been raised, amongst trade union leaders or elsewhere, suggesting that things might go wrong. I doubt whether this would have been the position even three years ago.

However, there is one insight into the Japanese scene which for many Europeans is new and striking, although no doubt long appreciated within Japan itself. This concerns the way in which Japan is fast becoming an aging society. Of course with falling birthrates and much greater life expectancy in most advanced countries Japan is not unique in this respect. But it looks as though the demographic shift is coming at a faster pace, and is going to be more dramatic in Japan than anywhere

else. The official figures, given coverage in several British newspapers, tell us that 25 percent of the Japanese population will be over 65 by the year 2043. What will this do to the character of Japanese society? Does it mean a loss of dynamism? Who will carry the growing burden of support for the elderly?

Questions like this can lead two ways. One view to which some commentators incline is that Japan is bound to follow Europe toward the over-burdened, and over-taxed welfare state. Fewer and fewer "workers" will have to support more and more "dependents," through state provision, with serious consequences for personal savings, work incentives and investment.

More Creative

But there is another view about the effects of population aging and it is one which I prefer. It is that an aging society may actually be a more balanced, creative and satisfying community than one dominated by the young. This is for two reasons, one obvious, the other more novel.

The obvious one is that experience and wisdom do in fact come with age, contrary to many of the assertions and dogmas of the whizz-kid era. The less obvious one is that people are not only living longer (and the Japanese apparently longest of all) but are remaining far more active and dynamic for much longer.

Recent American studies suggest that we may have reached the stage where it is those in the so-called third quartile of life, the period between 50 and 75, who have the most to contribute. Far from being a period of thinking about retirement and of growing dependence on others, this could be becoming for more and more people the most promising part of the life career, often marked by the development of entirely new skills and talents.

Japanese Traders should focus on more than Whisky Taxes

The Japanese, we are taught here in Europe, are practical people. They are not at home with generalities or broad theories, or with the great embracing philosophies over which the Europeans like to agonize. They like to focus on the detail.

I was explaining this point the other day to my friend who is both a brewer of fine beers and the proud owner of a Scottish whisky distillery or two. "In that case," he said bluntly, in answer to my observations, "it is high time we moved on from generalities to specific details in the matter of UK whisky exports to Japan.

"We have had plenty of fine speeches from the Japanese," he went on, warming to his theme, "about market opening and Japan's commitment to an open trading system. How is it then that my beautiful Scotch whisky costs as much as £3 or £4? What kind of open market is that? Even if I landed the stuff in Japan for free," he continued, "They would still add about fifty quid in taxes before it reached the consumer."

There can be no doubt that my friend is reflecting extremely deep feelings, although about a relatively small item of trade in the great tidal flow of trade between Japan and Europe, the total involved for whisky and other spirits being about £140 million a year

But it is this attitude which probably explains the unprecedented decision of the whole EEC, urged on by British ministers in particular,

35

to bring an action on whisky against Japan for unfair trade practices in breach of the General Agreement on Tariffs and Trade. Generalities are giving way to specifics. Here is a breach so blatant of the spirit of fair trade that no amount of general hand-wringing and assurances of long run good intent will really do.

It will be interesting to see whether this presages a broader change of tactics within GATT towards targeted measures related to individual products, or whether the new approach is just reserved for the indignant and incensed Scottish producers.

Either way, it all seems a pity that the genuineness of Japanese trade policy intentions, which many in the West now believe to be truly directed towards the full integration of Japan with the world's open trading system, should be compromised by trouble over "a wee dram." There is an old English phrase about not spoiling a ship for a ha'porth of tar. I hope this particular small but irritating problem can all be put straight soon, by which I mean now, in the next few months, and not after interminable committees have all reported to each other on some distant and imprecise day in the future.

It may however be that, even while these familiar trade squabbles continue in one area or another, the whole landscape of Japan-EEC economic relations may be shifting. It is often the case in government affairs that just when the policy-makers at last get wound up for action, the underlying issues are in fact already on the way to a solution.

Politicians nearly always act too late. Like generals, they tend to fight the last war. It is more than possible that, despite the ructions over whisky, the real high noon of Japanese-European trade friction has passed and we could now see Japanese exports to Europe actually continue to fall (as they have been doing lately) or certainly stabilize rather than soar ever upwards.

Of course the large Japanese trade surplus will persist, despite the high yen (now not quite so high). But minds in Europe are increasingly turning to a different kind of Japanese "invasion" which is the inevitable counterpart of this visible trade surplus — namely the prospect of large capital movements in the one form or another from Japan into the European economies. The constructive line of thought must be this: If the moment has come when we are going to see a really significant

growth in Japanese capital investment in Europe, what can we (that is, both the Europeans and the Japanese) do to ensure that the process is mutually reinforcing and in a spirit of partnership, rather than hostile and threatening? How, in other words, can Japanese capital imports into Europe be seen as a positive force rather than another "onslaught"? How can a replay of all the bitterness that has arisen over physical trade questions be avoided?

Much depends on what form the Japanese capital investment takes. For instance, no one is going to be antagonized merely by growing Japanese portfolio investment in the industrial equity of Europe. There may yet be some future purchase that should be handled, and we have yet to see how the major Japanese players in the London stock market are going to operate after the so-called "Big Bang," which in effect opens the doors for share trading in London to all comers. But that is another story. The point is that portfolio investment of this kind is relatively faceless and arouses no fears. Indeed, in the case of the huge privatization flotations like British Telecom and British Gas, Japanese investment has been actively courted.

What, then, about direct physical investment? So far we have seen a considerable amount of what might be called "production colony" Japanese investment in Europe and especially in the UK By this I mean investment in plant for assembly and some original manufacture, but always with the strategic decisions really being taken back in Tokyo. Speaking for the British experience I would say that on the whole this sort of project (e.g. the new Nissan plant on Tyneside or some of the TV and video producers located in South Wales) has gone down well, with only one or two minor cases of friction, although the scale still remains fairly small.

But might we now be about to see a new kind of Japanese capital invasion, in the form, for instance, of major property investment and development or outright acquisition of already existing European concerns? The great tycoons of Hong Kong have latterly been sniffing round some of Britain's more attractive business concerns. Could the even bigger Japanese giants be looking the same way?

The word on everyone's lips in this area of activity is "partnership." In theory the idea of partners from Europe and Japan collaborating in

either new ventures or restoring the vitality of existing enterprises is splendid.

In practice there have been a number of unfavourable "partnership" experiences with Japanese firms which have left some scars. Allegations have appeared in the newspapers about technology and markets being filched and about generally most un-partner-like behaviour of the Japanese. These may be teething troubles. But they do suggest that the path of massive Japanese capital rolling into Europe is not going to be entirely smooth. My conclusion is that the new investment wave is going to happen because it is in a sense inevitable. And I believe, too, that friction, fear and misunderstanding can be largely eliminated in the process. But at both political and industrial levels the ground will need to be very carefully prepared indeed.

This week I understand that senior Japanese businessmen working all over Europe met in London for an annual pow-wow amongst themselves about common problems and aims. I hope that high on their agenda was not yet another plan for targeting and attacking this or that European consumer product market. Instead, I hope the top question was how to make inward investment into Europe truly harmonious. Of course, I have no idea what they actually discussed. Perhaps they spent most of the time drinking our excellent and genuine scotch whisky.

29 NOVEMBER 1986

UN Seeks Sugar Daddy: Like Japan?

A T THE UNITED NATIONS, N.Y. These days the Japanese ambassador to the United Nations, Makoto Taniguchi, is a very popular fellow.

This is not just because of his personal qualities, high though those undoubtedly are (among many other things they include an Oxford blue). It is because the word has got around that Japan is now a very rich country with a very deep pocket. And there is no spot like the United Nations for finding large numbers of officials and governments who are very interested indeed in such reports and who therefore cluster around the Japanese delegation like bees around a honeypot.

Of course the United Nations has always been a place where the would-be spenders outnumber the would-be donor nations by a considerable majority. And with one vote per nation, however large or small, this has always tended to create an atmosphere in which most of the richer industrialized nations were on the defensive over questions of aid and economic development.

The one exception to this has been the Soviet Union which, through adroit diplomacy and swift alignment with almost every revolutionary group and every Marxist-tinged cause, has managed to get away with a wholly inadequate aid record while acquiring a general reputation for

always helping the underdog. It's amazing what good Marxist rhetoric will do.

Meanwhile it is hardly surprising that American enthusiasm for the United Nations should have waned over the years. With a popular perception that American taxpayers support far the largest aid budget to the developing world, yet seem to take most of the brickbats, it was inevitable that hostility would grow toward them.

Here was a forum which always seemed ready, with dreary inevitability, to line up an anti-Western majority on every conceivable issue, and to reinterpret the most fundamental principles built into the foundations of the U.N. such as self-determination and concern for human rights, in any way that happened to suit the so-called non-aligned majority, so long as it always showed America to be in the wrong.

All this has come to a head in a wrangle about financial support for the U.N. itself and its agencies. This year the U.S. Congress has simply refused to vote its usual contribution to the U.N. regular budget. Of $287 million outstanding, it has so far agreed to pay only $100 million.

Cutting and Pruning
The congressional argument has been that America is far the largest contributor, as well as the U.N.'s physical host in Manhattan. Other nations have been behind with their payments for years, notably the Soviet Union and some of its satellites. Why, demand congressional representatives like the energetic Mrs. Kassebaum, should American taxpayers go on coughing up, especially as the U.N. has acquired a reputation for administrative extravagance and over-staffing. It is all too much.

The effect of these withholdings and delayed payments has been to electrify the U.N. administrative machine. Economy is suddenly the watchword. Large numbers of posts are to be eliminated, agencies pruned, activities wound down. Some agencies such as the U.N. Development Program (UNDP) have survived the squeeze with only minor cuts, but everywhere the pressure is on to cut out waste and to implement the recommendations of a special high-level group of experts, the Group Of Eighteen who were asked to find ways of improving operations and have recommended accordingly.

In this kind of atmosphere it is to be expected that Japan, which now accounts for 10 percent of all aid from member nations of the Organization of Economic Cooperation and Development, and whose income per head, so the statistics say, is now higher than America's, should be the recipient of a deluge of inquiries and suggestions as to how it might spend its wealth.

Antiquated Club?

What attitude Japan is taking to all this I do not know. But it would be thoroughly understandable if there were some hesitation. If, as the whole postwar record of the U.N. suggests, it is the big givers who get invariably branded as imperialists, that is hardly an encouragement to Japan to follow the same thorny path.

Nor is it as if the U.N. has so far shown the slightest readiness to adapt its structure to the new fact of Japanese world economic strength. No place on the Security Council is on offer or in prospect. In essence the U.N. system still reflects the immediate postwar order, complete with a special sop to the Soviets by allowing them in effect three U.N. seats, one for the Soviet Union itself, one for the Ukraine and one for Byelorussia.

There is admittedly a reform idea going around that the world powers of today, (as opposed to those of 1945), might sit on the Security Council in some kind of annual rotation, but so far it has received very little support from the West, and none at all from the Soviets.

Is this the kind of United Nations club which really fits the modern world? Or is it just a tired repertory company, endlessly replaying the quarrels of a world of ideological conflict, East-West confrontation and decolonization which is losing its meaning?

Yet although the old lines and the old tunes certainly continue, there is some evidence that beneath the surface things could at last be changing. The issues which preoccupy the U.N., and the wider world today — such as drug abuse, population control, terrorism, ecology — do not fit in at all easily with the old stereotype "bloc" thinking which has characterized so many of the U.N. debates hitherto.

Drugs know no ideology. There was a time when they were seen as just another part of Western decadence, just as terrorism was seen by

41

many U.N. member nations as no more than freedom fighting. But as the virus spreads, as hijackers cease to discriminate between East and West, views alter.

And then there is Iran and the fanatical fundamentalism which it is determined to export wherever it can. In whose interest is it to see that kind of infection destroying stable regimes throughout the Middle East, spreading terror and toppling long-established thrones and governments?

Realignment

The Americans themselves may not know the answer very clearly, as their current extreme confusion over their policy and attitudes toward the ayatollah confirms. But the answers aren't clear among the non-aligned countries either. Iran gives the Arabs the shivers. It divides loyalties in Africa. It worries the Soviets with their huge Islamic minorities.

The reality is that the new issues preoccupying the globe no longer lend themselves to the simple slogans and battle lines of the postwar world. Old alliances at the U.N. are breaking up, new ones growing. Regional interests and common causes are overriding old ideological groupings.

It is not just reform of the U.N. budget that is needed. It is reform of the whole institution itself which is required, so as to give it a new relevance.

In the meantime those nations with the needs but without the cash to meet them will continue to set the pace, and those with the money will continue to get the demands. And since the former still have much the louder and more numerous voices it can be safely assumed that for the wealthier nations the U.N. will remain, reformed or unreformed, a somewhat uncomfortable place.

Softnomics Wise Lessons from Japan

About four years ago a friend at Osaka University sent me a paper entitled "Softnomics Proposed — A Report of the Study Group on the Structural Transformation of the Economy and Policy Implications".

At first reading I confess that I viewed this paper as a piece of macro-economic gobbledygook, especially since the English translation left something to be desired and the word 'softnomics' struck my Western ear as a hideous union of syllables from Greek and Saxon roots.

But reflecting on the document I began to see that I held in my hand the key to something very much more profound. I realised that the underlying message from the authors of the paper was one of an importance which it is impossible to exaggerate.

For what the fascinating thinking from Osaka questions is the entire set of assumptions upon which modern macroeconomic theory is based. Advanced, knowledge-intensive economies, it suggests, are beginning to behave quite differently from their predecessors. Their cyclical behaviour is changing and their response to central stimuli and signals is changing.

This is because the microcomponents of economic life which make up the aggregate pattern — individual investment decisions, consumption decisions, work decisions and the personal attitudes behind all these

things — have themselves begun to alter quite radically in the new 'soft' economic landscape, in which heavy industry is no longer predominant.

They are more dispersed and they are based on infinitely better information and a far higher proportion of non-material inputs. They are much harder to measure, and therefore to aggregate — and also, therefore, much less susceptible to Keynesian policy. We stand no chance of understanding our economies, says the softnomics thesis, let alone devising suitable policies for them, unless we first understand what has been happening in all these areas.

New Characteristics: New Behaviour
Specifically, the softnomics analysts see the following characteristics as now being the dominant ones in the economic behaviour pattern of today and tomorrow:

1) The whole texture of industrial activity has changed. A soft economy is one in which people's interests, needs and values have shifted and in which demand swings decisively in the direction of services rather than physical goods. This is more than just saying (as I sought to say over a decade ago in The Times, and received a barrage of criticism for my efforts) that advanced economies like the Japanese and our own are now much more involved in services than manufacturing.

That is certainly true, but the softnomics thesis takes the point much further. It argues that the 'soft' activities, such as information handling, financial services, research and development, design, marketing, communications of all kinds, are now deeply interwoven with what was previously described as 'manufacturing'. The old industrial classifications are becoming meaningless and should be revised.

2) The new economic activity pattern is far more dispersed. This is because the need for heavy concentrations of employees and heavy equipment at a single location and the need to concentrate in order to achieve economies of scale are both diminishing. Information and control techniques accessible previously only to large organisations are now equally available to small undertakings. Indeed, the balance of advantage now switches to the smaller unit which is free of the inflexibility and the overhead burdens which go with larger systems. Large organisations therefore seek to shrink by dispersing and

sub-contracting a wide range of activities previously undertaken 'in-house'.

In other words, the economies of scale are actually being reversed in many areas, reversing with them, of course, a large group of assumptions about industrial economic behaviour.

The Real Issues behind Today's Unrestrained Japan Bashing

LONDON — It will be no news to readers that the British press and Parliament have been going through a period of unrestrained Japan bashing. Emotions have been running high and, as always at such times, some extraordinary silly things have been said.

Believing that it was best to wait until the situation became a little calmer this column has restrained itself so far from joining in the general clamour.

But perhaps the time has now come when it is possible to offer a few background reflections on how and why these events have occurred, and on their implications. First, let us be clear about what has actually happened. As far as Britain is concerned it is not correct to say that there have for years been "mounting feelings on anger and frustration" about Japan's policies culminating in an explosion over the Cable and Wireless affair. That is pure media hype.

On the whole, criticism of Japanese trade success and the large UK-Japan visible trade imbalance has until very recent times been muted. The feeling all along has been that Britain has somehow got to match Japanese competitive skills rather than keep out Japanese goods.

Meanwhile, Japanese direct investment in the UK has been warmly welcomed (and in fact subsidized), as the prime minister demonstrated at the opening of the Nissan plant at Sunderland.

Of course, there have been minor irritants. The Scotch whisky issue has been a bit of a running sore, as this column warned some time ago it would become. There was undeniable disappointment that British investors were kept out of the NTT privatization. British financial institutions were getting restive about their speed of access to the Tokyo markets. But that was, until these last few weeks, about the sum of it — hardly the stuff of a popular anti-Japanese crusade.

Second, the visit to Japan of Michael Howard, the junior trade and industry minister, was planned months ago and was never originally intended to be the sabre rattling mission to demand better terms for Cable and Wireless into which the newspapers subsequently built it up.

Third, the British outcry has nothing whatsoever to with the much larger quarrel between America and Japan over microchip imports. On the contrary, Britain and the rest of the European Community have been highly critical all along of the U.S.-Japan microchip cartel which sharply forced up prices to the European users. There is no particular surprise, or dismay, in London that it is now all coming apart.

So why on earth, then, did the furore develop?

False expectations

The trail seems to start with Sir Eric Sharp, the lively and thrusting boss of Cable and Wireless, and with the expectations that were prematurely allowed to grow that the company had acquired an inside track in Japan's booming telecommunications business.

Sir Eric's disappointment when this turned out not to be so was briskly communicated to the British prime minister, who promptly let her considerable displeasure be seen and known by the press. Conservative backbenchers in Parliament soon joined in, demanding "action," with the Labour opposition (which is anyway in favour of protection) not far behind. Within hours the issue was ablaze and Howard, off on a quiet working visit to Japan, found himself propelled to the front pages as the banner-carrier of British outrage.

In practice, despite the blood-curdling headlines in the popular press and a certain amount of residual anti-Japanese sentiment which is always bound to be there, the effect has been to produce a number of very informative and profound comments on the realities of the new

47

world trade situation at the centre of which Japan now lies.

These have included not just the point that the statistics are misleading, and interpreted quite differently in London and Tokyo, but that on any measure Japan's exports have been falling and imports rising sharply.

Background comment has also helped remind people that the Japanese and British economies are now inextricably woven together not just at the trade level but also in the manufacturing and financial sectors and that trade is anyway nowadays a criss-cross of thousands of multilateral relationships which any country tries to cut at its peril.

Commentators have also gone on to point out that the soaring yen is now putting many Japanese goods in the luxury price class for overseas consumers and that this is bound eventually to have a severe impact on the huge Japanese trade surplus, even if the politicians are getting on a much more fundamental and worrying question.

Japan, A Giant

The reality, which is far more important than any passing bilateral trade dispute or tiff, is that Japan has now risen by virtue of its sheer economic power to the forefront of the global scene. The time which Japan has to adjust to this new situation is much shorter than some people within Japan seem to appreciate.

A leading world power simply no longer has the option of trying to keep itself to itself in a sort of cosy half-neutralism. On all the big questions of world growth, currency stability, global defence and security, Third World development, Japan has now tumbled into the leading role from which it cannot walk away.

This is not just a Westerner lecturing the world's richest people. I doubt whether all that many Westerners appreciate the point either. It is a simple observation of the new facts. And I think it is the message Prime Minister Yasuhiro Nakasone has been patiently trying to get over to Japanese public opinion, which has made him not all that popular in the process.

Until this message is received and understood we will undoubtedly continue to see these or bilateral issues — like the whisky, or the boiled Evian water or the ski-bindings or the room for more seats on Tokyo

Stock Exchange, and so on — flare up from time to time.

But that is not the real danger. The real danger is that Japan's size, strength and global centrality, if not accompanied by radical and swift policy readjustment, will lead to world dislocation, exchange rate chaos and economic decline with direct consequences for Free World security, stability and survival. And no country could be more vulnerable to these events than Japan itself.

All of us would be badly hurt and none of us want such things to happen. As George Gilder has put it, writing in the Wall Street Journal, Japan is a "supreme and precious asset of world capitalism."

But by the same token it is an asset whose continued rapid growth. vigour, openness and international involvement are now of universal concern to the rest of the capitalist community. It has truly become no exaggeration to say that the fate of the world lies — just at the moment, at least — in the hands of Japan.

16 JANUARY 1988

A New Mood for a New Year

LONDON — I detect a new attitude emerging here toward Anglo-Japanese issues. This is reflected in the style of the newspaper coverage being given to the visit to Japan by Sir Geoffrey Howe, Britain's foreign secretary.

For once the interest is not exclusively on bilateral trade issues — the old favourites like whisky and car quotas — but also on much deeper, and to my mind infinitely more important, questions like world security and development; and the potential for joint and mutually reinforcing action between the two island monarchies in these areas.

Of course, one must not exaggerate the degree of change. The thorny trade issues continue to attract attention and there would have been surprise if the tireless Sir Geoffrey had not raised them. Nervousness remains, too, about the next steps which might be taken on the world stage by Japan's giant financial houses.

But alongside these familiar worries there is also a new perception — namely, that Japan, like Britain, is undergoing a significant transformation, that it is now a leading and increasingly active participant in the international community and that the British and the Japanese have a great deal to learn from one another.

The reality that Japan has indeed changed enormously and rapidly, and that the old stereotyped views from Europe about the country need

revising, has been slow to permeate to popular levels, this is always the way of things. We in Britain have experienced just the same sensation about our own status.

The cassette of established prejudices about a country and its ways continues to be played again and again long after the statistics and the facts have removed all foundation from such views. One can still find commentators, both at home and overseas, who will tell you confidently that Britain remains a strike-ridden has been nation, riddled with class divisions, which has never recovered from its loss of empire.

The fact that Britain has one of the lowest levels of industrial disruption in the world, that it is growing almost the fastest, that it is far less class-ridden than societies such as East Coast America,that it is one of the world's richest creditor nations — all these things are brushed -aside by those who have been writing the same headline for years and find it easiest to go on doing so.

Similarly with Japan, I still hear it asserted that Japan imports nothing, remains totally inward looking, spends nothing on defence and is not interested in the general economic health of the globe. Never mind about the facts. That is what people are used to hearing. Nor is this just a Western state of mind. Not a month goes by without some senior Japanese journalist calling on me in London and I am honored that my opinions should be sought. But too often I feel the story has been written before I speak. The Japanese, I'm told, "know" that Europe is terrified of their competition, that the British especially are hostile and primarily concerned to keep them out. What do I feel should be done about it all?

My answer is that this no longer properly reflects the European, and certainly, the British view. The facts are slowly getting through, even if at the pace of water dripping on a stone. Japan's soaring imports are beginning to be a "happening" that even the most blinkered critic can no longer dismiss. So, too, are its efforts to maintain a reasonable pace of economic growth while other parts of the global economy falter. So, too, has been the Japanese contribution in trying to combat dollar instability and world currency upheavals.

One could even argue that Japan is now emerging with rather more

credit points in the world economic leadership class than the United States.

Opinion is now starting to look expectantly to Japan to play a forward and leading role in the world's trouble spots, such as the Gulf and the Middle East, and the world's economic crisis areas, such as Africa.

Credit for this shift of attitude must surely go largely to former Prime Minister Yasuhiro Nakasone, the first postwar Japanese leader who really made an impact on the popular mind in the West and who seems to have got the key message through to his countrymen that they must look outwards.

Much obviously remains to be done. Japan's overseas aid policy still looks a bit puzzling. Is it truly a policy for development in the Third World or is it all to do with Japanese export promotion? And Japan seems as infected as everyone else with agricultural protectionism, although to write this from Europe is truly to be the pot calling the kettle black.

But the days really do seem to have gone when Japan made the Europeans uneasy and when predominantly negative attitudes prevailed. The impulse now is to see how we can work together on the world problems which will fill the rest of the millenium.

The list is formidably long. We could start with the quagmire of the Arab-Israeli dispute, the rising tensions in Eastern and Central Europe, the famines in Ethiopia, the Latin American imbroglio, Southern Africa and apartheid — all areas which may seem a million miles from Tokyo but all demanding the attention of world statesmen if they are not to blow up in our faces.

So the message for Japan via Sir Geoffrey is simple. Thank you for the progress so far. Welcome aboard the international community. Stand by for a lot of thankless tasks, diplomatic headaches and insoluble problems. But we need you very much.

25 JANUARY 1988

Explaining the New Japan

When Prime Minister Noboru Takeshita comes to London in early May, he will find that this other island at the far end of the globe from his own will have a good story to tell. Things are not what they were in Britain. British Prime Minister Margaret Thatcher will make that crystal-clear to him.

But he also has a perfect opportunity to tell a good story himself about the changing Japanese scene and approach, and for this he will find a receptiveness among the British which is undoubtedly far greater than it was only a year or so ago.

For what it is worth, my suggestion is that he should present the Japanese side of things in three separate packages for the British to unwrap.

First, there is the short-term, immediate scene, characterized by world financial instability and a general lingering sense of unease after the great financial crash last October. What part, he will be asked, are the Japanese playing in restoring immediate stability?

His answer can be a forthright one. Japan has undoubtedly moved swiftly and positively since October to support the sagging dollar (at a cost of several billion dollars), to expand its internal economy and thus provide some "locomotive" stimulus to the world scene and to sustain stock-market confidence by ensuring (by means too obscure for

lay Westerners to comprehend) that the Tokyo market stays amazingly strong.

Without going overboard with congratulations (and the tough bits are coming in a moment below), the reality is that Japan and East Asia generally have played the key role in preventing Black Monday from turning into a full-scale world depression — at least so far.

Second, there are the medium-term issues of Japan's readiness to open up markets and generally join the international economic community. Here Takeshita will find more scepticism to overcome.

Admittedly, Japan's imports are now soaring, although the bulk of the increase seems to come from neighbouring Asian economies such as China and the four "dragon" NICs (newly industrializing countries). And admittedly, in the smart, up-market shops, European fashion goods abound.

But there is still something distinctly odd about the way imported consumer goods arrive, or do not arrive, in Japan's medium-priced department stores and supermarkets, as I took the trouble to check for myself recently in an area outside Tokyo. The local whiskey, as well as the local gin, is standing there on the shelves at one-third the price of the imported brands.

Until we see this gap dramatically narrowed, I think it will be difficult for the British to believe that markets really are open.

All the same, credit must be given where it is due. Tastes and habits in Japan are clearly at last internationalizing fast, and this is recognized in the West. As it was put recently at a Tokyo international conference (the Trilateral Commission), the era of Japan-bashing is passing. Instead we hear Japan-praising. I hope Takeshita picks up a bit of that while he is in London.

The third major policy area is the most difficult — the question of Japan's longer-term strategic role and contribution to global security. This is a subject filled with paradoxes. The British do not really want to see Japan as a great military power again, any more than the Japanese want to become so themselves. Even less do they, or any other European nation, want to see Japan as a military nuclear power.

But there is some puzzlement at Japan's continuing low profile in so many key trouble areas of the world. Is it right that others should do

Japan's peacekeeping for it?

For example, should Japan be taking a much more forward position in the increasingly dangerous Gulf dispute, given its vital interest in oil supplies? And where is Japan's voice on the other Middle East issue, The Palestinian question?

Do the mild injunctions administered by the Japanese government to their traders with Africa constitute a serious policy toward apartheid and southern Africa? Or has Japan a more decisive role to play in preventing renewed famine in war-torn Ethiopia?

Above all, does Japan regard itself as in the front line against Soviet expansionism, even if that tendency is temporarily below the surface? Or does it just hope for a Russia which will be a benign power, with which it can live in a neighbourly, and profitable, harmony?

All these, and many more, are issues of vast complexity, bringing few gains and many risks to those nations dragged into them. It is all too easy to understand the reluctance of any nation, and especially Japan, to volunteer to play a bigger role in such unrewarding endeavours. Compared with these matters, the usual mundane squabbles over videos, car quotas and whiskey, which have been the staple fare of Japan-Europe relations for so long, must seem easy and familiar.

But we have reached the point when there can be no going back for any of the major nations to that kind of cosier order. The entire structure of the Free World now rests and relies upon a strong and active participation by the Americans, the Europeans (who are at last uniting more effectively) and the Japanese and other East Asians, who now stand above the United States in terms of economic power and dynamism, and whose political influence is now catching up with that colossal economic influence.

If Takeshita does no more than convince the Europeans that the rulers of modern Japan have received this message loud and clear, as I believe they have, and are now working out how best to act upon it, then he will have achieved a very great deal on his mission.

Oh — and I hope the May weather remains fine for him, but I must advise: — Bring a raincoat — British-made of course!

25 JANUARY 1988

Japan and Europe in the Nineties

It used to be argued in the seventies that the only real European company was IBM or more sweepingly, that the US multinationals were the true driving force in European economic integration, with their investments and plants in almost every Community state, while the Europeans themselves trailed along behind.

True or false, the thought occurs that a similar role could be assumed by Japanese inward investment into the EC in the nineties.

The numbers are already getting very big. Japan now has 414 manufacturing projects of one kind or another in Community countries, (January 1989) with the emphasis on the UK, France, Germany and Spain. The major Japanese trading names are becoming familiar on office buildings in every European capital and at building and construction sites the hoardings proclaim the active presence of leading Japanese property companies.

Meanwhile the British motor industry has a large Japanese interest and Japanese banks and security houses are penetrating deep into the European financial system.

Like the Americans before them, the Japanese have 'arrived' in Western Europe in a most visible way, whilst of course beneath the surface all kinds of further networks are spreading through joint ventures, minority interests and a hundred other links.

A Different Europe

Yet here the similarities with the USA end. The Europe of the late eighties and nineties is proving to be a very different animal to the Europe of the post-war decades, with different attitudes, different responses and different complexes.

America was not just an economic partner and one which had played a large role in Europe's recovery through the Marshall Plan but also a defence and technology partner.

General de Gaulle could raise his voice against the American challenge but when the chips literally were down he had to watch French computer technology pass under American control.

Anti-American sentiment was there in Europe (it still is) but it had to take second place to the realities of European dependence on American power.

Nothing like that exists today in the relationship with Japan. Nobody in the Community yet regards Japan as a nation upon which their security depends or as a decisive and influential voice in geopolitical issues.

The connection is still seen overwhelmingly in terms of economic matters, especially trade questions. On issues like disarmament and weapons control, or the opening up of Eastern Europe, or cultural and philosophical developments, or changing social and work patterns in Western Europe, the Japanese contribution or interest gets virtually no mention.

The awkward arithmetical fact that Japan substantially finances the US budget deficit, and the US deficit allows America to continue defending Europe with its heavy US troop commitment, somehow seems to hang in mid-air, with no political conclusions at all being drawn from it or connections made about its political consequences.

That Japan might have a security role to play in these areas is greeted with surprise or a dismissive laugh. Recently I talked with one of the chief arms negotiators in Geneva an American who saw no real place for Japan in the unfolding disarmament scene and regarded Japan's "late in the day" involvement in the Intermediate Missile Treaty talks as a sort of coat-tails operation which would set the pattern for all future negotiations and deals.

This continuing narrow confinement of the relationship to economics is both good news and bad news for the health and maturity of international understanding and future intimacy between Japan and Europe.

The good news is that amongst the populace at large in Europe, attitudes to Japan remain remarkably tolerant and admiring.

There is no talk nowadays of Japanese or yen 'imperialism' to match the bitterness of feelings in the sixties against 'Yankee imperialism' and the 'almighty dollar'.

Government and Brussels Commission officials may grumble about local content and 'screwdriver factories'. And the banks may eye nervously the prospect of full-scale Japanese competition in their own backyard.

But for most people the Japanese 'presence' is not only welcomed but actively sought, as evidenced by the numerous missions to Japan to solicit still more inward investment.

Learning from Japan

There is no sign of this changing even though the Japanese economy itself is undergoing yet another change and emerging as a super-innovative, high research, new product-driven economic machine 'Learning from Japan' presents no problems of pride or vanity, any more than 'working for the Japanese'. 'These are friendly aliens,' the feeling seems to go, 'who mostly keep themselves to themselves and do not bother us with too much except their money, of which we can certainly help them dispose!'

The bad news is that this is a one-dimensional and shallowly-based relationship which could, of course, go sour at any time, as it seems on the verge of doing in some parts of the United States.

Japanese attempts to redefine their businesses in Europe as 'global' are viewed with deep scepticism, as are most other moves by Japan to adopt a more convincing global role.

For example, the West marvels at the reported size of Japan's ballooning overseas aid and development programme but asks what the motives are? Is this a vast budgetary commitment inspired by a deeply-rooted sense of global mission in an outward-looking Japan?

Or is it merely a kind of excuse-payment, driven by the need to prove

to the world community that Japan is 'doing something' towards world stability and advance?

World scepticism is not reduced by the antics and tribulations of Japan's political leaders and ruling party. How, goes the question, is the rest of the world to take seriously a society which seems at times to be politically headless and therefore (in European thinking) without strategic vision or direction?

My own view is that this persisting tendency to view Japan as a kind of gigantic fruit machine, clattering out its produce and wealth, but not much more, is both unfair and out of date.

Much more rapidly than the West understands, Japan is turning its inward, private face and soul to the outside world. This is happening not just in policy-making circles in Tokyo but at all levels of society.

Indeed, it seems to me that much of the political upheaval is itself a product of this enormous welling up of demand for change in the way Japan works and thinks. Japan is now in revolt against old practices and old hierarchies, and consequently caught up in a raging crisis of transition.

The other side of this tidal wave of change I expect to see a Japan emerge with a massive intellectual contribution to make to world deliberations. I expect to see not just Japanese personnel but Japanese wisdom and perception applied with confidence and vigour in all the world's leading institutions.

In place of that constant message of the past emanating from Japan that world issues 'are not our business', reflected in the polite silence of too many Japanese attendees at too many international gatherings, one would then begin to see a far more positive stance without the arrogance that came in the past, of course, from insecurity and a sense of inferiority which is now wholly unjustified.

We might also see an end to the apparently deep Japanese fear of being criticised — a fear which still leaves Japan at the UN, for example, very much on the sidelines — a super-rich non-participant in any of the current UN peace-keeping operations.

But the litmus test of this will be whether Japanese opinion-formers get away from their tendency to equate 'global' with 'regional' when they speak of Japan's new wider perspective.

While Mr Nakasone and others, for all their difficulties, deserve praise for awakening Japan to the need to match its colossal economic power with broader world responsibilities, and throw off its image of an American protectorate, the weakness of the Nakasone era was that the new leaders did not set the sights high enough.

There was, and remains, too much talk about Japan and its Asian neighbours and too little realisation that Japan's power, combined with modern information technology, now makes it everyone's neighbour, including Europe's.

The globe is now electronically integrated. Even the Chinese have found that they cannot retreat into mediaeval practices and horrors without instant, planet-wide exposure and costly repercussions.

The concept of Japan as a resurrected regional power is as outdated as the concept of Japan as an American dependency or a separate island race. Its security is now wrapped up with that of the NATO powers. Its future is being shaped by events in Moscow and eastern Europe. Daily life in Japan is being touched by what goes on in New York or London or Paris.

Best Qualities

Japan's best qualities must now be taken out of secret hiding places and made available to enrich Japan's links with other continents, and especially Europe, in every field.

No-one is asking that Japan should take on an undue share of world responsibilities or become Europe's milch-cow, saving and working while Europe spends. That is not the right relationship at all.

Nor is anyone suggesting that Japan should somehow step forward and fill the unenviable slot of the world's Number One nation which America seems inclined to vacate. In today's conditions the 'Number One nation' concept no longer makes sense anyway.

But that every major nation does have a distinctive and crucial part to play on the world stage if the 'play' is to be well and peacefully acted out, working closely with all others both behind and in front of the scenes, there can be no doubt.

That is the task confronting the amazing Japanese as their machines, their techniques and their financial power spread across the world that

they come on stage and join the cast, or team of friends, and uphold the team rules.

Friendship and team-work of course mean both giving and receiving. They mean revealing weaknesses as well as using strengths. There is no pretence that this is easy, especially for such an ancient and self-contained nation as Japan. But once the Japanese take the plunge they will find themselves much more welcome than they still seem to believe.

9 AUGUST 1990

Japan Shirks Its Global Role

Iraq's invasion of Kuwait provides the first real test of Japan's declared new role as a-truly global power.

No one can accuse this column of being fond of Japan-bashing. But it has to be said quite bluntly that, as far as one can see from Europe, the Japanese have failed to get over even the first hurdle in this challenge.

The expansionist ambitions of the ruthless Iraqi dictator Saddam Hussein threaten an area in which Japan has absolutely vital interests, relying, as it does, heavily on Gulf oil supplies.

So this is a crisis in which one would have expected the Japanese to have been in the fore from the start. Maybe, given the distances involved, actual logistical support for the other world powers in bringing Iraq to heel would not be practical, but a strong Japanese voice from the outset in insisting that the status quo be restored, plus a massive pledge of resources, would surely have been the very least to offer.

Given the encouraging readiness of the Soviets to make a reality of "mutual security" with the West, it would not have been difficult to envisage a thoroughly effective package of forceful measures resting on U.S. and Soviet sea and air power, European naval support and Japanese resources and technical know-how all aimed at pressuring Iraq into the unconditional withdrawal for which the United Nations has called.

But, so far, all this seems much more than Japan can manage. Japan's

voice, with its comment that the appalling rape of Kuwait was "very regrettable," sounded almost as weak as the dismal and feeble reaction of the Arab League to the destruction of one of its members. London's Financial Times summed it up with a headline "Indecision from Japan."

Let us hope that this is just a shaky start and that Japanese policy will rapidly firm up to the needs of the situation. Because there can be no doubt at all that this affair is THE crucial measure of the effectiveness of the newly emerging world order, whose failure or defeat would inflict a huge penalty on all advanced nations and threaten global stability at its foundations.

The danger now is certainly not a lack of fine words and ringing declarations. Everyone who is not blind can recognize a bullying dictator when they see one.

The question is whether deeds will match words. Will the major powers have the collective resolve not merely to stop Saddam but to roll him back?

The omens are not good. Already there are disturbing signs of pathetic readiness to compromise with the aggressor force, so the Americans seem to be arguing, will be used only if Iraq attacks Saudi Arabia, implying that Kuwait is a virtual write-off.

Meanwhile, Saddam's monstrous and worthless undertaking to withdraw his troops on all sorts of conditions, which would leave Kuwait as an Iraqi puppet state, is actually being seriously discussed by his Arab neighbours.

North of Iraq, the stance of the Turks, who could inflict sharp damage on its neighbour by cutting the Iraqi oil pipeline that passes westward through Turkey, has been equally nervous and inglorious.

As for the European Community, its member states have now agreed to a fairly robust list of trade and financial sanctions, although beyond these their stance is so far limited to a rather lame pledge of support for "any other initiatives the Arab states may take" — which means none.

The strongest and most encouraging response to the whole crisis has come in the form of Washington-Moscow cooperation. If the Soviets really are willing to cut off all arms supplies to Iraq immediately, then Saddam's allegedly battle-hardened army of a million men could soon look quite sick.

If the leading powers are prepared to go beyond that, putting military backbone into both Saudi Arabia and Turkey, imposing a united ban on all trade with Iraq, genuinely freezing all capital transactions and blocking Iraq's access to the Gulf with a naval force, then it is just possible that the Baghdad tyrant can be pushed back and international law reasserted.

Anything short of that will leave Saddam exactly where he wants — no doubt protesting that his demands have been satisfied; promising that he will behave from now on, but in practice merely waiting for the dust to settle before pouncing again (on Jordan, Syria or Saudi Arabia?).

Japan should be up there leading the initiative to forestall this catastrophic outcome. The Americans have the warships, the Europeans have the support vessels, the Soviets, the weaponry and aircraft, and the Japanese, the cash.

Let them all immediately get together and act, and keep acting until Kuwait's independence is fully restored. They will do so with the blessing of the United Nations and the entire civilized world, with the exception of a few tremulous voices.

The alternative is to wring hands, issue statements, bemoan the difficulty of any combined military response and let the Iraqi dictator get away with it.

Everything in our history books tells us that the price of that course will prove infinitely higher than risking decisive and conclusive action now. Each and every nation with pretensions to global responsibility and international influence should note this lesson and respond with vigour accordingly.

9 AUGUST 2000

A Modern Friendship:
Priorities for the UK-Japan 2000 Group

Japan has made no secret of its wish to develop much closer political ties with Europe and to be positively associated with the historic processes reshaping both the politics and the security of the European continent.

This is both an understandable and a thoroughly welcome development. It makes obvious sense in a fast-shrinking world that both Europe and Japan should reach out and touch each other more closely, thus completing the triangle of relationships between the Americas, East Asia and the new Europe on which the global order rests.

But greater togetherness between Japan and Europe also raises some difficult and sensitive issues which demand careful handling.

For example, how do both the Japanese and the Europeans ensure that their respective long-standing and vital connections with the United States are kept in good repair? How do Japanese and European policy makers gain each other's full confidence after years of mistrust and antagonism on trade and commercial issues?

Bridging the Gap
And perhaps most fundamental of all, how is the huge gap in culture and perception to be bridged?

Just as there are plenty of Japanese who cannot understand their own

65

political leaders' interest in Europe, except as an export market and a part of the global financial network, so there are also Europeans, many of them in high places, who simply cannot see what events in Europe have to do with Japan at all.

It has long been my view that the UK has a particular role to play here in weaving together Europe's and Japan's best interests and showing how they can reinforce each other. And I believe that the UK-Japan 2000 Group has a central responsibility in this process.

By this I do not for one moment mean that Japan and the UK should seek special deals or strike bilateral treaty bargains in the old-fashioned sense.

Both nations are far too involved in the modern international, and transnational order to try anything of that kind. It would anyway be highly counter productive for the UK to be narrowly labelled as Japan's lobbyist at the European 'court' or for Japan to be developing 'a special relationship' with just one of numerous European Community member countries.

But I do mean that in all the tasks of closer collaboration between nations which lie ahead, the British are very well placed to guide and encourage Japan's expanding links with the European scene, both East and West. Likewise, the Japanese have undoubtedly much to offer the British as we struggle to find our way around the new map of the Pacific and Asia, which looks so utterly different from the one we left behind with our imperial past.

On the British side the obvious starting point is that Japanese direct investment has proved both very welcome and exceptionally popular in Britain, as reflected in the overall figures which show inward investment into the UK from Japan running at about the same level as the whole of the rest of the Community put together.

But perhaps this is too obvious. After all the Japanese arrive with large cheque-books. They come like a fresh breeze into the stale and highly politicised atmosphere of British employer-employee relations and success has bred success. Where Japanese managers can link up with a Japanese community already up and running, where the problems of schools and food and shops and above all language communications are already half solved, more managers and more investments follow almost inevitably.

This is all very satisfactory, but the UK-Japan linkage is surely now beginning to be woven of more materials than investment flows alone, and it is this deeper and richer texture with which the UK-2000 Group must be particularly concerned.

It is perhaps now on the political and cultural fronts that the promise of most progress lies.

For instance, Japan has now signalled a strong interest in being involved in more than a mere spectator role in the whole process of establishing Europe's 'new architecture' now slowly getting under way.

Specifically, the hope appears to be that there could be a Japanese input into the thinking and talks leading up to any new European security order under the auspices of the Conference on Security and Cooperation in Europe.

Since the status of the Soviet Union is at the heart of this matter, and since the Soviet Union is Japan's largest and most awkward neighbour in Asia, it might be thought reasonable even natural, that Japan should be in on the new arrangements.

But this is not a thought which occurs automatically to the introverted Europeans, and in my view it needs to be pushed hard by the British.

Permanent Forum

So, too, does the idea that some forum of permanent standing should be established in which Japan and Europe can deal with common problems, whether commercial, financial, or political. The OECD is focussed too narrowly on economic questions and at the other extreme the Economic Summits cannot offer the daily and continuous engagements of minds. They are just too far up the mountain.

There is yet another front on which the British and the Japanese may also have a mutually reinforcing role and that is the awakening Eastern Europe. To put it at its bluntest the Japanese have the resources and the British have the language or at any rate a good chance of ensuring that English captures the position of second language in place of Russian throughout Eastern Europe.

The task is a very big one. The British Council estimates that in Poland alone there is a need to train up 20,000 English language teachers in the next decade.

It is not a task which the UK can sustain alone. Nor on the other hand, can the Japanese alone hope to mount the kind of aid and investment programme in eastern Europe which Mr Kaifu seemed to envisage during his recent whirlwind tour of the emergent capitals of Europe Warsaw, Prague and Budapest.

A hand-in-hand approach by Britain and Japan in these areas might be very effective. It need not be very formal or structured. But it could do wonders. It should certainly be thought about further.

Perhaps peering a little further still into the future there are some intellectual citadels in Europe for Japan to capture, with British support.

Eastern Europe's leaders, whilst accepting that free markets and capitalism offer the way forward, have nonetheless been questioning whether Western political philosophies, with their grinding counterpoint between the state and the individual or the employer and the worker, give them the whole model they need for the twenty first century.

The Japanese do have a 'third way' of sorts to offer here, although they have been very poor presenters of their ideas and approaches which remain widely misunderstood throughout Europe. There is just a chance that the British and the Japanese in tandem, working hard to bring together Japanese and British philosophers, thinkers and scientists, may begin to produce some new approaches which the new democracies both need and could find very attractive.

Turning more specifically to the Japanese side of this agenda for a burgeoning friendship - for that is what it amounts - to there is the question of what Japan can do for Britain in Asia.

Again one is talking not about bilateral deals but about general guidance and support throughout the East and South East Asian regions.

For example, the British are particularly in need of friends and trusted allies in dealing with the tricky Hong Kong situation. A firmly supporting line from Tokyo in handling the super-sensitive Chinese would be an invaluable act of friendship, with major benefits for both Britain and East Asia alike.

On a wider canvas there is the question of our respective roles in the whole Indian sub-continent. Here, too, Japan and the UK together may

be able to accomplish things and to help in a way in which either nation separately could not.

History and memories although of very different kinds heavily condition both British and Japanese links with the area. But Japan and the UK working together should be able to offer packages and programmes which minimise the negative aspects of the past and bring out the very best of both British and Japanese qualities to help India, and her continental neighbours, to modernise and develop dynamic market sectors.

Friendship Pact

A new UK-Japan Friendship Agreement might be one way of underscoring all these current and potential common interests between the two island nations which sit at either end of the planet.

Would that sound too much like trying to recreate the idealised past between Britain and Japan in the early years of this century? Not necessarily. We cannot escape our history and there are anyway parts of it we need to keep fresh, just as there are other parts which should stay buried.

The world of the Anglo-Japanese Treaty of 1902 (renewed in 1911 and 1920) has long since vanished. But in a totally different world two very ancient countries still exist, still possess their ineradicable characteristics and can still work together in shared aims.

Without being either romantic or nostalgic one can surely say, gazing into the swirling future of our planet over the next few decades, that Japan and the UK look like being a partnership with potential, in fact a thoroughly good and suitable match.

18 MARCH 1992

Islands Far Apart, Yet Close
Japan-UK Group Charts Convergent Data

The annual meeting of the UK-Japan 2000 Group has now come and gone. The group, consisting of about 12 to 15 so-called "buddhas" from the British and Japanese policy establishments respectively, was brought into being back in 1984 by the joint efforts of the two prime ministers at the time, Margaret Thatcher and Yasuhiro Nakasone.

Over the years it has flourished mightily, becoming a sort of unofficial agenda setting forum for relations between the two island monarchies which are so far apart geographically and yet curiously close in their concerns and outlook on the fast-changing world.

Successive prime ministers in both Tokyo and London have encouraged and heeded the work of the group and this year was no exception. Despite Prime Minister John Major's understandable preoccupation with the forthcoming British general election, which will be a close and bitter contest, he found time to lunch with the group and discuss a whole range of ideas and proposals for further development of this remarkable relationship.

Just how much it has evolved already in the last decade is worth noting. The most visible signs nowadays in Britain of a Japanese presence are of course the substantial direct investment (in 450 enterprises) and, recently, the staggering success of the Japan Festival, which was held in cities throughout the UK amid almost universal enthusiasm.

Perhaps more telling, in terms of everyday life, is the fact that the London Underground system is running a competition among its millions of passengers to compose appropriate haikus. Everyone is busy with pencil and paper trying to include the required seasonal allusion within the laid down number of syllables.

More seriously, it is interesting to note that both Japanese opinions about the British economy and the importance of Japan's own economic development to Britain are being referred to with increasing frequency in the domestic political debate. In the Chancellor of the Exchequers recent budget speech to the House of Commons I counted five references to Japan, while the alleged attitude of Japanese investors to Britain's prospects were frequently cited in the ensuing stormy exchanges across the floor of the house in its last few days before it is dissolved and the three-week election period officially begins.

So where is all this leading? Is the increased familiarity with things Japanese just part of normal bilateral links between the two countries or are there more special factors at work? The UK-Japan 2000 Group is in no doubt that there is indeed some very special chemistry in the relationship and that its significance is growing, the more that Japan seeks to play a full global political role in line with its economic weight. Put simply, the two sides are beginning to realize that the new world order is not going to be just a neat triangle of relationships between the United States, a united Europe and Japan. The familiar trilateral concept, so beloved of editorial writers and strategists, therefore oversimplifies the future.

First, Europe is not going to be a single bloc but a large and quite diverse and expanding area, as numerous new members join the Community. Japan's relationship with this whole area will be increasingly demanding and complex. Without being Japan's "Trojan Horse" in Europe, Britain can undoubtedly help guide Japan through the labyrinth and speak up for Japanese viewpoints.

Second, there is the question of Russia. Japan is going to need allies and understanding for its view that the Kurile Islands issue is a global question, and that its resolution could bring the whole force of Japanese economic strength into the task of sustaining democracy in the former

Soviet Union area, including central Asia. The British seem to see this more clearly than the Germans, who are impatient with Japanese caution, or the French.

Third, both Britain and Japan have had intensely "special" relationships in the past with the U.S., but those relationships are now changing, and must change. It is not just that the Cold War is over. America's increasing interest in its own "Common Market," the great North American Free Trade Area, which will soon include Mexico, is bound to preoccupy it increasingly at the expense of trans-Atlantic or trans-Pacific connections. Japan and Britain have much to gain by frank sharing of experiences as they tread a similar path.

Fourth, there is the complication of the Islamic factor, now of growing significance for the Europeans as its extends through North Africa, but also for the Japanese as the new Islamic states of central Asia begin to assert themselves and form alliances.

Fifth, in an age of weapons proliferation, with both rockets and warheads in danger of falling into irresponsible hands, both Britain and Japan, as two vulnerable island nations, will need to rethink their territorial self-defence.

Sixth, Britain is going to need more support in the Hong Kong situation. It is profoundly in the interests of both Britain and Japan that the Hong Kong transition works successfully and that the whole coastal region of China, with Hong Kong as its pivot, prospers.

Seventh, Japan and Britain can work more effectively together, through their aid and other development agencies on the ground, in stabilizing the South African situation, promoting Third World growth and dealing with the swelling problems of refugees and economic migrants that bedevil development and stability in so many areas.

Finally (although this list is not exhaustive), Japan and Britain need to understand each other at the United Nations. The idea that Japan might somehow supplant the UK in a reformed Security Council needs to be dismissed and replaced by a constructive strategy based on the two countries working together on U.N. reform.

All in all, the UK-Japan 2000 Group sees the agenda of cooperative endeavour between the two countries, far from being diluted or somehow running out of steam, growing massively as the Cold War

ends, Europe acquires its new architecture and the Americans grope for a new purpose.

This is exhilarating work. A great deal has undoubtedly been achieved in the eight years since the 2000 group was first formed, but it could well be, in Shakespeare's phrase, that "what's past is prologue," and the play is only now about to begin.

Free Trade Under Attack

World trade themes are now of the utmost topicality, as the latest round of GATT trade talks teeters in the balance, as the narrower North American Free Trade Agreement project is decided, and as debate rages in Europe about the right response to the high overheads and the patent uncompetitiveness of much of European industry.

Broadly, there are two kinds of reaction being advocated to this central issue of future European trade and prosperity.

The first is to blame Japan, and other Asian "tigers," make allegations of "social dumping," demand industrial policies to protect home industry and generally ascribe to Japan all sorts of wicked practices, mysterious state interventions and so on which make it regrettably necessary to raise trade barriers in Fortress Europe.

This is the line which sounds good in political speeches to local interest groups but which just does not stand up to detailed argument. For example, social dumping, as everyone knows, is defined by distinctly screwy rules which can turn almost any import coming in at a keenly competitive price into a candidate for restriction.

Furthermore, while the old chorus continues about Japan, and other Asian markets, as still being tightly restricted, a few voices are beginning to falter as they see the restrictions in reality disappearing. Suddenly the

old picture of the trans-Atlantic free trade virtue contrasted with all the dark illiberal practices of the rest of the world is beginning to look not only unconvincing but an actual reversal of the newly emerging scene.

The "unfair" state intervention so often quoted as a Japanese trick turns out to be just as much the practice in the United States with its protectionist Congress and defence industry preferences, and Europe with its state monopolies.

The claim that Japan is really a government-run economy, led by the all-powerful Ministry of International Trade and Industry (MITI) is also looking far off course. It is not so much that MITI has done more intervening. The point is that Japan's interventions have been reinforcing market trends instead of trying to resist them with vain subsidies to inherently uncompetitive sectors.

There is also something a shade hypocritical about the protectionist lobbies pleading against cheaper imports, while importing them faster than ever to incorporate in their own products.

Even while American, and some European car-makers, toolmakers, semiconductor-makers, office machinery manufacturers demand a "get tough" policy with Japan, the same firms are busy buying vast quantities of Asian components and products for re-labeling and selling as home-grown.

The more one studies the real world of Western trade practices the more worrying the picture that emerges.

It is a scene of governments talking about free trade while a cobweb pattern of restraints, quotas, restrictions and other devices is being woven round too many Western industries to keep out not only Asians, but also the new low-cost challenges from Eastern and Central Europe, where skilled workforces are busy raising quality fast while keeping costs at a fraction of those in the EC.

For example, Polish unit labour costs are now said to be one-tenth of those in the western part of Germany. So while the European Summit proclaims an undying determination to see the struggling new democracies of the former Soviet bloc safely into the democratic and free market camp, in practice all kinds of barriers are kept firmly locked in place against Polish steel, Czech machine tools, Hungarian foie gras and a lengthening list of other East and Central European products, all

of increasingly high quality.

Even motor vehicles from eastern Europe, once the butt of many jokes about inefficiency and poor workmanship, are beginning to look smart and modern, as the recent appearance of some very striking new models at the London Motor Show confirmed.

Thus a quite different trade world is now shaping from the one in the textbooks. Protectionism and inward-looking arrangements are spreading in America (where NAFTA could yet take on this character) and in Western Europe. While it is the Asian bloc that is becoming the outward-looking region and the free trade champion.

The terms on which the Asia-Pacific nations are agreeing to work together, in the APEC forum, for example, seems to confirm this trend — the insistence being that any favourable new trade arrangements between the APEC countries should extend to all outsiders as well — in other words no exclusive trading blocs in Asia, thank you!

The GATT test will be fundamental. Even if there is a deal between the EC and the U.S., the outcome will be a sure indicator of the way policies are going in the West. If GATT is fudged then the protectionist march will be well and truly under way.

None of this is intended to suggest that Japan and its Asian neighbours are now pure, liberalized, open economies. That would be going too far. Concessions may have been bravely commenced on rice, but the Japanese distribution and retail system clearly lags a long way beyond the supermarket super-efficiency from which the European consumer now benefits.

The question now is whether a more open Japan will stay that way or whether it will begin to succumb to the same pressures as recession-ridden Europe. Will rising social overheads and unemployment reinforce the political pressures for a reversal of the open market policy?

The going for Japan is certainly getting harder but my guess is that the drive for new techniques and innovative products, impelled by an excellently educated workforce and skilled team management, remains unimpaired — no magic or undercover trickery, just sheer intelligence and dedication.

Japan's real challenge (apart from outraged protectionist sentiment in the West) will come from elsewhere in the next phase.

It will come from very low-cost but very high quality products from the rest of booming Asia and especially from Hong Kong and the Guangdong region — in other words from a dynamic and awakening China.

And what is a challenge for Japan from this quarter is of course a challenge 10 times over to the European single market. If Japanese products have shaken Europe to the core, that is nothing compared with what could yet be coming from the newer Asian producers.

The hard negotiations over GATT are a jolting reminder that we have not got much time to get our response together, and that the wrong response — more protection and a multiplicity of bilateral deals — is grimly probable but utterly defeatist and negative.

Coping with a Nuclear World

The coming year, 1995, will be a crucial year in terms of the survival of our planet.

This is because it is the year in which the nations of the earth are supposed to come together and renew an agreement (the nuclear non-proliferation treaty or NPT) which in turn is supposed to halt the proliferation of nuclear weapons.

The word "supposed" has to be used because, first, there is a real danger that agreement will not in practice be reached and, second, because all such agreements are useless without full inspection and verification procedures. Unless those are accepted and really work, no nation's signature on a non-proliferation treaty is worth very much.

For the so-called existing nuclear states — the United States, the UK, France, Russia and China — the situation is fairly straightforward. The NPT regime confirms their recognized nuclear weapons status, although placing them under a wide range of restraints, and imposes obligations to be open about all their nuclear activities.

It is therefore in their obvious interest to see the present order continue to be frozen, with new nuclear states discouraged and the treaty indefinitely extended.

But that is where the consensus ends. The rest of the scene is a melange of "suspect" nuclear states — like India, Pakistan, Israel and North

Korea, aspiring nuclear regimes such as in Iran and Iraq, inheritor states from the former Soviet Union and all the others who either want to live under somebody else's nuclear umbrella for safety or just want to stay clear of the whole business. Many of these would prefer the NPT to be revisited every few years, rather than indefinitely extended.

The question arises as to where nations like Japan and Germany stand on this vital matter and what part they will play in seeing agreement reached for the next few decades.

In Japan's case the answer in the past was easy. It was to stand on the sidelines, declare total commitment to non-nuclear status, refuse to have anything to do with the manufacture or siting of nuclear missiles and leave others to argue out the problems.

But this detached moral posture will no longer do. Wishing to stay clear of the ugly and messy nuclear weapons issue is no longer an option — if it ever was. As the novelist E.M. Forster once remarked "atomic weapons are not in my line. Unfortunately, I am in theirs." Japan is now well and truly enmeshed in the nuclear proliferation debate, indeed at the centre of it, for three major reasons.

The first if these is that it now lives in a threatened region. North Korea may have some kind of deal with the U.S. about nuclear development, but no one knows whether it will be adhered to and in practice it flouts the existing non-proliferation and inspection requirements.

The second reason is that Japan is a major handler of plutonium and likely to remain so. It may all be civil reactor-grade material, but since it is technically feasible to make explosive devices out of such material the control and management of plutonium resources of all kinds is a central international issue.

Third, and most important, Japan is now a major nation in the world order. It has a vast and inescapable obligation to participate actively in the non-proliferation debate (of both nuclear and other terrifying weapons of mass destruction, such as biological and chemical devices) and to take the initiative in high technology areas, such as satellite surveillance, where it has a lead.

Surveillance and verification, it must be repeated, are at the heart of the non-proliferation process. As Iraq has shown, a country can be a signatory to the NPT and give all sorts of assurances, while quietly

developing nuclear capabilities undetected. Even now, when Saddam Hussein has been compelled to open up his activities to inspection, no one can be sure that he has revealed everything.

The banning of nuclear weapons tests, which is now proposed through a Comprehensive Test Ban Treaty — in a separate although related procedure to the NPT — also depends on super-efficient surveillance.

The nuclear weapons states say they no longer need to test to maintain. But this could also imply that the would-be nuclear states, such as North Korea, will soon be able to develop without detectable testing. Methods have to be invented for checking the much less visible techniques now being devised. Otherwise a test ban treaty will be useless as a means of preventing further proliferation.

The easiest, and least responsible, stance in this great debate, is to urge that all countries should ban nuclear weapons and sign up accordingly. This is the ultimate cop-out. For it leaves the field clear for every rogue state or pirate regime to do what it likes: it ducks the key issue of unravelling the vast Soviet arsenal of both warheads and delivery missiles and it bypasses all the problems of plutonium stocks and how they, as well as the rest of the nuclear fuel cycle, should be handled.

It also leaves un-tackled the central issue of developing an effective, high-technology verification system, with pooled information on a global basis — something which Japan is ideally placed to take the initiative in developing.

The one valid point which the total ban enthusiasts have is when they argue — although very few of them do — for the faster development of defensive anti-ballistic systems. If all major nations had in place such systems on a foolproof basis that would truly remove the cases for nuclear bombs and missiles, whether offensive or purely defensive and deterrent in intent.

The heartening news from East Asia, although it is not very widely broadcast, is that Japan is responding to the North Korean threat not by planning to go nuclear but by considering a ballistic missile defence system in collaboration with the U.S.

If this comes about. it will require some hard thinking about the existing Anti-Ballistic Missile Treaty, which the Russians have always set great store by and which no one has yet dared denounce as a relic of

the Cold War (which it is).

So that is one more complex international debate about armaments and security into which Japan is now inexorably being drawn. It looks as though the coming period is going to be one of unparalleled work and activity for Japan's foreign and security policymakers and negotiators. How much simpler life must have seemed in the old days of the Cold War and the bipolar superpower world.

But then no one ever suggested that life as a major world power was going to be easy. It looks as though in 1995 it will be getting more difficult by the day.

26 JANUARY 1995

In the Aftermath of Kobe

When it comes to catastrophes the Western world has traditionally had two standards.

Horrors near home have received enormous coverage with lessons being drawn from them for years afterward. Much bigger disasters in distant continents have had only a brief mention, as though happening on another planet.

For example, the sinking of the Titanic in 1912, with more than 1,400 lives lost, has been identified by historians as a formative turning point in the way the world felt and thought. It was held to have punctured the mood of technical triumphalism which had sprung out of the 19th-century industrial revolution and which led men and women to believe that big was beautiful and that no engineering task, however gargantuan, was beyond man's reach.

Then there was the R101 airship disaster, and later on, the loss of the Hindenburg Zeppelin. Those events may have had relatively small death tolls yet they put an end to airship development.

Meanwhile, the European attitude to disasters in distant lands used to be distinctly detached. A few column centimeters well down the inside page would tell of tens of thousands drowned in some flood horror in India or Bangladesh, or swallowed up in a volcano somewhere in the Asian vastness.

How many people remember the loss of literally hundreds of thousands of lives in the Great Kanto Earthquake of 1923, or the millions slaughtered in Bengal at the time of partition in 1947, or drowned in the appalling Chinese floods of the 1970s? Did these events last in the Western press as news stories for more than a day or two?

So, if the past is any guide, one would have expected the 5,000 Kobe victims to have received scant and passing attention, as yet another Asian event in a far off land, where the noughts on the death toll were scarcely comprehensible.

But this time the opposite has been the case. The coverage of news and comment has been on a massive and sustained scale, far exceeding the usual Western treatment for Asian catastrophes.

This can only be because in Western minds Japan is now itself part of the West, and a very advanced and special part, too.

Somehow the feeling had grown up that Japan, at the very frontier of science and technology, as well as at the centre of the global economic system, could defy nature and history. These sort of events were not supposed to happen in modern advanced societies. Our world, of which Kobe had become as intimate a part as Birmingham or Düsseldorf or Marseilles or Pittsburgh, was supposed to be immune from such things.

So by extension, this is an earthquake which has not only shaken the earth's crust and destroyed a great city, it has shaken the confident crust of modern existence. Like the loss of the Titanic it has undermined cocky faith in state-of-the art solutions in a way that much, much bigger natural disasters in Asia never did.

The irony is that the jar to optimism and confidence is probably much stronger outside Japan than within it. Within the country, while there appears to be much talk of local disillusion with Japanese official performance there is also much evidence that the Japanese people in general, and the people of Kobe in particular, take a stoic view of what they always knew would happen some day, and may recur quite soon.

To European minds this fatalism seems strange and out of line with the bustling efficiency and readiness of modern Japan to tackle and overcome any problem. In short, with our financial globalism, our Japanese equipment, our ever-closer networking on political, social and cultural, as well as economic issues, we had forgotten that Japan was

83

in Asia and could suffer such events — in a way that Japanese people themselves, through their folk memory, their history and their daily lives, could never forget.

The jolt to world confidence coincides with other jolts at just the same moment. Financial collapse in Mexico, plus signs of the great Chinese economy boiling over again, have pricked the bubble of passionate enthusiasm for emerging markets everywhere. The great Asian investment opportunities that looked sure-fire winners only a few months back, and which no investment wizard could afford to ignore, suddenly turn out to be much riskier than the experts claimed.

It is the old, old story, but in a new and more frightening guise. The assumption grows up that all is under control, that somehow nature has been tamed, that this time all precautions have been taken, that past disasters "can never happen again."

But then they do. And the world information system, which is now all wired up in one huge volatile electronic bundle, hurtles from crazy optimism to extreme pessimism in minutes.

Such is the nature of the modern condition. Judgment, experience, knowledge and memory of history, even knowledge of geography, have all taken a back seat to instant information and instant analysis.

Last month, the Asian boom was scheduled to go on forever and Japan was in "a recovery situation." This month the "experts" have suddenly remembered that Japan is in Asia, not just around the electronic corner, and that earthquakes happen there.

Next month some new "surprise" will no doubt send the global mood soaring again, only to spin downward as the next reality breaks through.

Or perhaps mankind has really learned a lesson from this earthquake — that nature is mightier, and infinitely more enduring, than man — and will spend less frenetic time staring at screens or in cyberspace or virtual reality, and more time in thought and reflection about the way the world really is, has been and will evermore remain.

It is a lesson which the poor people of Kobe, dignified, orderly and almost passive in their appalling suffering, have taught the rest of humanity.

Is there any hope it will remain in the rest of the world's mind for more than two minutes, before the next great wave of forgetful optimism

comes coasting along, followed, inevitably, by the next great surprise, disaster or disappointment ?

25 MARCH 1995

East Meets West in Asia

Some well-known sayings embody timeless wisdom. Others do not weather so well.

For example, Kipling's adage that "East is East and West is West and ne'er the twain shall meet" begins to look less and less relevant as globalization proceeds and as systems, technologies, interests and lifestyles of the West and the new Asia intertwine.

Nowhere is this more vividly demonstrated, in more practical and concrete terms, than in the fast-multiplying number of joint ventures between leading Asian and European partners in third countries.

The UK-Japan 2000 Group, a think-team which seeks to mastermind and inspire the agenda for future relations between the two countries, has just been meeting in the Alpine surroundings of Hachimantai, in Iwate Prefecture, and has been focusing on this very issue — with particular reference of course to Japanese and British cooperative projects, although other Asian powers are following the same line of thought and action.

So what is so special about joint projects between two nations from opposite ends of the globe in a third country? First, combined operations double the areas which look promising. For example, Britain is strong in India and South Africa, and Japan more so in North and Southeast Asia.

Second, the involvement of both a "Western" and an "Eastern" nation in a major infrastructure project can spread political risk and set recipient governments at ease. Third, and this is the revolutionary thought for those accustomed to think of Western superiority as "natural," British and Asian operators, technicians and scientists now have complementary skills. East and West can deliver results together in a way that neither can achieve apart.

"Catalyzing" is now the buzzword in this field. Since third countries will naturally demand the maximum amount of local manufacture and supply in any project or venture, a huge number of players become involved — including, initially, governments and officials — if only to overcome bureaucratic obstacles, of which there often plenty. Bringing all these together becomes in itself a major international collaborative, or catalytic, operation.

The interest at the Iwate conference was very much on India and China as the two vast areas where the potential looks greatest. This is not very surprising. Both giant nations are growing at breakneck speed, although in patches rather than uniformly, and in both cases Britain and Japan are already major investors of capital.

Not only do the British have business ties with India going back into history, and deep involvement in many key sectors, but Britain is also Europe's largest investor in China — although with Germany and France coming up fast behind.

The question is what Japan and Britain, as two major capital-exporters, can do better together, in the whole field of investment, in these countries than on their own. And will such collaboration work ?

The answers may turn out differently in each situation. Both India and China are high-growth, high-risk economies. Both have a legacy of socialism as well as civil unrest. Both are trying to deregulate and privatize. But the risks are not of the same order in the two areas, and they do require a rather different approach in each case.

It also has to be noted that not every British business in these markets is overjoyed at bringing in the Japanese. In India the British have the priceless advantage of being seen as friends, despite the imperial past. The crude thought might therefore be that the Brits provide the entrée and Japan provides the cash.

But this would be quite the wrong way forward. For one thing it provides no assurance of the sound teamwork which must be based on the two investing partners respecting each other's strengths. There must be no superior presumption of a one-way flow of Westernized culture and technology in these matters. This above all is where "Easternized" skills and technology must be recognized by unaccustomed Western minds. It is significant that one of the arguments being used by would-be Japanese collaborators is that the British are seen increasingly as not only good engineers and specialists but also suppliers of components and equipment at low cost.

So much for the traditional Western arrogance about Western technology and quality combining with cheap Asian labour. That myth has now been stood on its head.

What both parties need in order to make joint projects work are complementary capabilities — which is jargon for a good match and plenty of authority delegated on the spot rather than held at head office back in Tokyo or London. Whether the project is a petrochemical plant or an electronic component factory, or a water treatment unit or an airport terminal it is dovetailing skills and understanding which will make "East and West" combine most effectively.

In China, where the welcome for foreign capital is more ambiguous and neither the Japanese nor the British are all that popular — for understandable historical reasons — the team approach is even more essential. The same applies in Turkey, Pakistan, Indonesia, Hong Kong, South Africa, Brazil and a dozen other locations where Japanese and British firms are already collaborating successfully. The huge Tsing Ma bridge, carrying the road and rail to Hong Kong's new airport, is one of the very best, global-scale examples of British and Japanese contractors in alliance.

There is one further ingredient for success in joint projects in third countries which perhaps ought to have come first. A joint project is really a trilateral project, between the two investment partners and the host country or community receiving it. The British track record in respecting local sensitivities has been on the whole very good — which is why British money and British personnel tend to be welcome almost everywhere. Japan has left a legacy of bad memories which it

must overcome, especially in India and Southeast Asia. But Japanese entrepreneurs have demonstrated that they have learned a lot about dealing with local sensitivities by their amazingly skilled placing of massive investment in the UK itself, with scarcely a murmur of protest.

Armed in this way, the British and the Japanese ought to be able to develop many more highly successful partnerships, setting a role model for the Taiwanese, Singaporeans and others. East can meet West on equal terms, and the two can combine in a network of complementary skills to the vast benefit of the host country and its peoples.

If the politicians and commentators find it difficult to discard their traditional prejudices and suspicions in these matters then let the businessmen, the bridge builders, the civil engineers and contractors show the way.

They usually do, letting the policymakers catch up with the new global reality of Asian superiority afterward. So not only have the "twain" of East and West already met, but they are busy catalyzing — whatever that actually means.

UK Ready for Asia's Rise

The issue for Japan in the second half of the 19th century, and subsequently for the whole Asian world, was Westernization — its impact, opportunities and dangers.

Could it be that, with the world now being stood on its head in so many respects, that the 21st-century issue is going to be not Westernization but Easternization? And could the societies under challenge from the forces of innovation and confident alien cultures be, this time around, not those of Asia and the Pacific Rim but those in the West and the Atlantic region?

This was the colossal question which was hanging in the air over a remarkable conference which took place in London recently on the theme of "Britain in the World."

Organized largely by the British Foreign Office, and addressed by both Prime Minister John Major and the Prince of Wales (who speaks with increasing influence and authority on world affairs these days), the conference brought together most of the so-called "great and the good" of the British political, academic, business, diplomatic and artistic establishment.

The thought behind the gathering, as Foreign Secretary Douglas Hurd explained, was that Britain, while obviously a European power, should also remember its wider global role and interests. The British

should not forget or ignore the fact that four-fifths of their huge overseas assets, now rebuilt to pre-World War II levels, lay outside Western Europe, nor that over half their annual overseas earnings came from non-European sources, and especially from booming Asia.

The conference was reminded of some bald facts and statistics that still come as a surprise to most people in the West. To take one example, it is now estimated that by the end of the millennium, which is only 56 months away, the fast-growing economies of Asia will contain over 400 million people with disposal incomes in excess of the average in the European Union.

Put another way, if one takes Asia to include not just Japan but the successive new sets of "tigers," as well as the two awakening giants, India and China, then their purchasing power will shortly far exceed that of the entire European block, even now that it is enlarged by new members.

They will, in short, constitute a more important market than Europe, and probably do so already.

If one factors in the projection that the Asian economies seem set to continue growing at twice the European rate then the gap between the Asian living standards and the West grows even wider as the years go by — so much so that it requires no great imagination to see the cities and lifestyle of large parts of Asia almost as far ahead of those in Europe as the West was ahead of Asia and the emerging world a century or so ago.

This coming shift in the world's centre of gravity is the most important development confronting old Europe — and the United States as well. It is heartening to see British policy thinkers begin to address the prospect and even more heartening that the British seem to have a lot of friends and interests in Asia, not least through their old Commonwealth links. Five of the world's fastest growing economies happen also to be members of the Commonwealth network.

Indeed, it could be argued that of all the European powers Britain is best placed to meet this new "Easternization" challenge. It is demonstrably the favourite place in Europe for outside investment from Japan and other emerging Asian sources of capital investment, such as Taiwan, and it is perhaps more "adjusted" in a psychological sense to the need for partnership with Asian enterprise, based on equality and mutual respect, than its neighbours.

As one leading Japanese banker pointed out at the conference mentioned above, Britain continues to look like a good place for Japan to invest precisely because it is so well attuned to the new conditions of international economic life, because its labour market is flexible and its mood competitive and welcoming to incoming enterprises.

The very fact, this same banker went on, that the British are keeping clear of the heavy social costs and arthritic centralizing tendencies of the Continental European bloc, make their country all the more attractive.

In reporting on the "Britain in the World" conference the poor British media largely missed these key points. This is unsurprising since the British media today is in a sorry state — hopelessly out of touch with world realities and totally preoccupied with increasing its readership levels and audience ratings in a frenzied, competitive media world.

Meanwhile, out in the real world, British business and foreign policy practitioners are shifting their interest and their emphasis, and adjusting to the rising influence of Asian trade, Asian investment, Asian skills, know-how and management methods.

Access to the European single market of course remains vital but relationships outside Western Europe are becoming vital as well. And the British do seem to have a big range of assets and advantages on this new global scene, providing they have the confidence to develop them.

As Prince Charles put it so well, Britain has been suffering from a dangerously contagious mood of cynicism and self-denigration, perpetuated as a chorus of doom among the media and an educated elite which has come to be known as the chattering classes.

One conference, however successful, is not going to cure this chattering habit. But a few hard results may quiet it down a bit. Supposing, for instance, that Britain was to achieve a trade surplus with unbeatable Japan? What would the chorus of critics say?

It has. The total UK trade and earnings balance with Japan has actually turned favourable.

Of course, this striking fact does not fit into the chatterers' negative thesis. But eventually it will, and then it will dawn, even among the most dedicated pessimists, that, far from lagging behind the rest of the West, Britain may actually be the best prepared to face the revolutionary impact of Easternization in the next century.

12 OCTOBER 1995

A Cult of a Different Kind

The Japanese are said to have become very fond of Beatrix Potter.

It seems that the creator of Peter Rabbit, Mrs. Tiggywinkle (of the hedgehog tendency), Squirrel Nutkin, Jeremy Fisher (the frog gentleman), Tom Kitten, Pigling Bland and many others has become a sort of cult figure in Japan.

It is reported that Beatrix Potter's little cottage in the Lake District in north-west England, where the author lived and worked, is besieged by parties of Japanese enthusiasts and that tour bookings must be made months in advance to prevent the site being swamped.

Why all this should be so is hard to explain. Clearly there is something in the works of Beatrix Potter that appeals to the feelings and idealism of Japanese people.

It certainly cannot be said that the Beatrix Potter characters are models of political correctness. Peter Rabbit's mother is clearly totally immersed in motherhood and the home and has not been liberated at all. Her delinquent son, Peter, not only nearly gets slaughtered by an angry gardener but is severely punished when he gets back to his family, rather than being given counselling and sent on a training course.

Meanwhile Mrs. Tiggywinkle, with her laundry service, is typecast in a sexist role. Jeremy Fisher eats grasshoppers for dinner, while in "The Tale of Two Bad Mice" the leading character, Hunca Munca, is plainly

an unreconstructed vandal. The same goes for Tom Kitten.

Maybe the appeal of the Beatrix Potter tales lies in their traditional quality, the vision they conjure up of a gentler, quieter age, complete with peaceful countryside and modest towns and villages. In the Beatrix Potter world, in which animals go about their business endowed with human qualities, simple ideas of right and wrong still prevail. The baddies get their comeuppance, usually, and virtue is rewarded.

Or maybe we are seeing here part of the worldwide rejection of fashionable political correctness and harsh modernity.

Certainly in the United States, and to some extent in the UK, a new mood is growing that warmly embraces the values and virtues of a past era, especially in relation to family life, marriage and the stability of the home. Perhaps the rural idyll that emerges from the pages of Beatrix Potter evokes the same longings — to return to a world of settled and absolute values in place of today's terrifying uncertainty and relativism.

The reaction to the age of liberation, with its anti-family rhetoric, its egotistical obsession with people's rights rather than duties and its refusal to accept the different role of the sexes, has really set in. Has the same mood now reached Japan as well?

If not, I believe it soon will. If one were to identify the strongest current running in today's politics and public desires, it would surely be the swelling torrent of revolt against permissive liberalism, excessive toleration of minorities — however extreme their demands — and denigration of the old family values.

People not only yearn for a return to a more stable order with clearer rules, more vigorously enforced. They are now preparing to fight for what they seek. The dismissive cry that one cannot put the clock back is no longer accepted. More and more voices are arguing that in matters of behaviour and moral standards the clock can indeed be put back if only society's leaders have the courage to face down the liberal establishment. They are no longer prepared to sit by and watch the entire social order being undermined by ever rising crime and violence, the collapse of the family as an institution, soaring illegitimacy, contempt for the elderly and the spread of drugs.

In the U.S. this backlash against the so-called demoralization of society has begun in earnest. Leading women's groups are reasserting

that the women's place is indeed in the home and that the now common pattern in which both parents have to go out to work should be reversed and discouraged.

Half-forgotten words like "shame," "guilt, stigma" or "disgrace," having been banished by liberal thinking, are now re-entering the social lexicon. It is being argued that the maintenance of social cohesion and a rigorous moral order demands not merely rewards but also punishments for deviant individuals. The excuse for bad or criminal behaviour that someone is from a minority or poor or handicapped in one way or another, and that society is really to blame, will no longer suffice.

"This Will Hurt the Restoration of Virtue and Civic Order" is the name of a remarkable collection of essays recently published by a group of academics from both sides of the Atlantic and now being very widely read. It is edited by the British academic Digby Anderson. The authors make the point that the rising moral crisis in Western societies will only be checked and disciplined by sanctions which are both sharp and painful. It is time for the stick as well as the carrot.

For politicians these are unwelcome messages. No vote-seeker likes to promise pain or hurtful sanctions as a policy except in times of dire national emergency.

But for ordinary people the message cannot get through soon enough. It is time the old virtues were resurrected instead of being ridiculed and dismissed. And it is time the forces causing families, and therefore society itself, to disintegrate, were confronted head on.

This may seem a long way from Beatrix Potter, and it may be that morality and values have nothing to do with her revival. It could be that the Japanese just happen to like the exquisitely precise drawings of her characters, which adorn every story.

Perhaps that is a better and simpler explanation of the popularity of this strange and eccentric English lady so long after her death. But nevertheless one is left wondering whether it provides the whole story, or whether her simple moral tales from her humanized animal kingdom are not touching some deeper and increasingly responsive chord in our worried and uneasy modern society — especially, so it appears, in Japan.

13 APRIL 1996

The Not-quite-Pacific Rim

Up to now the governing perception in the West has been that Europe is the danger zone, where threats to global security hover, While East Asia is one huge, peaceful enterprise zone, pacific both in name and character, and utterly preoccupied with money-making and commerce.

That, after all, is a reasonable lesson to draw from two world wars that began in Europe (even if they spread to Asia), from 40 years of Cold War and from lingering conflicts in the Balkans and on the Russian borders. Security chiefs all continue, as usual, to plan to fight the next war on the assumption that it will begin. At least geographically, like the last.

Yet this could be the wrong way around. It could be that over the next decade it will be Europe that gets on peacefully with business matters — with the new, ex-communist democracies rapidly being transformed into miracle economies — while crises, arms build-ups and threats to global stability all begin to boil over in the Asian region, especially in the so-called Northeast Asian Arc of Crisis.

There are more men under arms — and in direct confrontation — on the Korean Peninsula than in the entire armed forces of either the United States or Russia. In China the arms race is under way, with the region awash with second-hand Soviet weaponry and the Chinese

themselves freely exporting missiles and the associated software to Iran. The Chinese are buying or constructing warships in quantity. Japan is under growing pressure to match this threat, while further south, Indonesia has purchased the entire former East German battle fleet. Chinese claims to most of the South China Sea are adding to the tensions.

Over all this looms the shadow of oil crisis dangers — something which the Europeans had almost forgotten about with cheap oil apparently in abundance.

China's oil imports are already surging, yet the Chinese consumer has hardly begun to use oil products on a large scale. The Beijing decision to go all out for a mass-produced "people's car" should sound a tocsin to all energy watchers.

Already, the rest of East Asia is massively dependent on Middle East oil, with Japan alone bringing in three quarters of its total supply via supertankers from Persian Gulf sources.

It needs no imagination to see the looming danger to these heavy supply routes. The Persian Gulf itself is precarious enough, with growing signs of unrest in the long-established sheikdoms and kingdoms, as evidenced in Bahrain.

But the sea route right round to Northeast Asia is even more so. The Chinese are developing a clear strategy of naval power projection — both into the South China Sea and right down into the Indian Ocean. They are also building air bases in the Paracels and in Hainan. And in 15 months' time Hong Kong will be a Chinese port, offering the largest and finest facilities in the world for operations of all types, both civil and military.

No wonder that Taiwan, only 144 km off the Chinese mainland, has long been arming itself to the teeth. One can only wonder whether policymakers in any of these three countries are even faintly aware of the rising Asian threats to global peace.

Meanwhile, the arms race is spreading into South East Asia as well. Indonesia, Malaysia. Thailand and Singapore are all building up their combat forces, fighter-bomber capabilities and naval power, both on and under the sea surface. Indonesia, in particular, is challenged not only by its strategic positioning in relation to Asia's life-line sea routes

but by China's uncomfortable claims to sovereignty, and therefore oil rights, in the offshore zone to its north.

There is also the question of nuclear power. As a modern response to energy shortage the development of civil nuclear power, especially in Northeast Asia, makes obvious sense. But will it stop there.

Clearly not in the case of both China, which is a declared and open nuclear weapons power, and North Korea, which retains nuclear military longings despite the 1994 North Korean Agreement with the U.S. in which Pyongyang agreed to limit nuclear development to non-military applications.

China and North Korea both have fast-extending ballistic missile reach. Japan and Taiwan are well within range. The pressure on these island states to protect themselves, at least with anti-ballistic missile shields, is growing by the hour.

All in all, Pacific starting to look like a very dangerous place. Yet this prospect opens up at the very moment when the Americans are losing their will to be Asia's policemen and security guardians and when they are anyway being made to feel less and less welcome, as the dramas and complaints surrounding the great American bases on Okinawa confirm.

It is high time that the Western powers began thinking through more rigorously the contribution they can make to defusing Asian tensions and rivalries. At the heart of this should be a balanced and sustained policy for dealing with an irritable, resentful, nervous and fast-growing China. This will require endless patience, understanding, respect and dialogue, and the opening up of as many networks of contact — at both official and non-governmental levels — as possible. The British example in the handling of the Hong Kong issue is sadly not a good one in this regard.

Meanwhile, it must be a primary and strategic aim of Western statesmen to ensure that the Asian powers are fully integrated into the global order, and firmly woven into multilateral frameworks, not just in economic matters but on the security front as well.

11 SEPTEMBER 1996

East Asia's Troubling Silence

A mystery hangs over the latest eruptions in the Persian Gulf region, marked by Saddam Hussein's rampage into Kurdistan and the Tomahawk cruise missile response by the United States.

The mystery is this: The countries with the most to fear nowadays from renewed instability in the Gulf are neither the U.S. nor the UK, nor even France. Rather, they are the rising Asian powers whose dependence on Middle East the oil "lifeline" starts right inside the Persian Gulf.

A renewed bout of Iraqi expansionism, or a revived Iran-Iraq war, both of which are possibilities, would spell oil panic for East Asia. Even more serious would be the destabilization of Saudi Arabia, the accelerated spread of Islamic extremism and violence throughout the area and a general turning of Arabia against the advanced industrial world.

Yet the voices from East Asia have been almost silent during the latest crisis. It has been depicted as almost entirely an American affair or at best a matter between Saddam and the West.

Not only does Japan ship millions of barrels of oil a day through the Straits of Hormuz, at the mouth of the Gulf, but Korea, Taiwan, Singapore and others are all drinking increasingly at the same well.

China, too, is now an oil importer and looks set to depend to a

growing extent on Arab and Iranian oil. Currently, Chinese net imports amount to little more than half a million barrels a day. But it needs no imagination to project future demand when China builds up its already planned domestic vehicle production and the Chinese take to the car in their tens of millions.

This explains why China is already taking a sharp interest in the protection of its supply lines from the Middle East, down through the Strait of Malacca and into the South China Sea.

China has been in practice the one major Asian power to raise its voice over the Saddam situation — acting in its capacity as a permanent member of the U.N. Security Council.

But that voice has been not in support of law and order or curbing Saddam Hussein, but totally against the U.S. action. The language from Beijing has been vintage Cold War stuff with blood-curdling references to Yankee imperialism.

Even the Russians, who nowadays sees themselves as an integral part of the capitalist world have been unable to resist the temptation to put the boot in and criticize the Americans with the result that the Security Council has been largely neutered over Iraq.

There is, of course, the argument that one can be against the Americans' undoubtedly impulsive attacks on Saddam while still in favour of curbing his dangerous antics in other ways. That is an argument that several key Arab leaders have been using, as well as strong voices within the EU.

Indeed, the only nation backing the U.S. action wholeheartedly has been the UK And even in London, where the overriding importance of the Anglo-American alliance has always been seen as paramount, there have been many private doubts expressed.

But at least all the Western nations have been showing concern of some sort, even if they disagree on what to do about Saddam. So where have the Asian voices been?

The answer has to be that the rising Asian powers, for all their talk about political equality with Europe and the U.S., are not fully prepared to participate in world policing, even when their own long-term interests are directly threatened.

And threatened they certainly are by the poisonous goings-on in

Kurdistan, with their potential for sparking renewed conflict all round the region.

The most immediate danger is that Iran and Iraq will lock antlers again, either directly or by proxy as the different Kurdish factions turn to their immediate neighbours and sponsors for military assistance.

The Iraqis claim to have been called in to Northern Iraq, supposedly an exclusion zone or safe haven under U.N. protection, to help the Kurdish Democratic Party, against the Iran-supported Patriotic Union of Kurdistan. The Iranian Revolutionary Guard have been operating inside Iraqi borders on the grounds that hostile Kurdish factions have been mounting cross-frontier raids against Iranian villages. Farther north the Turks are waging their own Kurdistan war against yet another ultra-militant Kurdish faction, the PKK.

The first risk from all this maelstrom has already turned into a reality. It is that Iraqi oil exports, which were just in the point of mounting again, and placing a healthy downward pressure on world oil prices in consequence, have been put back on the embargo list. Crude oil prices have duly risen sharply.

The second risk is that the Iranians, delighted to see their old adversary given a black eye by American missiles, will grow bolder in asserting their own agenda in the region.

That agenda includes destabilizing the sheikhs and emirs in the Gulf, promoting Islamic militancy everywhere, undermining attempts at peace between Arabs and Israelis and encouraging violence and terrorism right through the Maghreb along the north coast of Africa. Egypt, Tunisia, Algeria and even Morocco all have plenty to fear from an overconfident Iran.

But so do the oil-consuming nations. Sheikh Ahmed Zaki Yamani, the former Saudi oil minister, has recently estimated that oil reserves in Iraq could in the longer term prove to be the biggest of all, much bigger than even Saudi Arabia itself.

So it is on a brutalized Iraq, a fanatical Iran, the uneasy Gulf kingdoms and the terrorized Maghreb that future secure energy prospects in booming Asia lie.

These are very shaky foundations indeed. Asian nations that wish to maintain their economic momentum and rising prosperity cannot walk

away from the situation or delude themselves that somehow alternative energies and oil sources can free them from Middle East dependence. They should be as much involved as the Western powers in attending to these dangerous and complex instabilities and threats and helping to curb violence in the region.

The fact that they are not shows wishful thinking and complacency.

3 FEBRUARY 1997

Britain's Lessons for Japan

The Japan-Britain relationship is now moving into yet another and still stronger phase.

The chief feature of this new phase is its quality of symmetry, or its two-way content, which makes it different from, and better than, what has gone before.

Of course Britain and Japan have sought for years to make their excellent relationship a balanced and reciprocal one. And we have tried to achieve this in recent times particularly in the fields of culture, security and scientific research.

But it has to be faced that the biggest item in the past on the UK-Japan agenda was the enormous and welcome inflow of Japanese investment into Britain, which we hope very much will continue, together with a British zest to learn the secrets of Japanese dynamism and success.

The picture now is beginning to look quite different. It is the Japanese who are seeking to learn from British experience, especially on deregulation, and to study "the British model." Meanwhile the balance of trade between the two countries was last year in Britain's favour, to the tune of 21 billion, and British exporters, investors, bankers and fund managers are moving rapidly into Japan.

These new factors emerging in the relationship have their roots in both some happy and some less happy developments.

On the Japanese side, large parts of the proverbially super-efficient economic machine, although not all parts, have begun to falter. As Japan faces the super-competitive post-Cold War liberalized world economy it has begun to matter increasingly that important chunks of life and business are protected in a cocoon of high costs and archaic procedures. The old feelings of insecurity and vulnerability have begun to creep back into the national mood.

In Britain the situation is the opposite. For years, the British have had to reconcile themselves to economic retreat, lagging living standards and poor productivity. Now the pattern has changed. Driven by necessity the British have spent the last decade and a half deregulating and liberalizing their aging economic and social structure.

The process is far from complete, but it has gone far enough to make a significant and increasingly favourable contrast with other major nations. Interestingly, and in a way ironically, the turn-around has been helped substantially by the large inward flow of Japanese investment, which has brought with it new labour practices and management methods, which were long overdue in British industry.

Now that Japan faces the same imperative need to deregulate, cut business costs and increase competitiveness, the question is how far the British can assist with a reverse flow of expertise, information and indeed investment to restore full Japanese dynamism — and the answer is "very considerably," although not in every field.

To be fully effective our contribution will have to trespass into areas of Japanese politics and Japanese psychology, as well as actual policy.

This is simply because the central lesson of the British experience in recent years is that deregulation restructuring only work if the political will and strength to see them through is really in place. Otherwise the usual pressure groups and lobbies. who have a vested interest in keeping protection and high costs, will always prevail.

The psychological point is also vital, although probably even more difficult for Japan than it was for Britain.

It is to recognize that liberalization means truly opening up Japan to foreign ownership and involvement. The pleas for protection against alien cultures and foreign domination have to be ignored.

That is what we went through in Britain, especially when it came to

liberating the financial sector and allowing all financial services to be operated under one roof, rather than compartmentalized.

But the reward in the British case was huge — the creation of the world's strongest financial centre in London. Whether Britain participates in the proposed single currency in Europe, the Euro, or not will make no difference to London's pre-eminence — or of course to our central involvement in the European single market.

The price of resisting these liberalizing changes in Tokyo is also sadly evident. Tokyo has not developed as a global financial centre. Japan's great banks have failed to keep up with world changes. The medicine of deregulation and restructuring that now has to be taken will be all the harsher.

But I remain totally confident that Japan can handle these changes, and can do so without the loss of its national cohesion which has proved such an asset in the past.

After all, this is the nation which dealt skilfully with the Black Ships and which carefully organized the inflow of Western technology during the Meiji period.

So what was done before can be done again, and no doubt will be. First the Japanese took from the West, then, in the second half of the 20th century, after a disastrous interregnum, they gave to it on a huge scale. Now, like the cycle of the seasons, the pattern is swinging back again to both giving and taking a new balance and a new symmetry.

It is a good process and creates good feelings — the kind from which deep and enduring friendships grow. So it should be welcomed and reinforced on both sides.

Japan Juggles Key Questions

Visitors who come to Japan to discuss policy issues these days are warned that they will find the country in the grip of a fervent debate about the Japanese future.

Actually, this is not quite true. As it soon become clear at the recent annual meeting of the UK-Japan 2000 Group, held this year at Kyoto, Japan is gripped not by one debate but by several going on at once — like a series of pictures all showing simultaneously on one TV screen.

For example, there is the debate about deregulation and whether or not it is the right path for Japan. There is the debate about Japan's overseas investment and where it goes. There is the debate about Japan's industrial competitiveness and how it is to be maintained in the coming years. And finally, there is the most fundamental debate about Japan's world role and position, now that America is rethinking its Asian role and Chinese ambitions in the region are stirring.

The deregulation debate topped the agenda at the UK-Japan 2000 Group meeting this year, since the so-called "British model" of deregulation has clearly been a success and Japanese policymakers may have something to learn from the experience. Deregulation has certainly been good medicine for Britain, but will it be Japan's salvation?

In the financial sector it is probably unavoidable if Tokyo is to survive as a key world financial centre, and this is acknowledged in Prime

Minister Ryutaro Hashimoto's plan for a "Big Bang" liberalization of financial procedures within the next five years.

But this will not bring rapid results, and there are some formidable hurdles to overcome. Financial liberalization means truly opening the banking and financial services scene to foreigners that is, to foreign takeovers, foreign ownership and foreign capital in general. Is Japan even remotely ready for that?

Full-blooded deregulation also means sweeping changes in the labour unions, in the state monopolies, in retailing and services, in the professions — indeed in the very role of the state and in large parts of the Japanese way of life.

Some of this is plainly necessary and overdue, but there is a real danger here, if reforms are pressed too ruthlessly, that the very qualities upon which Japan will depend for its next economic leap forward — namely, its network of cooperative ties and its consensual methods — could be undermined.

In the United Kingdom the deregulation revolution was driven by determined politicians with a solid political majority behind them. In Japan the process will demand much wider support and backing than the political system alone is capable of delivering. There is also a danger that a demoralized bureaucracy will then be unable to perform the huge administrative tasks that deregulation entails including of course the inevitable degree of re-regulation that more liberal markets will require if they are to stay stable.

The second, and very lively, debate at the Kyoto meeting was about Japan's overseas direct investment. This has been given a highly topical spin by the recent and much-distorted remarks of Toyota President Hiroshi Okuda on the obvious advantages of a single currency in a single-market region like Europe — other things, of course, being equal, which usually they are not.

At Kyoto it became evident that Japanese thinking about the complexities of European monetary union and the single currency proposal is at a fairly primitive stage. There is no shame in this, because the same can be said about thinking in large parts of Europe itself, as well as the United States.

Everyone agrees that if one starts with a clean sheet a unified market

with one currency is simpler and easier to trade in than a multi-currency area, especially for big multinational corporations.

But in the European case the sheet is by no means clean at the outset. Not only are the European economies far from converging, some of them, notably the British, have developed far more flexible and competitive structures by keeping well clear of the heavy social overheads and creaking controls that burden the major European continental economies. That is one reason why the UK is such a congenial place for foreign inward investment, not least by Japanese auto manufacturers.

All this suggests that the single currency in Europe may have a far from smooth take off and may not even fly at all. Doubts are spreading about the timing and design of the EMU project from sceptical Britain to Germany, France and, now, to international financial institutions as well.

So caution about reaching any conclusions on all this for Japanese investment policy is probably much the wisest course — a Japanese version of the wait-and-see policy that the British themselves are now following.

A third and much deeper debate arises not just from the issue of Japanese investment in Europe but from the whole question of Japan's own industrial, technological and scientific strength and how this is to be maintained as the Asian "tiger" economies close in fast.

"Hollowing out," by moving Japanese plants overseas, has been one response to the challenge of the high yen; now that the prospect is of a weaker yen for some time to come, there may be some reversal of this pattern.

But if Japan is really to compete with the ferociously competitive tigers around it, something more will be needed, as NEC Chairman Tadahiro Sekimoto wisely suggests. Sekimoto's view is that Japanese producers should now move on, not merely to computer-controlled management and production systems, but a step farther. He argues that they must now seek to "integrate audio, visual and text capabilities into multimedia networks for manufacturing."

In other words, manufacturers, to survive, must in effect merge their processes into the tertiary, information-dominated sector in its most advanced form. The key to achieving this will of course lie in the talent,

scientific and technological qualifications and general numeracy and literacy of the younger Japanese generation. In short, it all comes back to the quality of education.

Finally, there is the deepest debate of all, about Japan's position in the post Cold War world, now that American commitment to Asian security is being reduced or refocused. Is Japan to be an outpost of the West, a new Asian regional leader or the centre of an open global system that overrides regional and hemispheric divisions altogether?

The answers to these great questions turn on the even greater imponderables over China's future. Is China going to be the new military and security threat to Asian prosperity or the mighty foundation stone of unlimited further growth and dynamism in the entire region?

None of these fascinating debates aired at Kyoto looks like reaching an early conclusion and of course they overlap extensively.

Japan must naturally work out its own solutions, building on its innate strengths and harmonizing with its history, just as the UK has tried to do over the last decade and as Japan itself has done before in the more distant past.

The most useful piece of advice the British can offer is to urge that the whole many-sided debate is truly encouraged to continue in the frankest way possible. A society that can analyze and criticize itself will always have the strength for self-renewal. It is when the critics fall silent and the disputes wither or are suppressed that the dangers of stagnation and decay close in.

Asia Will Come Roaring Back

New depths of juvenility have been plumbed by British press commentators in their writings on the current Asian scene.

The general tenor of many of these articles has been that the Asian miracle is over, that most Asian countries are a socio-political mess, than Western values are superior to empty Asian ones and that Europe and America are safe from all the contagion and much the best places to be these days.

This is a complete reversal of the sort of comment that was being handed out up to six months ago. One minute the Asian "experts" were telling us that Asia was the unstoppable rising power zone of the world, and that "Asian values" would win out everywhere. The next minute it was the opposite, with exaggerated denigration and total denial of Asian dynamism becoming the fashion.

Nowhere has this see-saw kind of opinion-forming been more evident than in the case of Hong Kong. The same people who were lecturing the world a little while back about Hong Kong as the perfect economic model, which all should copy, are now hastening to write off the territory altogether. It is only a matter of time, so we are told, before the peg between the Hong Kong and the U. S. dollar breaks and confidence dives into a black hole of pessimism, fleeing capital, collapsing values and avian flu.

The reality is completely different. Hong Kong economy is still extremely strong, with markets functioning smoothly, the dollar link solid and investment expanding. Emigration is at a 10-year low. Almost all the predictions of doom following the handover to China have been proved false.

The demise of one high-profile investment bank, Peregrine, may shake sentiment but it has little to do with the underlying economy.

The pundits who prophesied that Hong Kong dollar would go the same way as other Southeast Asian currencies like the ringgit and the rupiah failed to grasp the way the Hong Kong monetary system works, or the huge size of the region's reserves, or the openness, accountability and efficiency of Hong Kong's regulatory system.

Western opinion, having been sadly misled by both those who proclaimed the rise of so-called "Asian values", and by those attacking these Asian values — the one group building windmills, the other tilting at them — has been astonished to find that Hong Kong actually continues to thrive normally. Obviously it is affected by the general Asian turmoil, but far less than elsewhere. The currency now shows every sign of being as fit to weather the present storms as it has survived the past storms such as the crash of 1987, the European exchange rate turmoil of 1992 and the Mexican peso crisis of 1995.

This underestimation of Asian economic strength and resilience extends as well to those countries that have suffered financial turbulence and seen their currencies fall dramatically in value against the dollar.

Their banks may be struggling and some investment plans may have been put on hold, but this does not mean that their capacity to produce competitive goods and services has been severely curtailed. On the contrary, in many sectors the immediate prospect now is for a flood of much more competitively priced and very high-quality products from Asian exports to sweep into Western markets.

This is the real danger that commentators busily dismissing the Asian miracle seem to be overlooking. And it is not just a shadowy future threat. Already, high street shops and stores in Europe are carrying top quality consumer goods from Southeast China, as well as from China and Korea, at ever-lower prices. Korean and Japanese cars are better — and cheaper — and than ever. This is where Asian events are going to

hurt — right in the heart of European industrial production.

The fashionable view that Asia is "finished" leaves people in Europe hopelessly unprepared for this return of Asian strength in an aggressive and revivified form. As it dawns that so much of the reportage has been ill-informed, and that loud-mouthed opinion-formers have got the Asian story wrong, the reaction is going to be one of fright and surprise, followed by a demand for protection from the new wave of competition.

That, of course, will be precisely the wrong reaction and will make matters much worse. The right reaction should be to see that this is the time to invest in the Asian economies, as never before. Hong Kong in particular looks set to be the first Asian market to recover its poise. Economic activity there will be boosted by large-scale infrastructure in rail links, port facilities vestment and the completion of the gigantic new airport. The authorities in Hong Kong continue to operate tight budgetary discipline with very little borrowing, and have shown themselves reassuringly immune to the seductive neo-Keynesian quack remedies (spend and borrow your way out of the mess) being peddled elsewhere in Asia.

All in all, the proponents of the theory that Asian economic power has evaporated are about as reliable as the proponents of the earlier theory that there was some Asian magic formula that would conquer all.

Asia, in all its vast variety and diversity, has many lessons — both economic and social — to teach the West, and the West has plenty still to teach Asian societies, as I sought to argue in my pamphlet "Easternization" published two and a half years ago.

Asian societies and their priorities made them especially suited to the knowledge-based technology and economic growth of the future (and actually stronger at grass roots and family level than many Western countries) is as valid today as it ever was.

The Asian currency and financial turmoil does nothing to change this picture — and those who believe and preach otherwise are in for a very sharp surprise.

24 JUNE 1999

Asia's Back? It Never Left

Meltdown? Eclipse? Or has Asia miraculously recovered from what many observers believed only a few months ago was near-terminal economic sickness? This question is making analysts in Western Europe scratch their heads as they try to interpret the ever more confused world scene.

If Singapore was the only touchstone the answer would be unambiguous. Prosperity and confidence are plainly returning to this little city-state. New tower blocks and hotels fill the skyline and the tourists are back. The endless shops may not all be full, but then they never were, and this does not seem to deter developers from opening ever-larger shopping malls.

Indonesia has held relatively peaceful, although confused, elections and has not disintegrated into chaos as many people feared. On the contrary it turns out that while the inevitable media impression was of riots and instability, powerful industries located in Indonesia operating in a global context were quietly strengthening their competitive position. Malaysia's Prime Minister Mohamed Mahathir now seems to have been forgiven by both world political leaders and world investors for his departure from economic orthodoxy by imposing mild capital controls.

South Korea has put together some sensible reforms and has fully won back investor confidence, even though it may not have followed every cure prescribed by the doctors from Washington. Thailand has followed the same confidence-building path, despite some old-style obstruction by militant trade unionists. The Philippines also seems to be on track with growth returning and renewed international investor interest.

As for the real giants of Asia — Japan, China, India — the news there, too, while not euphoric, is undoubtedly less pessimistic than it was. The consensus view on Sino-U.S. relations may look bad, but at the calmer level of global business things appear to be under control — just.

India, that other worry zone, is drawing back yet again from outright war with Pakistan over Kashmir. At the same time it is pressing ahead with liberalizing structural reforms, including extensive privatization.

All this blossoming of recovery, even if it is still early days, presents many Western commentators with a dilemma.

How can the situation in Asia be getting better so fast when these same authorities were explaining only a few months back that the entire Asian scene was fundamentally sick and how it would take years, plus a few political revolutions, to put right?

One part-explanation that could be reasonably advanced is that the recovery mood in Asia may not go very deep as yet. That is a fair point. There can be no doubt that financial markets and enthusiastic investors looking for good returns do, by the nature of things, get a bit point in the correct direction.

The Asian tigers may be up and prowling again, but in many eases factories are still half empty and bank credit for business expansion is still pitifully scarce. Huge overcapacity in sectors like vehicle manufacturing signal crippling price wars ahead — which will take their toll in Europe as well.

What the wrong-footed experts will be reluctant to admit but which looks increasingly like the real explanation of last year's Asian turmoil, is that we all — East and West — now live in a totally different economic weather system, driven by high-profile economic weather system driven by totally globalized electronic finance. This can turn mild storms into hurricanes and punish almost any economy however superficially healthy.

The question then becomes how each society, in its own unique way, creates the solidarity and internal robustness to withstand the hurricanes when they come, as they will inevitably do from time to time in the globalized world system which embraces everybody.

Malaysia chose one way, India another, Korea and Thailand a third and fourth. The societies that look best placed to confront the future storms may not necessarily be those with the freest or most open markets, but those with the strongest sense of inner cohesion, the strongest bond of civic duty and obligation, the strongest commitment to the ethic of hard work and the strongest degeneration and to do the best for the younger ones.

The example shown by South Korea, where at almost every social level people have been prepared to accept stinging pay cuts and even hand in their jewellery in order to get back on track, is perhaps the most vivid instance of this sense of finding unity in action, and of this basic unity allowing maximum speed of adaptation and maximum flexibility.

Long before the Asian turmoil occurred, there were some in the West, including this writer, who were arguing that these deeper values were the ones that were going to matter most and that, despite the superior claims of Western liberalism it might be in Asian countries that these essential qualities were now most developed and would make them the most "advanced" societies.

When the turmoil came, those who upheld this positive view about "Asian values" were showered with abuse and ridicule.

Now those same overconfident voices are silent, or have moved hurriedly to other issues, as well they may. They had missed the most important point of all about economic development — that it is the inner qualities and resilience of a society and its citizens that ultimately make or break a nation. Sound economic policies and well-ordered markets help, but much more is also required.

Only those who understand the limited relevance of economic theory to the prosperity and wealth of nations will not be surprised by Asia' swift revival.

SECTION II

Japan-UK 2000-2010
A Normal Country?

OPENING COMMENTS
Japan-UK 2000-2010 -
A Normal Country?

The first decade of the 21st century was a bad time to be a passenger. Bracketed by the 9/11 attack in New York near the beginning, and ending in the near collapse of the world financial system, it was an age in which nations needed to keep their nerve and play their part.

Japan was coming to the end of its so-called 'lost decade' of economic growth (mis-named in the Western press as years of stagnation, but in fact more like consolidation). The call was for this major industrial power now to step forward and accept its global responsibilities in an increasingly dangerous and confused world.

It was time for an end to those long silences. The late Sir Peter Parker used to joke about Japan's attendance at key global meetings – long silences while the others squabbled. Now it was time for a strong and responsible contributory voice to the new global direction as the crises multiplied.

Slowly the Japanese people were seeking to modify their deeply rooted pacifist stance and accept the burdens of world power. And slowly a divided West was beginning to grasp that Japan's international weight was not just economic but came in terms of security and international influence. The world's power centre was shifting away from Western domination to a more balanced pattern and even to full Easternisation as the globalising forces of technology accelerated. Hand-wringing

about Japan's trade pre-eminence gave way to a deeper realisation that in a world of storm clouds, Middle East chaos, jihadist terror and rising populism Japan had something to teach beyond industrial miracles.

Japan was indeed becoming 'a normal nation' as the West's problems piled up.

Happily, too, for the UK, Japan was seeing itself increasingly as the UK's best friend in rising Asia, where the bulk of world market growth lay, while also seeing the UK as its best friend in Europe.

All this was in due course to be put to the test.

27 MAY, 2002

Global Soccer Invades Japan

Now for the really big story — and Japan is at the centre of it. But the focus this time is not on dreary economics but on soccer. With the curtain rising on the great drama of the Japan/South Korea-hosted World Cup, all eyes and world media attention are beamed on the teams, the players, the coaches, the fans, the matches, the pitches, the logos and all the rest.

The past 10 years have seen a geometrical expansion of media and public interest in the soccer world — at least in Europe. America, of course, has its own brand of soccer and is widely regarded as a baseball nation — as was Japan until recently. But the rest of the planet has been more or less conquered by soccer, and with the massive public support has come equally massive flows of cash and investment.

Soccer, with all sports-related industries spun off it, is now a multi-billion-dollar world. Its personalities are global celebrities. In the old days, attention used to be focused on the actual teams and the star players on them. Now the spotlight turns not just on teams and who is picked for them, but also on the squads from which the teams are picked, how they come to be chosen and, above all, the team coaches and managers, formerly near-anonymous figures who have become headline material.

Thus England's Swedish coach, Sven-Goran Eriksson, is now a

household name. His private life — quite an exotic one, it seems — is just as exposed to the public glare as his coaching skills. Actual players are bought and sold between clubs for astronomical sums. Top players, in contrast to their relatively small-earning predecessors 40 years ago, are now paid fees that put them in the same class as investment bankers, or above.

The health of these star players, and the injuries they all regularly incur, receive the sort of attention once reserved for the health of monarchs. Their life-style, avidly reported in detail, matches that of the richest dukes and merchant princes.

For example, David Beckham, England's temporarily injured captain, is probably the best known face in Britain. With his wife Victoria — the former Spice Girl popstar known as "Posh," the most elegant of the remarkable four-girl band — he leads a life that eclipses that of the highest-living Hollywood stars of the past. Palatial residences and vast parties receive pages of newspaper coverage, most of it favourable and completely free of the envy that usually accompanies accounts of the activities of the super-rich.

While all this elevation of soccer to the status of religion is harmless, and certainly preferable to other outlets for national energies in past history, such as wars, there are inevitably one or two darker spots in the soccer universe.

The globalization of the sport — for that, in effect, is what is occurring — is having the same results on soccer as on other walks of life — namely, that the rich are getting much richer and more celebrated, and the big clubs are getting bigger, but those not falling within the spotlight tend to be forgotten or squeezed out.

Thus, many smaller British soccer clubs are in seriously financial straights, with attendance falling. Similar problems — falling attendance — seem to have afflicted the Japan Soccer Association and the J. League.

Meanwhile, the international bodies governing soccer worldwide have been touched by scandal and political infighting, with FIFA in particular said to be in a very bad way.

And finally there are the fans and the soccer crowds who also bring their problems. Britain has been both plagued and shamed by the behaviour of soccer hooligans — mostly decent-enough lads who seem

to lose all self-control after a few pints of beer — who bring terror to the grounds and the towns, both at home and overseas, they happen to be visiting.

Intimate international police cooperation has helped obstruct the travels of some of the worst offenders and it is to be devoutly hoped that this has worked for the World Cup events now beginning. The British are also placing much faith in the proverbial efficiency of the Japanese police and in the belief that those potential hooligans who have escaped the British net will be caught in the Japanese net — literally, it seems, since devices that throw nets over unruly troublemakers are to be used to curb any crowd violence at World Cup events.

But the downside should not be allowed to cloud the upside of the world soccer mania, which is that sports, and this sport in particular, unites a troubled world, it diverts enthusiasms and energies from more dangerous channels, it creates wealth without envy and it brings much joy and excitement to life the world over.

It does not, of course, solve world problems — it is after all, only a game and not a matter of life and death, as some of its more obsessed followers sometimes think. It cannot solve the terrifying tensions and slaughter of the Middle East or Kashmir or Chechnya. It cannot halt the growing starvation and misery across Central Africa, or release people from the oppression of tyrants such as Iraqi President Saddam Hussein or Zimbabwean President Robert Mugabe. It cannot penetrate the twisted minds of terrorist fanatics.

But it can provide a respite from these gloomy facets of a dangerous world, and it can provide a little of the cement that keeps the globe together rather than tearing it apart.

So good luck to the players, referees, coaches, managers, supporters and commentators who make it all happen, and good luck to Japan, which has to put up with the whole crowd of them for the next few weeks.

Beware The Property Bubble

These are worrying times for the world economy, and perhaps even more so for the armies of highly paid analysts who failed to predict the current slump in world stock markets.

A few wiser heads have been saying for a year or more that the whole structure of stock prices was unsound — that stock prices in relation to prospective corporate earnings (the famous P/E ratio) were far too high. But they were in a tiny minority compared with the experts from big banks who were forecasting future stock levels that now look like pure fantasy.

Yet for all the pessimism in the financial community — the dire warnings about the value of pensions, the forecast of another 1929 crash and other blood-curdling predictions — the general public, at least in Britain, has seemed curiously unmoved by these dramas.

It is as though, at the level of the ordinary citizen with common sense, everyone always knew that shares surge up and down and that all balance sheet arithmetic, along with spuriously precise rules of the accountancy profession, needed to be judged with a pinch of salt. As in other branches of economics, it turns out that solid-sounding concepts like "profits before tax" or "total assets employed" depend on impressions and value-judgments rather than on concrete numbers.

Add these uncertainties to the mad, bubble world of dot-com hype —

when all sensible business values seemed to go out the window — plus the suspiciously arcane procedures of "energy trading" businesses, and one had all the ingredients guaranteed to produce an Enron collapse, or a WorldCom scandal, or a dozen other doubts and queries about those pages of big numbers in glossy company reports.

So while stock market pundits rush from cheerful hope to apocalyptic gloom, the rest of us are probably right to wait for the pendulum to stop swinging so violently and settle down. The underlying economic situation remains not all that bad, so why panic?

Yet a disturbing thought hangs in the air, one that might even rock the most detached and stoic member of the general public: that the stock market collapse may be followed by a property collapse. And since most British citizens have far the largest part of their wealth tied up in their homes that would spread anxiety faster than any big slide in share values.

The property-price bubble in recent years in Britain has been even more pronounced than the now-deflated share-price bubble, although the size of the increase in the price of a home depends on where one lives.

London, the southeast and the southwest of England have experienced rocketing prices in the past decade; in recent years some prices have doubled. The average cost of a home in London is now more than eight times the annual salary of a nurse and five times that of a police officer. Smarter houses in central London have trebled or quadrupled in value. The £1 million townhouse is now considered a bargain!

Cheap borrowing costs have driven the demand for houses to even more frenzied levels, while the actual building of new homes has slowed to the lowest level in decades as environmentalists and rural interests fight ever more tenaciously to protect green fields from being gobbled up by developers.

Meanwhile, in northern England and parts of Scotland, prices have languished, and in some areas homes stand empty and virtually worthless.

This extraordinary imbalance is rapidly leading to crisis. Key public sector workers in the south, such as firemen, social workers, policemen and hospital workers, simply cannot afford homes. The government is

convinced that this situation will not cure itself (for instance, by people moving north to cheaper homes) and has now stepped in with a plan to build 200,000 more "affordable" homes (meaning subsidized in some way) in the already crowded southeast.

Typically, this government initiative may have arrived at the very moment when the problem is about to cure itself in the most painful sort of way — namely by a burst of the property-price bubble. Suddenly the immense demand for homes is faltering. People are getting frightened of being stuck with high mortgage loans and declining property values. The rented housing sector has already gone sour. By the time the government's extra "affordable" houses get built around London, the price of housing generally may have crashed.

An ominous thought occurs. Could it be that Europe and America are simply following the pattern set by Japan over the past decade? The sequence there was a share-price collapse, a steep decline in sky-high property prices, minimal inflation with price deflation in some sectors, and stagnant growth.

Both Europe and the U.S. now have three of these four symptoms. Only on the housing price front is gravity still being defied. But that could change very soon, and the property bubble could go the way of all other bubbles, as happened in Japan.

Perhaps Japan, far from lagging behind in the world economy over the last 10 years, was ahead of the game after all.

MARCH 2003

The Global Economy. Heading for Recession? The Sneeze remains Infectious.

When America falters, coughs, sniffs or wheezes the virus still gets blown around the world on the Atlantic and Pacific winds, leaving Europe and Asia shivering.

There was a theory around recently that this would not, could not, happen - that unlike the situation in the 1930s, this time, when the U.S. economy slowed after a decade of phenomenal growth, a re-energized Europe and a buoyant Asia would offset the trans-Atlantic downturn, and that the European Union, in particular would take over the role of motor to the world economy.

But this is just not happening. On the contrary, the very sharp U.S. check on growth, falling in a few months from last year's powerful 5% to a probable 1.5% this year and probably much less next year, is being transmitted to the rest of the world even more rapidly than on past occasions – confirming the obvious point that in the age of information technology we are bound together with more immediacy than ever before.

Far from compensating for the U.S. slowdown the European economy, with Germany at its centre, has started dipping in ominous parallel. Meanwhile the Asian tigers, still limping after their currency miseries of the late 'nineties, have seen their export markets wither and recovery falter – with their one hope, a Japanese revival, looking less and less likely and fading into the indefinite future. So is it recession

time all round, or merely, in U.S. Treasury Secretary Paul O'Neill's phrase 'a lull'? It depends where you start. In Silicon Valley in California recession has clearly arrived. Stock options are under water, property prices plunging, jobs vanishing, firms collapsing, all ground down in the Nasdaq slump – with power cuts to add to the misery.

But how far does this affect the rest of America? So far, not as much as feared. The Nasdaq may be down by two thirds in a year but the Dow Jones Industrial is not. In fact it has dropped by only 16% from its heady peak at the beginning of last year – and this despite a steady stream of profit warnings from American companies, lay-offs on all sides and miserable earnings figures. So if stock markets are anything to go by- and as early warning systems they are usually quite good - this is not the time to move to panic stations or use the R-word. Things may have slowed, but even a modest 1% growth rate on the back of the enormous American economy adds huge amounts to world production.

People forget that for years after the Second World War, in an age of U.S. full-employment and glittering prosperity, the world's largest economic machine seldom grew much faster than this. Less easy to sound positive about is the dead halt to which misguided policy-making seems to have brought Japan – the other great engine which has failed. But here, too, we are looking at a very different picture from the 1930s, when many Japanese in the countryside literally starved to death.

Today Japan is vastly prosperous society with enormous hidden reserves of wealth and dynamism which cushion its stagnation – and indeed make it much harder for policy-makers to generate a sense of crisis or a consensus for radical reform.

The economic textbooks say that Japan's savings are the problem. The Japanese save an amazing 30% of their income and the economic witchdoctors' prescription is that they should stop saving and start spending. But this is nonsense. It is looking at things from the wrong end. A society's wealth is created not by inflating consumer demand but by originality and innovation, usually of a kind which is highly disruptive to established production and management patterns and which is sparked at the grass roots of business and enterprise. That is how Japan prospered before and once it remembers the fact it will prosper again.

The same formula applies world-wide. In the booming nineties the propellant was clearly the electronic revolution, opening up opportunities in almost every sector which were then seized by a myriad of new minds and transformed into expanding wealth.

The very fact that the American-led decade of spectacular global growth (with a brief interruption from the Asian currency upheaval) was so long and its roots so widespread means that the lull is bound to be quite long as well before it ends. But end it will, thanks not to central bankers' magic or juggling with interest rates, or other quick fixes, but because somewhere a new spark will re-ignite investment and colossal new markets will be created in areas which probably no-one predicted.

Although the internet age is only just beginning, despite the crowded dotcom graveyard, I suspect that the really motivating innovations and new markets in the next expansion phase will emerge in the areas least touched by the knowledge explosion, such as living space, mobility, health and age care and local environment – and also in regions of the world where billions live who have largely been left out of the wild ride of the last decade.

Now it could be their turn. The global economy is a process, not a model or a machine as we used to be taught. It surges, pauses and then finds its way forward again. It hates political uncertainty – of which there is plenty around – in the Middle East, in Southern Africa, in the oil markets, around China, within the trans-Atlantic alliance, and even amongst the squabbling crew on the bridge of the good ship Eurozone.

But while we will all feel the draught from America the precise way our individual economies fare in the rougher seas ahead will depend a lot on local circumstances - on history, culture, social attitudes, specific domestic issues (like our foot and mouth crisis) and on how much confidence we feel in ourselves and our nation. These are matters far outside the reach of economics – a point which policy-makers would do well to remember.

MAY 2003

Economic Rocks Ahead
The Borrowing Can't Go On

These are difficult and dangerous days for economic forecasters and financial experts. As usual they are deeply divided on the fate of the world economy. On the one hand, the giant American economy is showing faint signs of recovering its nerve as the last wreckage of the dotcom bubble is cleared away.

On the other hand, there are some ominous trends in most of the advanced economies that cannot be allowed to continue, as they could bring all recovery to a juddering halt. The most obvious of these trends is the worldwide splurge in government borrowing. Some investors have been surprised by the sudden fall in government bond prices, especially for U.S. Treasury bonds. But there shouldn't be anything surprising about that. Governments in most of the bigger economies have been running huge deficits. Borrowing money by issuing ever greater volumes of paper is the least painful way of bridging the resultant gap.

Governments in democracies always go on borrowing until they can raise no more that way. They turn to higher taxation only as a last resort, since raising taxes is the quickest way to lose votes. Currently the United States, Japan and Britain are the biggest offenders, but both Germany and France have been borrowing and spending on such a vast scale that they have burst through the golden Eurozone rule, embodied in the famous Stability and Growth Pact, which supposedly limits deficits by member governments to 3 percent of gross domestic

product. The greater the quantity of bonds on offer, the cheaper the prices. And that means the interest rate that has to be offered on them must rise to attract increasingly nervous investors.

In theory, but only in theory, lavish government borrowing and spending is supposed to counter recession, raise economic activity and restore confidence. But in practice the implied threat of higher interest rates and inflationary finance does the opposite. German figures released recently show that unemployment has risen to 4.35 million and that improvement is not in sight. Newly released French figures show that unemployment has reached a three-year high of 9.5 percent. Prospects for economic growth in the Eurozone are dismally weak, or non-existent.

Britain has so far avoided rising unemployment, but only at the cost of a large increase in the number of public sector workers. Since 1998 the figures have soared to the point where some 7 million workers, or quarter of the total workforce, are now on the government payroll in one form or another. Worse still, the public sector tends to develop its own dangerously high inflation rate, as trade unions push for far bigger pay increases on average than does the private sector of the economy.

Thus much of the extra spending by the government, now running at more than £10 billion above official estimates, is disappearing into pay increases (and invented and unproductive jobs) rather than into improved public services. Meanwhile, British consumers have also been borrowing to the limit and plunging into debt at record levels, falsely reassured by the colossal rise in house prices — all of which could come tumbling down if the government starts retrenching or interest rates rise again.

Where is all this going to end — for end it must because it is certainly not sustainable? The answer is probably in very slow growth or stagnation, plus a degree of renewed inflation — a state of affairs that used to be called stagflation.

The room for manoeuvre by governments is very small. They dare not cut public spending too sharply at a time when electorates everywhere are clamouring for more welfare and better services. And providing the security and defence that every citizen nowadays demands in the age of global terrorism adds still heavier public spending pressures, as the $100

billion bill for pacifying Iraq confirms, with much more to come.

With other courses of action blocked, the Eurozone governments are being reduced to muttering the familiar mantra about the need for radical structural reform, which everyone knows is a euphemism for taking away much loved subsidies, hurting protected groups and raising taxes — all sure recipes for government unpopularity and possible defeat at the polls. The Americans have another way out, denied to the European nations, which is to let their currency, the mighty dollar, slide sharply downward, thus flooding the rest of the world with cheaper U.S. goods and boosting the earnings of U.S. manufacturers while neatly transferring the agony to other countries. Is this a good or bad thing?

On the one hand, it is in the whole world's interest for America to avoid a prolonged recession and to hasten its economic recovery. On the other hand, a sliding dollar wreaks havoc in other markets, as the poor Europeans are painfully finding out.

Generally, the collapsing dollar creates still more instability and uncertainty. Fears of inflation and deflation jostle with each other, while none of the traditional economic remedies seems to work. Economists as usual disagree — leaving policymakers even more confused about which way to go.

Faced with such contradictions, the former U.S. President Harry Truman used to say in exasperation "bring me a one-handed economist." Needless to say, his wish was never granted.

DECEMBER 2003

Resist the Potions of the Past

" \mathbf{C} apitulation bottom" is the ugly and inelegant phrase used by financial analysts in London to indicate the low point in the cycle of investor optimism and pessimism — the point where investors give up in despair, sell their shrunken shareholdings, if they can find a buyer, and start putting what money they have left under the bed.

Such a point may have been reached long ago in the eternally sliding Tokyo stock market, but it is a new and unpleasant experience on Europe's bourses, especially on the London stock exchange, where stocks and shares throughout the 1990s soared ever upward.

Today there is plenty to despair about. Rafts of corporations have joined what is grimly known as the "90 percent club" — companies whose share prices have fallen by at least 90 percent from their peak in London in 2000. Of course, the bad news is not just confined to stock markets and share trading.

Not a day goes by without some new corporate disaster in the headlines. Two weeks ago it was British Aerospace, the week before Cable and Wireless and the week before that British Energy — the near-bankrupt owners of all British nuclear power stations. Before that, there were the long string of trans-Atlantic collapses such as Enron, Tyco, WorldCom and many more. Earlier in the year, there was the spectacular implosion of Marconi, once the flagship

corporation of British electronics, telecoms and heavy electrical machinery.

More corporate disasters will follow. The latest bad news comes from the quintessential global corporation, McDonald's, the burger chain that has come to symbolize buoyant American capitalism around the planet, sometimes to its disadvantage. Even Harrods, the iconic London store, is sliding into the red. The general collapse in share prices, now at half their 2000 level, has also played havoc with people's pension prospects.

The huge funds necessary to meet future pension liabilities are suddenly huge no more. Fund managers and life assurance companies are having to trim their commitments, and at least one is on the edge of bankruptcy. Employers are cutting down sharply on the once generous pension arrangements they used to offer their employees upon retirement.

Amid all the bad news it seems to have at last dawned on the world's financial experts that a major, bone-shaking recession is at hand and that no obvious source of recovery is in sight. On the contrary, looming war in the Middle East adds to the uncertainty and deters even the doughtiest investor from committing any funds. The stock market gurus who were predicting recovery in 2002 have either fallen silent or changed their tune. There have been so many false dawns that none now dare forecast anything better for 2003. In the language of investors, the growling bears still remain in charge and the hopeful bulls have vanished.

What is true, and painful, for investors and companies is also true for countries. The major European economy, Germany, once the driving force of European expansion, is now motionless.

Apparently unable or unwilling to deregulate their cat's cradle of labour restrictions, the Germans watch as unemployment soars, growth evaporates and new jobs fail to appear. The other bigger European economies toy with the idea of lifting activity through budgetary expansion (more public spending) or monetary boosts (interest rate cuts).

But the grim example of Japan, where cutting interest rates to practically nothing proved as useless as "pushing on a piece of string," is on everyone's mind. Even reformed Britain, which hitherto has defied

the general gloom, is catching the slowdown disease from continental neighbours and running up an enormous trade deficit, said by some to be the largest since the 18th century.

Meanwhile, the swelling British property bubble is at last bursting, and house prices are already tumbling from their crazy highs — notably in central London. The mighty American economy, the world's economic engine, is also spluttering, despite optimistic noises from Federal Reserve Chairman Alan Greenspan.

But Greenspan has been wrong before, and the great days of the central bankers, as the demigods who controlled everything, may well be over. The politics of recession are just as challenging as the economics. With governments everywhere under pressure from their electorates to "do something," the greatest danger of all is that they might try some of the old discredited remedies, like laws to protect industries, new barriers against foreign imports, more subsidies and unsound job creation schemes.

Those with the longest memories will recall that these were the policies of the 1930s, the Great Depression years, which led to war and global disaster. The one hope this time is that the world's statesmen have learned the absolute necessity of maintaining open trade at all costs and the colossal dangers, indeed the impossibility in the information age, of closing their economies. The global electronic network could be the new tutor of politicians who might otherwise weaken in the face of demands for panic measures. Remaining steadfast will not bring early relief, but it will stop things from getting worse. If finance ministers and other political leaders can resist short-term pressures sufficiently, the crisis will of course pass. After the uncontrolled boom of the late 1990s and the mad excesses of the dotcom era, a protracted period of caution, fear and stagnation was bound to follow and, in this globalised age, spread worldwide. Many great companies will disappear. Familiar corporate brands will vanish, as many have already. But all life goes in cycles.

If the policymakers can keep their nerve, there will eventually be an economic spring, but first there will be a long economic winter.

30 MAY 2004

Taming the Culture of Blame

An independent judiciary has long been taken for granted in Britain.
It has been regarded down the ages as one of the majestic bastions
of British liberties and a necessary pillar of the free democratic state.

The difficult and delicate issue for the learned judges was always
how to be independent without being too separate and remote; how to
reject all political interference in administering the law, but take proper
account of public feelings, customs and attitudes.

Until recently this complex balancing act seemed to work rather well,
and even more important, it seemed to endure. The law was respected
and people felt it was fairly administered — at least so far as Britain was
concerned.

Lately, deep unease has crept in. Both in the law courts at home and
on the international legal scene, a feeling has grown that the judges are
out of touch and out of control, in the sense that they are taking too
much power for themselves. The delicate boundary between proper
independence and improper wielding of power is being transgressed,
or so it seems.

On the home front this concern has focused on the tendency of judges
to interpret the law too freely and, so many people feel, in much too
liberal a manner. Thus those who defend their own homes and families
with force find themselves penalized and jailed, while their attackers

136

go free. Illegal immigrants are granted endless rights of appeal. Bizarre sentences — too long for minor misdemeanours, too short for ugly crimes — are handed down. Aggressors seem favoured over victims.

This has encouraged all those who ever believed that the law has gone against them to rush to court in the hopes of a new and more favourable interpretation. Governments and public authorities find themselves under constant challenge from those who claim that some law or regulation somehow infringes on their human rights.

Behind them have come an even bigger army of redress-seekers, determined to sue left, right and centre for the slightest mishap, on the grounds that they deserve compensation. There seems to be no such thing anymore as an accident. Someone — the authorities, the employers, the management, the suppliers (of a product) — is always to be blamed. And if they are to blame, they can be sued. Both the blame culture and the compensation culture have arrived with a vengeance, and the courts have done little to discourage them.

The same trend — toward everything being settled by the courts and the judges rather than by common sense and the democratic political process — has grown international wings. National governments now find themselves constantly battered by charges of human rights infringements in the various supranational and world tribunals and courts. Sometimes these are justified, as with the horrific abuses by American soldiers of Iraqi detainees. But sometimes they can be frivolous — witness the attempt by Greek lawyers to get a court case going against senior British ministers for war crimes in Iraq.

Anyone who feels wronged under national law in Britain can try appealing to the higher European Court of Human Rights at Strasbourg. Lobbies and interest groups who feel disadvantaged, or who just object to government policy, can tread the same path.

The situation is all set to get much worse as the European Union tries to adopt a full legal constitution, with the European Court of Justice as its constitutional court. Individuals all over Europe will have access to this court to complain about any aspect of EU-related policy, including foreign and defence policy and how it affects them or why they object. And it is the judges who will decide — in effect transcending national sovereign authority.

From the ordinary citizen's point of view, these lofty courts and others like them, such as the new International Criminal Court, are bound to seem even more remote than courts on home ground. They sit on foreign soil, follow unfamiliar codes and procedures, and by definition consist of a majority of foreign judges. Were they confined to traditional matters of international law and justice that would be understandable. But when they reach deep into home affairs and daily lives, the unease can only increase.

Can anything be done to stop the judges in their courts from seemingly taking over from politics, making every national law or policy challengeable, every quarrel a path to litigation, every setback or mishap a human rights issue?

Wise men said long ago that the best and happiest societies were those with few laws and therefore few lawyers. It is notable, for instance, that Japan stands out as a nation and a society with relative few lawyers and a welcome insulation from the American tendency, now spreading worldwide, to litigate or sue on every occasion.

So perhaps the first step is for Western lawmakers and law administrators, both national and at the EU level, to learn from Japan and pass fewer laws, as well as to encourage a more balanced approach to human rights concerns, both at home and internationally.

William Shakespeare had a more radical solution. "Let's kill all the lawyers," says a character in one of his plays. That of course nowadays would be considered a politically incorrect, even illegal, suggestion. Shakespeare would certainly be prosecuted in some court or other, possibly under human rights legislation, and given a heavy sentence by the judges, since they, after all, are now in charge.

1 JANUARY 2004

We're All in this Mess Together

Comparisons are often made between Japan's relations with the United States and Europe's trans-Atlantic relationship. In practice, though, the two links are quite different and seem to be getting more so.

The blunt truth is that, for most Americans, Europe is no longer on the front line in the battle for global freedom and stability. The threat from Russia has evaporated, and while ethnic and tribal troubles continue to bubble in the Balkans, these are not matters for which Americans are prepared to put their lives on the line.

A change of U.S. president in the near future, should that happen, will not alter this basic perception about Europe. John Kerry might be more tactful than George W. Bush and his team — who go out of their way to insist that America can "go it alone" and that Europe is of little interest — but the heyday of U.S. commitment to Europe is over.

By contrast, Japan is seen as being right on America's front line nowadays. Its big neighbour is the oil-thirsty, weapons-supplying, expansionist antidemocratic China, and its smaller neighbour is the dangerous and completely unpredictable North Korea, which seems to be limbering up to attack something.

Despite talk of American troop withdrawals from Japan (and South Korea), the reality is that Japan and America are now closer together than ever. This is reflected in the warm links between Prime Minister

Junichiro Koizumi and Bush (in stark contrast to Europe's distaste for Bush) and the increasing integration of Japanese and American military forces, both land and sea.

Back in Europe things do not look this way at all. Defence "separatism" from America is clearly developing, and Britain, hitherto the closest European power to the U.S., is being steadily sucked into the new European defence system.

All this raises in turn an even more fundamental question: Is Europe still under the American nuclear umbrella? The North Atlantic Treaty Organization alliance is meant to provide a cast-iron guarantee that any member state threatened with nuclear weapons will have American nuclear might behind it. An attack on one is an attack on all.

The British "independent" deterrent, which is in fact heavily dependent on American technology and shortly due for renewal, is also included in this guarantee. The position of the aging French nuclear-weapons system remains ambiguous, although what this system now targets is obscure. Surely it cannot be cities or sites in Russia, which is supposed to be the West's ally and friend.

The likelihood of such an attack may indeed be remote, but it would certainly amaze the citizens of, say, Ohio or Arizona nowadays to know that if, say, Poland, Slovakia or Estonia were threatened, the U.S. would instantly be pulled onto the front line of a nuclear war.

Whereas 20 years ago it seemed natural that America would risk all to defend European soil against the Soviets, today it is probably more acceptable to think of the U.S. doing so in defence of Japan or Taiwan rather than distant and unimportant (and not very friendly) Europe. So while Japan can safely consider itself under American protection, the European position is now much more ambiguous.

The whole position is complicated by American plans for expanded antimissile missile systems, allegedly to supplement traditional nuclear deterrence. With whom are the Americans going to share this additional and supplementary "umbrella"? Japan seems both willing and in favour to be the one (as well as being the closest to possessing the complementary technical know-how).

Britain has also been considered a favoured partner in a future U.S. antimissile "cover" because the American system needs advanced

warning stations somewhere on European soil to alert its own devices. Britain can offer those. But this sounds a little strange because it implies that incoming enemy missiles would come from somewhere east of mainland Europe. Again, one wonders, just who that enemy is supposed to be.

Meanwhile, the Europeans seem to be taking no chances and going ahead anyway with their own satellite navigation system, called Galileo, which will be completely independent from the American GPS system.

And who will have full access to this new satellite system, with the means to guide and track missiles and view launch sites that it offers? Why, none other than China and Russia!

So if either of these giants is still held to be the potential enemy, then Europe has reached the extraordinary position of simultaneously being under American-missile protection in case of nuclear attack while increasing its alliance in space with those who could conceivably be the attackers.

This makes no sense at all. And of course if the attackers of the future are not even states but instead shadowy terrorist organizations that have somehow got their hands on nuclear missiles, the whole question of nuclear umbrellas and just who is protecting whom against what becomes even more nonsensical.

But perhaps we have reached the stage where these questions should not even be asked. We have, after all, moved into a totally new phase in matters of global security. The only realistic and safe assumption to make now is that an attack from anywhere on any part of the global network in which we live is an attack on all of us.

So perhaps, after all, there are no great differences between America's Pacific connections and its European ones. We are all deeply into this dangerous new world together.

14 MAY 2007

Cherry-picking an Identity

Political leaders nowadays are fond of talking about national identity and culture, but do we know what they mean by either identity or culture, and do they know themselves what they mean?

A prominent British Labour Party leader, Jack Straw, the former foreign minister — and quite likely to be become foreign minister again soon — has been telling the British people that they should think more about their identity and have a clearer idea of what it is to be British. He urges teachers to teach in schools about Britain's "long struggle for freedom," and argues that while the country's numerous different ethnic groups and minorities should be allowed their separate cultures, this should not override their Britishness.

So there we have it — "identity," "culture," "freedom" — these are big words that get thrown about, and words are very powerful. But those who use them need to do so with great care. Identity gets much talked about nowadays because globalization and the total international pooling of information via the worldwide web seem to dissolve national identities and leave people wondering where they belong and where their roots lie.

Much of the best "glue" to tie people together in any nation is a good knowledge of that nation's, and society's history, both the good bits and the bad bits. Yet who were the people who rubbished history in Britain,

and marginalized it in school syllabuses? Why, the self-same Labour Party leaders, including Straw, who now bemoan the lack of Britishness and want children reminded of their history again.

But this time they seem to want a somewhat different version. Instead of the old sort of British history, which told youngsters all about their nation's battles and victories, about its place in the world, its conquests and defeats, they want the emphasis to be on "freedoms," which means on the overthrow of feudalism and absolute monarchy, the securing of individual rights and religious toleration and the arrival of democracy (which only came late to Britain — 1922 when half the population, its women, finally got the vote).

Nothing wrong with that, except that it leaves out half the story — the more important half. The key answer to the question "Who are we?" lies in understanding how a nation or society has evolved, how it fits into the rest of the world, where it stands and what its national purposes and values are.

Being British only becomes a credible concept in relation to being foreign. It is a nation's foreign and international policy and the whole history of its relationship with its neighbours that define it and tell its population where they stand in the world. This is a fact that applies especially to island nations with stormy pasts — such as Britain and Japan. In the British case, however, all this is now far from clear.

One moment the British are told to forget Britishness and be good Europeans. The next moment we are America's closest friend and ally. And the next we are warned that Britain is no longer really a nation at all but a polyglot collection of cultures and races. Moreover, it is a kingdom that is about to become less united if Scotland goes its independent way — the Federal Kingdom rather than the United Kingdom.

Nor is the meaning of "culture" much clearer. "Culture" means the laws, customs, traditions, values literature and history of a group, tribe or nation. If every grouping in a nation is encouraged to live inside its own cultural shell — the multicultural theory — the result is fragmentation and separatism — a clear departure from unifying national identity and loyalty.

For example, Islamic groups in Britain want to live under their own Shariah law. Is this consistent with Britishness? Nobody knows, and airy generalisations from political leaders merely confuse the matter.

143

So how much of their "own culture" are ethnic minorities to be allowed? And how much freedom do people feel they have in a society that is now dominated by public authorities and regulations and controls and surveillance. (A recent survey uncovered that officials now have more than 250 laws allowing them to walk uninvited into people's private dwellings).

The inconvenient truth is that these words are meaningless unless much more carefully defined, and Britishness is meaningless when its leaders cannot even decide where Britain belongs. Politicians who use them betray a deep ignorance of how the world works and of human nature and human hopes and aspirations.

This is an age when more and more people round the globe worry about their identity and their roots. Genealogists, archivists and librarians report an unprecedented public interest in family trees and origins.

The best unifying and reassuring message for any nation or society is to insist on honest, frank, unbiased and full teaching in schools of all history — in unvarnished form — and to insist as well on primacy of national laws and norms, with tolerance of local customs within limits.

Taking a nation's history away and then trying to put it back in doctored form is deeply misguided and fruitless. Only when most people know who they are and how their past has shaped them is the society or nation within which they live going to be comfortable and at ease with itself. That is a lesson that many political leaders have yet to learn.

29 FEBRUARY 2008

Sovereign Funds Rescue the West

Ten years ago some commentators were forecasting (on this page and in pamphlets)[1] that the age of westernisation was over and that the age of easternisation was about to begin. Capital and technology which had flowed from the West to the East for several centuries past was now about to start flowing the other way.

At the time the idea was ridiculed. Surely, it was claimed the rising Asian nations would go on needing Western techniques and Western investment just as they had always done? Was not the example of nineteenth century Japan, where the Meiji restoration set the pattern for importing advanced Western methods and blending them with traditional Asian cultures, bound to persist?

Yet now, ten years later, the turn-around has indeed taken place. The wealth that once flowed from Europe and America to the eastern world has dried up and vast new funds from cash-rich Asia and from the oil-producing Middle East, awash with dollars from oil sales, are cascading the opposite way.

These funds are mostly state-owned, or owned by sub-agencies of the state – hence the term 'sovereign funds' – and they are colossal. One estimate asserts that some three trillion dollars are now in the wings waiting to be invested in Western assets, over and above the vast sums

1 For example 'Easternisation and the Rise of Asian Power', by David Howell, published in London by Demos in 1995

which have already been advanced.

Hardly a day now goes by without news of big new acquisitions by these sovereign funds in banks, property, European and American corporations or in already existing financial holding companies. For example, Temasek, in effect the financial arm of the Singapore Government, has taken an eighteen billion dollar stake in UBS, one of Europe's biggest banking firms. Kuwait has put around five billion dollars into Merrill Lynch and into Citicorp. China, through its investment arm, has taken a big slice of Barclays Bank, one of the UK's largest. The newly established China Investment Authority has also taken a minority stake in Blackstone, the major American investment house, while the Qatar Investment Authority, bulging with earnings from its huge natural gas resources, has also been on a buying spree, although the Qatari attempt to buy into the major British supermarket chain, Sainsbury's, has not succeeded – yet.

These big new lumps of cash have turned up at a very welcome moment. Most of the Western banks concerned have been nursing immense losses, thanks to their somewhat careless (could one say 'greedy'?) acquisition of packages of American home loans, so-called 'sub-prime mortgages' which looked such easy money but turned out to be valueless. Where wiser and older heads might have warned about the dangers of too much lending against doubtful security, the young lions who control the major Wall Street and London finance houses thought they knew better. Now their apparent assets have turned out to be liabilities, the borrowings and credit they need to carry on has been withdrawn and they are lions no longer. The Asian billions have therefore come as a blessed relief.

But nothing comes without conditions, or without awkward questions attached to it. In the case of these sovereign funds the central question is whether they are straightforward commercial investments or whether there is a bigger political agenda behind them. Are they simpler shrewd investments by financial managers who are looking for a good place to park their funds, or are they part of a much bigger political strategy on the part of the governments behind them to own, and may be eventually control, major Western enterprises?

Most of the sovereign fund managers, and the Government

officials behind them, have been at pains to assure the world that their investments are entirely 'passive'. That is to say, there is no secret agenda aimed at seizing control of Western banks and other businesses and that these funds will act like all other quiet shareholders and will not interfere in the business.

The fact remains that these sovereign investments are not the same as normal commercial funds. They have behind them not shareholders but governments and states. These may be prepared to pay inflated prices for assets and to sit patiently on big losses since they may have other, longer-term aims in mind than merely making profits.

There is an even deeper question. Does money power bring political power along with it? Will those who lend the cash to shore up the Western capitalist system always be content to act in a passive role, or might their political masters, who in reality own them, start dictating the global political agenda as well. That is exactly what happened when the flows were the other way round in the 19th and 20th centuries. British, French, American and other wealth creators and investors, with the full backing of their respective governments, imposed their political will on the developing world, often using military force to occupy territories, subdue local opposition and 'protect' their investments.

Yet strangely enough it could be that the East in the 21st century may prove wiser than the West did in the past. It could be that by studying history the new political leaders of Asia have grasped the central lesson of the recent past – that sticking to open trade and concentrating purely on securing investment returns on their savings and capital provides a much sounder way to prosperity than taking whole companies and countries over. Managers should be left to manage. Politics and investment should be kept as far as possible apart.

That, at any rate, is what Western bank chiefs and corporate chairman must hope as they gratefully receive the Eastern cornucopia. But it is early days yet in this new order of things, and the financial muscle of rising Asia may yet turn into something much tougher.

17 JULY 2008

No Strong Leaders -
Let's Hope It's Over Soon

The world is now in the grip of a first-class financial crisis. Some will be hit harder than others, but no one is going to escape. Final confirmation of this has arrived with the news that the two giant mortgage companies, Fannie Mae and Freddie Mac, pillars of American life that underwrite, or insure, most home-loan lending throughout the United States, are in serious trouble with their share values halving.

Meanwhile, stock markets are collapsing almost everywhere, and in both Europe and America business profits are shrivelling and employment layoffs are beginning. Pinning down a single reason for this reversal of global fortunes is hard because the problems seem to coming from every angle — soaring oil prices, energy shortages, world inflation, currency volatility, environmental disasters, huge policy errors, terrorism and inept diplomacy leading to rising tensions between the major world powers.

But if there is one causal phenomenon that could be said to be behind all these growing troubles, it is the past decade or so of irresponsible lending, easy credit and mountainous debts in which the main Western economies have become trapped, thanks to lax financial regulation and unrestrained financial-sector greed.

In the U.S. the level of household debt has now reached three times U.S. annual output. In Britain the figure may be just as high. Complex

and clever schemes for hiding the risks of lending more and more are now falling apart. The argument that spreading the risks around the entire global banking and credit system, disguised as "assets" against which still more cavalier lending could take place, has been turned on its head. Spreading the risks has meant spreading the poison so that now no bank or financial institution holding or investing in these "assets" has much idea of the rotting elements within them, and therefore whether they dare use them as a base for more lending.

No more lending means no more investing — except for the lucky few who happen to have spare funds stored up. To try to keep up confidence the Americans have been pumping billions of dollars into the system, keeping interest rates low and cooking up elaborate plans to bail out helpless debtors.

But issuing more dollars makes for a much weaker dollar against other currencies and more inflation. Oil, priced in dollars, has taken off to the stratosphere in dollar terms. So the attempt to solve one problem worsens others.

In this case the worsening effects are reflected in a weakening of America's global status and influence on every front, leaving a new president to grapple with an appalling situation.

But if the problems have developed mostly in Western societies and mostly in relation to home loans and mortgages, it will of course be asked why the creditor nations of the world — notably the high-saving Asians and the cash-laden oil producers like Russia and Saudi Arabia — need suffer as well.

The answer is that with a world slowdown, exports to the markets of the West are shrinking fast while inflation is spreading everywhere. This is already reflected in plummeting Asian stock markets — especially China's. The deteriorating situation worldwide has been compounded by appalling policy errors and misconceptions, about which there was plenty of forewarning.

The liberalization of financial markets went much too fast. The shedding of the old socialist and collectivist patterns of the 1970s and '80s, which was certainly needed, swung to the opposite extremes not of stable and balanced competition but of unregulated market behaviour and monopoly rackets. The preparation for the clearly visible and

oncoming energy crisis, together with climate concerns, was pitiful. The need for maximum flexibility between nations and societies in the new network world was grossly underestimated. Old mind-sets clung on to dreams of yesterday's international institutions and bigger international blocs governed by more remote bureaucracies — of which the old, overly centralized European Union remains a classic example.

One lesson from all this is never to believe pundits or political leaders. In Britain at the beginning of 2008 leading expert commentators were asserting that stocks would go up and not down during the year, while the prime minister was flatly denying that the British boom would be followed by bust.

They were all wrong, and it is now too late to avoid the bust for many businesses, investors and individual workers. But wiser policies could help ensure that the crash is not too prolonged and the recovery is swift — swifter, if possible, than the 10 years of stagnation that Japan suffered in the '90s. For that the world needs strong national leaders working together more closely than ever, not merely to devise a new order but — and this is the most difficult part — to use the power of language to persuade people that it should be accepted.

Such leaders need to be in the mould of Churchill, of Roosevelt, of Marshall, of Harriman, of MacArthur, of Adenauer — big men with big visions and the ability to spell them out. The recent G8 meeting confirmed what most people feared — that no such leaders are currently on the scene. But change in that respect could come soon, and where there is change there is hope.

A Small Outbreak of Nationalism

The issue of Scottish nationalism has again come to a head, and is raising serious political issues for the whole United Kingdom.

The situation has been sparked by the outcome of a recent Parliamentary by-election which, to general surprise, the Scottish Nationalist candidate won.

This was no ordinary election. It was a stunning victory for the Nationalists, who already have a small majority in the devolved Scottish Parliament, in a Parliamentary constituency, Glasgow East - a poorer area of the otherwise re-vitalised City of Glasgow which has been a stronghold for the Labour Party since time immemorial. Almost from the birth of the Labour Party at the end of the nineteenth century Scotland has long been a Labour power base and the source of a large part of its overall national majority, enabling it to hold power and keep the Conservative party in opposition for long stretches, including the last eleven years.

The last two British Prime Ministers, Tony Blair and Gordon Brown, have both been Scottish, although Blair held an English Parliamentary seat. Ministers with a Scottish background dominate the inner councils of the present Labour Government

It is no exaggeration to say that if all Scotland goes the way of Glasgow East the British Labour Party will be decimated and the Conservatives will be at a huge advantage as the majority party throughout England. By any standards it is a shocking result.

Critics have turned on the Prime Minister, Gordon Brown, because he is failing to show the sparkle of his predecessor, Tony Blair, because the opinion polls show Labour at rock-bottom and because he is Scottish. His followers in the Westminster Parliament now see not only that Labour will lose the next General Election but, worse still, that most of them will lose their seats in Parliament altogether.

It seems at the moment that nothing Mr. Brown does is right. He is pilloried at every turn – in Parliament, in the media, travelling abroad, even on holiday with his family. Blame is piled on him for everything – for the slowing economy, rising prices, expensive fuel, financial turmoil, events going wrong overseas – especially in Afghanistan where British troops are dying in tragically rising numbers – and a thousand other upsets and irritations.

Yet his baying critics should perhaps pause and reflect a little on the reasons why life is so difficult for Mr. Brown and why he faces so many appalling challenges. Most political headaches and horror stories do not just develop suddenly. They grow out of past errors and blunders, often undetected at the time, but then emerging into the daylight to fall on the heads of those who had little do with the original follies.

Mr. Brown has only been in office for about one year. While it is true that he was in charge of the British economy for ten years before that, and therefore cannot escape the charges of bad management and lack of preparation for changed world conditions, it needs in fairness to be acknowledged that many of his problems are the legacy of his predecessor.

This is very hard for some Labour politicians to admit. For them the Blair years were golden and Blair could do no wrong. So there is a deep reluctance to defend Mr. Brown now by pointing out the many fundamental misjudgements made by that otherwise persuasive and adroit politician, Tony Blair.

Yet it is beginning to be seen just what an appalling legacy their former hero left behind.

Beginning by talking about the UK as a bridge between America and Europe, he ended up being dragged into America's wars with a lapdog status in Washington. Turning to the EU he also ended up there pleasing no-one and actually agreeing to a referendum on the EU's attempted

constitutional reforms. Meanwhile the arch tenet of UK foreign policy – that the country should always maintain a super-strong, superbly equipped fighting force – was fatally undermined. Meanwhile again, on the domestic front, lavish promises of reform and improvement were made on all sides, few of which have been fulfilled. Instead, heavy new taxes and charges have been levied on consumers already reeling from soaring food and fuel prices. The gap between rich and poor has widened noticeably.

A nation that emerged from the Thatcher era full of confidence and setting the pace in Europe has been reduced to faltering uncertainty and loss of international purpose.

This is the miserable legacy which the battered Gordon Brown has inherited. He is a resilient and very able man whose private persona, by all accounts, is very different to his brooding public image. He probably sees the way to a better future for a re-positioned UK, much closer to rising Asia and to its good friends in India and in Japan, as clearly as anybody.

But in less than two years he must lead his party into a General Election, assuming he is not undermined and replaced in the meantime by panicky colleagues. His opponents, the Conservatives, are miles ahead in the opinion polls under their youthful and agile leadership.

Can he recover? If the world economy rights itself swiftly, if things go better in both Iraq and Afghanistan, if the UK can take the lead in a confused and drifting Europe, he may be able to steady his Party and win back some voters.

But it will require iron nerve and Herculean courage. And in the meantime he will continue to be blamed for all that has gone wrong, fairly or unfairly, and whether on his watch or on the previous one.

But that, of course, is the way of politics. As President Harry Truman observed long ago, if you can't take the heat, then get out of the kitchen.

All eyes will be on the British Prime Minister to see whether he stays or chooses that particular exit.

3 OCTOBER 2008

Adjusting to a Power Shift

Just as one picture can tell more than a thousand words, so also one event can tell more, and provide a bigger shock, than a thousand written messages.

The almost unprecedented events of recent days, with banks collapsing worldwide, financial markets in turmoil, share values plummeting and the American political grass roots in revolt against its administration and against the whole official establishment, send a message more vivid than countless warnings, speeches, articles and lectures.

It has been pointed out for a decade or more that the true sources of power and influence in the world have shifted, both geographically and politically, thanks to the vast impact of the information and communications revolution, but this obvious message has until now strangely eluded political leaders in the West, and especially in America and Western Europe.

Both American and European politicians have continued to talk about world leadership, as though it was theirs by rights, and governments on both sides of the Atlantic have continued to assume that their powers to order and control global events were undiminished. In the real world, first economic and financial, and now political power, have been fast draining away from the elites on both sides of the Atlantic — in Washington as well as Brussels.

Two huge forces have been at work driving this process for some years now:

First, America and much of Europe, especially Britain, have become debtors, borrowers and spenders, trying to carry on living at yesterday's high standards in the face of today's reality — namely that they are ceasing to be either the richest or the most competitive parts of the globe.

Increasingly, it is the fast-growing and high-saving Asian nations and the cash-rich oil producers of the Middle East (plus Russia) who have had to come to the financial rescue of Western financial institutions, with the process accelerating in recent days. Massive Japanese stakes in American banks like Morgan Stanley, for example, and Chinese stakes in British banks (Barclays) are vivid demonstrations of this.

Second, power has not only slipped away from Western governments to the East and other capitals such as Delhi, Beijing, Moscow and Tokyo; it has trickled away from governments generally as the fantastic dispersal of information and knowledge has empowered billions of logged-on personal computers users and mobile telephone owners, thus creating a new worldwide network of influence and power outside any national government's control.

This is a centrifugal power that can be concerted, organized and directed for good or for evil, as the tragedy of 9/11 showed. It is not a question of new empires arising as old ones fall, as it would have been in 19th- or 20th-century terms.

There is no new "Rome" to displace Washington's dominion. Instead, the microchip has given birth to a complete asymmetry of force, command, authority and economic muscle. The smallest group or cell under control of no one state or government can now become coordinated, weaponized and empowered to challenge the mightiest traditional military force.

To its amazement, America's leadership has discovered that its titanic defence spending, missile arsenal and 13 carrier fleets cannot maintain its influence and ensure it gets its way. Although size and weight have increased, vulnerability has not diminished. Flabby international obesity has replaced giant global weight. Pax Britannica came and went, and now Pax Americana has truly gone as well.

That this has been happening for a while was obvious to many outside

Western government and ruling circles. The piling up of public debt, the weakness of the dollar and the huge accumulation of gold and dollar reserves in Asian central banks were all clear signs that the world had changed radically.

Now the shock waves have truly broken the illusion and the situation is plain for all to see. Wall Street no longer rules. The very American technological know-how and genius that gave the U.S. its predominance has been used to bring about its downfall, with endless computerized machinations turning prudent banking and money management into a toxic nightmare of complex uncertainty.

There is a school of optimistic thought that this means power has been handed to a new united Europe, with its more socialistic inclinations in contrast to raw American capitalism. But this vision, too, is flawed. To be sure there have been some strange role reversals within the European circle, with Spanish interests now taking over most of British home finance (did the Spanish Armada win after all?), and the East and Central European countries, once so backward, now show more spark and dynamism than struggling France or Britain.

But the big money, and the big influence, have moved eastward, away from the Atlantic sphere altogether. It is a measure of the upside-down state of affairs that the country best insulated against the financial contagion is Iraq — simply because it is still basically a cash economy and its banking sector remains unreconstructed and primitive.

Can the Western nations and their policymakers now adjust to this grand bouleversement? Can they trim their extravagance and indebtedness, restore financial prudence, and behave as humble and respectful partners rather than as haughty rulers within the global network?

To do so will require not a return to socialism, as some have called for, but an advance to realism — to the realization that the global financial system is no longer a Western monopoly to which the world must dance in obedience.

To understand that will be the beginning of wisdom, providing the best chance for the painful and slow return to balance and stability worldwide.

20 OCTOBER 2008

Now for the Consequences

The British Prime Minister, Gordon Brown, has been enjoying a much-needed boost to his status and popularity as he watches country after country round the world adopt the same pattern as the UK in propping up their struggling banking sectors.

But preventing widespread bank collapse is of course only one piece of the jigsaw of disaster that now threatens the global economy. Money and credit flows are the lifeblood on the whole economic system, and when they become infected the repercussions are felt everywhere, and many of them are unpredictable.

The most immediate and painful reaction as the huge edifice of paper credit crumples can already be seen in the shrivelling of trade and markets world-wide, and therefore the corresponding shrinkage and cutbacks in production by suppliers to those markets wherever they may be.

No country will be immune from this process, and it explains why stock markets round the globe have all continued to sag even though the big banks may have been saved for the moment from going under. Every sign points towards lower profits, lower yields and lower earnings. Even Japan, which has already experienced the fire of severe credit contraction throughout the nineteen nineties, is seeing its equity share values plunge along with everyone else.

Curtailed production in turn spells closures, lay-offs and rising unemployment – an outcome which every democratic government

dreads. In the UK context this means that the triumph of stabilising the financial system by the radical method of acquiring huge state holdings in the major banks may be short-lived as the unemployment fall-out grows.

A parallel consequence is that with lower demand come surpluses of unwanted commodities and lower prices for metals, for foodstuffs and most notably for oil. For many this will be a welcome relief after the ferocious rises in food and fuel prices of recent years.

But for those who live by exporting commodities, or are left without a job, or have seen their savings decimated, it will be poor compensation.

As trade diminishes the political pressures inside each nation for protection from the cold winds outside will increase. This has already begun. The prospects for further liberalisation through the so-called Doha round of negotiations within the World Trade Organisation look dimmer than ever.

Yet despite all these grim possibilities the gloom at what has happened should not be total.

We have been living in a series of unhealthy bubbles and life once they have burst will have its advantages.

Oil and commodity prices, which were far too high, will sink back to manageable levels (even though this may weaken incentives to invest in green alternatives and renewables).

Inflationary pressures generally will ease. Countries which were growing too rich with easy oil money and maybe a bit too arrogant (one thinks of Russia with its recent aggressiveness in Georgia) may well feel they have to curb their actions and behave more consensually.

The puncturing of the property bubble was also overdue. At last younger families will be able, at least in the UK and America, to buy a home without mortgaging their entire life's income in the process.

More generally, we may see the inclination of U.S. leaders to assert American 'leadership' here, there and everywhere, whether it is welcomed or not, give way to a more tempered, less unilateralist and even more humble approach, now that they are no longer master of the financial universe.

Above all, without wishing to see a return to centralising state socialism which paralysed and impoverished the twentieth century for

so many, this may be a time, as the state shores up the banks, when the balance between the state and the private individual becomes more settled and balanced and less of a frontier in the ideological war. The old polarity between the fears of harsh state dominance and the fears of private greed could give way to a more comfortable partnership between interactive and responsive governance working with an empowered and involved private citizenry.

But for these blessings we may have to wait. In the meanwhile fright and panic rock the world scene. The mass participation in financial markets which the internet age permits has led inevitably to mass shifts of mood and breathtaking volatility. Yet fear is always a dreadful counsellor – and crowd fear the worst of all. To prevent such global moods from producing knee-jerk responses and impetuous political reactions (as occurred after the Great Depression of the nineteen-thirties) will require statesmanship and powers of understanding and explanation of the very highest order.

Perhaps that kind of leadership is just over the horizon and on its way towards us. But it is not visible yet.

31 OCTOBER 2008

Finding the Right Kind of Leadership

In these troubled times everyone is looking round for decisive and wise leadership. In particular the world is looking to America, as still the biggest and richest nation by far, despite its current financial problems, to make a better contribution to world peace and stability under its new President than it seems to have done recently.

In fact in the recent Presidential campaign this is just the question that Americans on in all parts of the political spectrum have been asking each other - 'How can America best reassert its world leadership and influence and become loved and admired again as once it was?'

In looking for an answer Americans should perhaps try taking a leaf out of the Japanese book. In Japan the spirit of mutual obligation prevails – perhaps not as universally as it once did, but still quite strongly. People are guided by a sense of obligation to each other. That is the lubricant by which business is done, relationships are handled and teams are built. The concept of going it alone is unthinkable.

Like it or not, realise it or not and admit it or not, America is today more deeply obliged than ever to others.

It is obliged to China for holding such massive quantities of its currency and for a vast cascade of products and supplies which increasingly underpin the entire US value chain. It is obliged and indebted to South Korea, Japan, Abu Dhabi and several others for the same reason. It is obliged to India for the endless flow of superior computer wizards (who help sustain Silicon Valley) and it is obliged to Brazil for showing the

way with genuinely clean biofuels, and for much else besides in the way of design and now even aero technology.

It is obliged to Russia for keeping open the gas spigot to Western Europe (most of the time). It is obliged to Japan as a machine shop, innovator and defence ally, as well as for the reasons given above. It is obliged to Britain both for past services in standing alone against Nazism for long enough to let America gird up and turn up, as well as for recent Middle East support, for which the Brits have earned nothing whatever in return except world unpopularity.

The list goes on and on. Germany is certainly owed something for its loyalty and readiness to subordinate all past ambitions to a peaceful continental unity. A mutual obligation is owed to Turkey for eschewing Islamic extremism, to Palestine for struggling to come into being as a state, to Iraq for its efforts to develop its vast oil potential (recognition of which might have helped America get along faster with its Status of Forces negotiations with the Iraqis).

It could even be argued that the US shares a degree of mutual obligation with prickly Iran, as a huge nation with a strong culture and timeless history, well capable of making a major contribution to the whole Middle East region's prosperity and stability. Starting from that stance, instead of from the evil empire standpoint, might be just what is needed to move on to careful co-operation with the proud Iranians in developing a peaceful nuclear capacity, rather than sticking to the present mixture of confrontation, threats and sanctions which, although inflicting some pain, are ultimately futile. This is, incidentally, a course which wiser heads in Israel are already considering.

The central consideration in all this is that obligation is mutual. Globalisation sets the seal on this international structure of mutual indebtedness which seems not to have been taken fully on board by recent US foreign policy-makers. It imposes an almost universal pattern of mutual obligation not just in terms of trade and investment, but in terms of security as well.

The outgoing US Secretary of State, Condoleeza Rice has been talking about the need for America to take the lead again. She calls for an international order which shares American values and which expands the circle of America's allies. She calls this 'the new American

realism'. But the new realism is not as Secretary Rice believes it to be The new realism is that the American people today, more than ever, ow their prosperity, security and future welfare to many others. This put America in a position no different from most other nations, althougl in the American case its sheer size makes the obligation both ways evei bigger.

This is not what the American people are being told by their leaders on either side politically, or by their chief communicators and opinion shapers. America's contribution to world peace and stability would b vastly enhanced if they were, as would its internal peace of mind in plac of the present almost universal angst and bewilderment.

What the world now asks from the great, generous and a well meaning American Republic, with its fine, if today somewhat tarnished values and beliefs, is to sound less assertive and more cooperative an understanding of the position, values and political structures of other – to play on the team.

When a new Secretary of State goes before Congress early next yea to have his, or her, appointment confirmed, that should be the key issu addressed.

24 NOVEMBER 2008

The Oil Puzzle

What happens when the demand for oil flattens out or falls and the supply of oil continues as before or actually increases?

The answer is economics at its simplest – the price plummets. And that indeed is what has occurred.

All round the world the demand for 'black gold' has eased, with oil tankers lying off shore with cargoes unsold, inventories rising and stocks accumulating. American and European oil consumption, and imports, have actually fallen. It is reported that even China, with its recent vast oil thirst, now finds itself overstocked and is trying to ship surpluses back to Europe for resale.

Attempted OPEC cutbacks have made little impact. In a matter of months the price of crude oil has more than halved and is still sinking.

Of course, all this is in the very short term. What happens next, in the medium term, as reactions to this collapse begin to take hold?

Again, simple economics provides the answer. The suppliers begin to cut back. New wells go un-drilled, new projects are postponed. This, too, is already beginning, with the oil giants like Shell and ExxonMobil 're-thinking', or 'postponing' (which means cancelling) big new investments in such things as the Canadian tar sands and other ventures, which looked so profitable when oil stood at $140 a barrel and now look very shaky with oil at $55.

On the demand side it is the opposite. With oil suddenly cheaper again, users and consumers start being careless again. All those plans

to switch to non-oil energy sources, like wind and solar power, cease to look so attractive and are put to one side for the time being. Official appeals to save energy become – well, less appealing.

So in the medium term, with demand rising and supply falling, the inevitable occurs – oil prices start to soar again, the world panics and we are back in the same old crisis.

It has all happened before. Policy planners wondering how to escape this dismal cycle of boom and bust have a perfect model to study and from which to learn.

What that model confirms is that every phase of cheaper oil prices contains the seeds of the next price spike and the next energy shock.

In 1985 the price of oil soared to record heights, similar to those of recent times, and then crashed. By mid-1986 the price of crude had fallen by five times (from $45 to $9). Suddenly no-one wanted oil. The oil-producing countries were in despair, their hopes of big spending and lavish lifestyles threatened.

In the oil consuming countries enthusiasm for energy saving faded, Detroit gave up building compact, economical cars and went back to gas-guzzlers, lights were left blazing, most people forgot about energy efficiency. Alternative energy projects, suddenly looking hopelessly uneconomic, were cancelled and in particular almost all plans for nuclear power plants were postponed. Cheap energy seemed back, oil shocks seemed a thing of the past and the warnings were disregarded.

Then, starting in about 2004, the crunch came, intensified this time by the emergence of China and India as super-thirsty oil importers. The oil price climb seemed unstoppable. Dire forecasts talked about $200 or $300 oil. Now all that has once again been swept away in a matter of months.

Is there any escape from this destabilising cycle, and what lessons can be learnt from the past ups and downs?

It is true that last time, in the nineteen-eighties and nineties, most people in most industrialised countries forgot about energy conservation and alternatives, and carried on drinking up oil and gas. Most but not all. In three countries in particular the lessons were learned, although in different ways, and the focus remained firmly on the longer term.

Those three were Japan, France and Brazil.

In Japan, despite the late nineteen-eighties fall in oil prices the mood remained firmly in favour of cutting oil dependence, increasing energy efficiency and developing alternative energy sources. This meant that Japan came though the oil price cycle with lower imports and a better and more secure energy mix.

In France a different course was take. With the oil shocks of the seventies and eighties the French were determined never again to rely totally on Middle East oil, whatever the price. They built in record time a vast fleet of nuclear power stations which today deliver over 70 percent of France's electricity.

In Brazil it was different again. When the oil shocks occurred Brazil decided, as a matter of long-tern policy, to invest as much as possible in biofuel oil from sugarcane. Its cars were converted and the whole supply chain re-tooled to use this non-oil substitute.

When the world crude price subsequently flopped many people thought Brazil would be ruined by being locked into a high cost alternative. But brave policy –makers persisted and when the next price spike came their persistence was vindicated.

What these three stories tell is that now, with oil prices again sliding, wise governments and wise consumers should carry on with longer term plans. This time round they have an additional incentive to do so, namely the awareness that carbon from fossil fuels is putting the planet in growing danger.

Wise policy-makers will therefore do all they can to keep the retail price to the oil and gasoline consumer steady (if necessary by actually raising fuel taxes and cutting out all subsidies) and to sustain longer term alternative projects through the present phase, including pressing ahead with nuclear power.

Unfortunately that kind of wisdom is in short supply. Most governments are currently mired in financial difficulties and scared of any longer term policies that might increase the pain and lose votes.

But at least this time the history lessons are there for all to read and it is just possible that some, of not all, government leaders will have the courage to spell out the realities to their electorates and win support for sustained long term energy strategies. We live in hopes.

8 AUGUST 2009

Disaster in Afghanistan

Thousands of troops from the United States, the United Kingdom and several other nations are struggling on in Afghanistan, with the Americans and British in particular suffering heavy casualties. But why are they there, and what are they trying to achieve?

Former U.S. President George W. Bush had no doubts on the matter. America (with its allies, or alone if necessary) was going into Afghanistan, he proclaimed, to hunt down Osama bin Laden and destroy al-Qaida.

But that was six years ago; since then the situation has become much more vague and confused — quite aside from the fact that bin Laden has never been found, if indeed he is still alive.

From hunting down terrorists the "mission" seems to have widened into all kinds of blurred objectives. One is to somehow defeat the local extremists, the Taliban, who threaten constantly to overrun large areas of the country and retake the control they once had.

Another is to support the installed government of President Hamid Karzai, despite the fact that this government is far from happy with the presence of foreign troops. A third is to halt the opium trade, despite the fact that the Karzai government is hand in glove with the narcotics barons who control it. So far this has proved a spectacular failure, with poppy growing for opium more widespread than ever.

A fourth objective is to protect human rights from the dismal standards of the Taliban, who treat women like slaves or worse and seem

found of executing people with minimal legal niceties. And a fifth is to rebuild the whole state in the democratic mould with decent facilities, education and health provision.

The idea that any or all of these objectives can be attained by battling with the Taliban day after day, and night after night, is proving as elusive today as it did for the British in the 19th century or the Russians in the last. The Afghan people do not want foreign troops on their soil and will never rest or be "defeated" until the foreigners have been ejected, or give up and go away.

It is this hopeless muddle of aims that has led an important committee of the House of Commons at Westminster to deplore the lack of unified vision and strategy and call for a refocusing of priorities.

In fact the committee is saying nothing new because it has been obvious for a long while now to anybody familiar with the situation on the ground that the problems of Afghanistan cannot be solved by military means and that the lives of brave soldiers are being wasted by a policy aimed in completely the wrong direction. Perceptive personnel on the spot have long been saying that the real problem is the Karzai government itself. Little will ever be achieved if the government in Kabul is quietly undermining the efforts of the very forces that are supposed to be there to support it.

Some in the U.K. have argued that British military forces would suffer fewer casualties if they had better equipment, and particularly if they had more helicopters, thus avoiding perilous foot patrols along roads that have been heavily mined. But the real issue goes much deeper.

For one thing, it is doubtful whether many of the al-Qaida operatives are still in Afghanistan to be rooted out. It is more likely that they have long since moved their cells and training camps across the 1,600 km-long border into Pakistan, and into the unending valleys and mountain areas stretching from the Pamirs to Waziristan, which are beyond any central control and have proved the graveyard of countless expeditionary forces down the years.

Other al-Qaida units may well have moved further away to Somalia in the Horn of Africa, where new young terrorists can be trained up and the infiltrated with apparent ease into Western Europe, and especially the U.K., to plan new outrages and killings on the streets.

By that reckoning the U.S. and British forces are fighting the wrong war in the wrong country. But behind that lies an even deeper question. Should Western nations be intervening with military means in order to change governments and impose their values and democratic templates? And if so, how should they do that?

Global policing is obviously necessary to avoid world anarchy and instability. But it is surely high time that policymakers on both sides of the Atlantic, as well in all responsible nations including Japan and the rising Asian powers, conducted a robust re-examination of the doctrines of liberal interventionism and pre-emptive action that have led the Western powers into such quagmires of difficulty, both in Afghanistan and elsewhere.

It should now be clear that "the West" can no longer act alone, can no longer throw troops and conventional armaments into complex and remote societies and cultures, where the concept of democracy means something quite different, and can no longer impose new government structures against local opposition.

Advanced nations certainly have legitimate aims in wishing to protect themselves against terrorist extremism, destabilizing civil wars, massive human rights abuse on a genocidal scale and potential nuclear anarchy through proliferation.

These are the four new horsemen of the Apocalypse, the threats to every organized society. The strategic policymakers of the richer countries of the world need to learn to handle them with a good deal more skill and subtlety than they have shown over the past decade if their freedoms are to be preserved, their peoples defended and guarded, and their armies deployed to good effect, with clear aims, rather than being asked to achieve the impossible.

2010-2020 Japan and the UK
Allies For The Future In A Dangerous World

OPENING COMMENTS
2010-2020 Japan and the UK
Allies For The Future In A Dangerous World

As the new century entered its second decade things were not working out, either as predicted or as hoped for. As Japan stepped forward on the international stage with a powerful and respected new Prime Minister and renewed innovative momentum, the UK was sliding into confusion. Scotland was veering towards separatism and the Brexit writing was on the wall. UK policy-makers and journalists were discovering (belatedly) that populism, in many forms, was on the march and that the digital age had changed politics radically.

Then came the Japan shock no-one foresaw. On the night of 11ᵗʰ March 2011 a gigantic tsunami swept inland at Okuma in the Fukushima Prefecture, flooding out the Fukushima Daiichi power plant and knocking out all emergency generators and electricity supply. Three nuclear meltdowns followed and a 20 kilometre zone around the plant was evacuated.

There were more shocks and surprises to come.

Few in supposedly informed circles foresaw the Trump victory and even fewer predicted the British Brexit vote. Only one or two warning voices foresaw the Syrian catastrophe, or the survival of Bashar al-Assad, or the arrival of Russia and Turkey centre stage in the Middle-East.

At first the Japanese business establishment sounded loud alarm at the Brexit prospect, with protests of how Japan had invested heavily in

the UK as the best entry point to the European market, but now look what was happening. There were dire threats of Japanese withdrawal from Britain, especially from the car-makers

But later views were calmer as the prospect of a disorderly crash-out receded and Brexit began to be seen in the perspective of broader changes in the patterns of global trade and production. And was the world anyway falling out of love with the motor-car, especially the petrol or diesel one, and maybe with individual car ownership altogether?

Battering typhoons and earthquakes followed, although always met by the familiar and amazing Japanese resilience. Would and could the British show the same resilience as they were battered by political instability? Doomsters predicted the collapse of political order, the erosion of trust and respect and the weakening of democracy itself.

There is going to be no return to anything like normal times. That much is clear on every page of what is written here, even if some in both Tokyo and London persist in believing otherwise. Power has been redistributed too widely. The high-tech platforms, with their giant all-seeing algorithms, bestriding the globe, are too pervasive, for any return to the past.

The final article in this saga is penned with the hope that some of the 'beautiful harmony' which Japan has seemed able to extract from all its tribulations would rub off on a divided UK.

We shall see...

JANUARY 2015

Knowing when Not to Apologise

Here is a telling statistic about Japan's foreign policy that is little known in the West, and may not be widely known even in Japan itself.

Japan pays just under 20 percent of the whole United Nations budget - 19.47 percent to be precise.

This is very much more than any other nation except the United States, and a visitor from outer space would assume that as such a major "shareholder" Japan would naturally have a key place on the "board" or executive body at the head of the U.N.

But the visitor would be quite wrong. Japan has no place on the inner ring of Permanent Security Council members, who call the shots, and its polite efforts to join the ruling group are bogged down in a long-running wrangle about who should be members of an enlarged Security Council and with what powers.

Somewhat ill-advisedly, or so it is felt by Japan's friends, the application strategy has been to link arms with India, Brazil and Germany, each of which feels that it, too, should be full and possibly permanent Security Council members.

Each of these other three countries comes with a lot of controversial baggage as they all line up to apply. India's application is immediately challenged by Pakistan; Brazil's role is questioned by the other major Latin

American countries, like Argentina; and Germany's would-be membership is all bound up with the highly contentious question of whether the European Union as a whole should have a Security Council seat.

This means that Japan's perfectly straightforward and overwhelming claim to a seat, as one of the chief U.N. paymasters, is now all muddled up with these complex regional disputes, which could go on for years (as they have done already).

This is a good example of shyness and almost apologetic hesitation where a bold, up-front case, put forward with confidence, might well do better.

Of course Japan has plenty to be apologetic about over its World War II behaviour, as the gatherings to mark the 60th anniversary of the end of the Pacific War have been reminding everybody. These apologies have been made, are being made and will continue to need to be made for ages to come in fulsome fashion.

But Japan has nothing at all to be apologetic about in its current global role as an economic giant and major contributor to world economic advance, as an increasingly significant global player in securing world stability and development, and as a massive source of ingenuity and new design, improving the human condition everywhere.

Nor should there be any cause for apology or defensiveness over the question of aid volumes. Japan has been one of the world's biggest aid providers, as well as writing off very large debts owed by Iraq and other countries.

Criticisms aimed at Japan for not giving a big enough percentage of national income in aid, or for including relief for debts that were probably never going to be repaid anyway in the overall aid calculation are wrongly directed. The whole campaign for bigger aid flows, as promoted at the recent Group of Eight meeting in Scotland last month, and as asserted in the so-called Millennium Development Goals, is sadly flawed and misconceived anyway.

What matters is not the volume of aid handed out, it is the way that aid is distributed at the recipient end. Bitter experience confirms that the promise of lavish aid flows all too often props up indolent or oppressive governments. Thus it prolongs suffering and puts a stopper on innovation and new enterprise.

Aid flows to governments can have the same effect as huge oil revenues. They simply remove the incentives to encourage grassroots development and new business. That is what has been happening in the oil-rich states of the Persian Gulf — although some wiser ones have now sought to diversify — and that is what has been happening in Africa, the recipient of gargantuan aid donations over decades past, with largely negative results.

So no apology or hesitation is needed on this front at all. Japan should meet foolish criticism with wise actions, including the recognition that development and relief of world poverty are not "solved" by bigger and bigger aid checks, or higher percentages of national income paid out in overseas aid.

These fundamental ills are overcome, as they can be, not by crude demands for "more aid" but by a sensitive mixture of trade easement, encouragement to good governance, carefully targeted technical assistance and, of course, short-term humanitarian relief where disasters occur — as currently and tragically in Niger.

Japanese policymakers have slowly learned these important lessons and should not hesitate to take the lead in explaining them to others who are less enlightened. The same sort of international realism that is now at last being shown by some nations — including Japan — over climate change and global warming, should now be shown over economic and social development in the poorer countries.

Apologies should be sincere, but kept to the now quite distant past. Realism is what is needed for a better global future. And Japan is well-placed to take the lead in providing that vital ingredient.

MARCH 2015

Tattered NPT Needs Repairs

What has become of the globally agreed regime designed to prevent the proliferation of nuclear weapons — the Non-proliferation Treaty (NPT)? The answer these days is that while it has served the world well for many years it is now in tatters.

The original treaty was clear and concise. It aimed to confine the ownership of nuclear weapons to those five countries that already had them, or claimed to have them, namely the United States, Russia, China, France and Britain. These were designated the "existing nuclear powers." Both they and all other signatories to the treaty became subject to a strict system of compliance, verification, monitoring and regulation, whatever their nuclear activities, whether civil or military or in the grey area of "dual use" in between. And an often forgotten bit of the treaty was that the existing five would steadily wind down their arsenals.

That was the theory. Today's reality is dangerously different. Outside the original five, Israel has long possessed nuclear weapons in flat defiance of the NPT. So has India, although it has now been "rewarded" for its disregard by American bilateral action with access to various new nuclear technologies.

Pakistan has matched India all along with its own warheads — and with a very leaky nuclear-information system. Iran — in fact a signatory to the NPT — has nevertheless acted in secret and is now pressing

ahead with no credible means in sight of stopping it.

Meanwhile North Korea has stepped right out of the NPT system and is agreeing instead to six-party talks, which are moving at a snail's pace. It may already have full nuclear-weapons capabilities. It certainly has missiles that can reach Japan.

Proliferation breeds proliferation. Iran's progress to nuclear status, though it may take a few more years yet, is bound to prompt nuclear-weapons ambitions in Egypt, and maybe Syria and Turkey as well. North Korea's nuclear advance, if not somehow checked, is bound to lead to rethinking in Japan, either about acquiring a nuclear-weapons capability, which it could do with ease, or to agreeing to the forward deployment of American nuclear missiles on its soil.

So what happens next in this precarious and unbalanced situation? In theory three possible avenues exist.

The first is to try somehow to get the genie back into the bottle. That is to say, the illegal nuclear powers would somehow have to be persuaded to give up all military ambitions and conform fully with the original treaty.

That prospect is highly unlikely. The United Nations' instrument of nuclear discipline, the International Atomic Energy Agency based in Vienna, is a weak body at the best of times. The idea that Israel would willingly go non-nuclear is fantasy. The same applies to India and Pakistan. It is true that two nations in history have voluntarily given up nuclear activities — South Africa and Ukraine — but both in very special circumstances that apply nowhere else.

A second avenue would be just to shrug one's shoulders and allow proliferation to happen, hoping that mutual deterrence, which did seem to work in Cold War days, would stop any government using these horrific weapons.

That seems a counsel of utter despair. Governments can and do go mad, as history shows. New nuclear states, flushed with power, could threaten non-nuclear and smaller nations while the world trembled.

The third avenue is to start redesigning the architecture of the NPT system to embrace the new "facts on the ground" — namely that these weapons are now possessed, or about to be, by several countries outside the original five. What is therefore required is a much more powerful

regime of inspection, monitoring, verification and control that brings the activities of every nuclear nation, or would-be nuclear nation well and truly into the open, with all secret sites revealed and the inspectors welcomed. The whole philosophy would be complete openness.

This kind of solution would also involve the most carefully policed exchange of nuclear materials and technologies, universally agreed (in contrast to the Bush bilateral deal with India), with the possible sharing of facilities under international control.

Such an approach requires enormous leaps of faith and hope, but it just might work, unlike the other two. Israel would somehow have to be brought openly to the table, a step that probably only the U.S. could compel it to take. India and Pakistan would need to build on their existing nuclear standoff — which at least shows that the theory of mutual deterrence has some life left in it.

Iran will have to talk to someone in the end as well, but who? It has not accepted — at least not yet — the idea of Russian nuclear assistance and guarantees in exchange for allowing all uranium enrichment processing to take place on Russian soil. But the Iranians might just listen to their biggest oil and gas customers, China, Japan and India, if these three could be prevailed on to put aside all their other differences, at least on this issue.

In North Korea it is pressure from Beijing that offers the best hope of bringing that dark regime's nuclear activities into the daylight. Interestingly, the one development that might trigger a firm Chinese line with North Korea would be the prospect of more nuclear-weapons deployments next door in Japan. That might bring China to recognize more clearly than ever before that even with its billion-plus citizens, and even with its existing or planned gigantic cities (each of 50 million inhabitants) spread well inland, it could still be just as devastated by a disorderly nuclear world — and by a nuclear war — as America, Russia, Europe or the rest of Asia.

Beijing may keep reiterating that it wants "peace." So do we all, but it will have to be worked for.

Japan and Britain —
New Defences for New Realities

British defence and security policy has been undergoing a radical reappraisal, as security gurus in their think tanks and military commanders in their operations rooms ponder the unfolding implications of defending a vulnerable island in a world of global terror, rogue states, international instability and ever higher technology-based threats.

A British "white paper" review of defence policy has appeared, stuffed with new jargon, new theories and new doctrines. Is any of this relevant to Japan, where revolutionary developments, such as planning a missile defence system and troop deployments to Iraq, are also under way?

At the broadest strategic level most experts would have argued until quite recently that the situations of the two nations were fundamentally different, so that comparisons were pointless. Britain was a committed world player with a nuclear deterrent; Japan was constrained by the pacifist tradition stemming from the utter disaster of World War II.

But that, as the saying goes, was yesterday. What the 9/11 horror in New York and Washington revealed, and what developments since then, culminating in the Iraq war, have confirmed, is that the pacifist option simply no longer exists. A major nation that wants to be safe and secure cannot hang back; it has to be committed to the global security task.

So at this broad strategic level the differences have shrunk dramatically over the past two or three years. Geography now becomes far less important. Britain and Japan today face the same global threats: international terrorism, proliferation of weapons of mass destruction, failing states, yawning global inequalities, famine, environmental and health threats, migration threats and energy threats. All of these have become issues that any society that wishes to keep its citizens safe can no longer ignore.

Of course some obvious regional differences remain. Japan has a small but unstable and deadly dangerous state on its doorstep, North Korea, while Britain has no such threat — at least while missile technology dictates the present limited ranges. The Libyan decision to show responsibility actually removes the danger from the one country that might have been able to hit London with its longer range missiles — which were bought from North Korea.

Meanwhile, Japan has to live with a giant, unpredictable and prickly neighbour next door — China — while Britain does not. Britain has well developed regional defence arrangements through the North Atlantic Treaty Organization and European defence cooperation is increasing; Japan lacks such reassuring defence arrangements with its neighbours and has to look further afield for allies.

But take one step down from the strategic to the military operational level and the similarities begin to noticeably outweigh the differences. It is true that Japan used to put all its military emphasis on homeland protection and self-defence, while the British military stance was heavily slanted overseas. In the new context these two positions are merging. In Iraq, Japan has now made a crucial first move outwards to full participation in global security — and there will be more "Iraqs" to come.

By contrast, British defence thinkers are placing new inward emphasis on homeland defence, on the use of reserves, on "quick reaction" air defences to protect territorial air space and on close domestic integration between civil and military powers — and all this alongside Britain's still extensive military commitments around the globe and the capacity to mount new expeditionary-force operations at a moment's notice.

So at this operational level it could well be that the latest British ideas have suddenly become of real relevance and importance to the Japanese

military planners as well, and vice versa. Maybe Japan can pick up some new tips about what it takes to operate globally these days, while the British can learn more about self-defence forces and how to make them most effective.

Either way, this makes for an incredibly demanding and expensive defence and security agenda for both countries. The British are now putting heavy emphasis on maximum force flexibility, on more linkage than ever before between people, weapons and communications systems — whether on land, in the air or at sea — and on faster response to so-called asymmetrical threats.

An even bigger novelty in this changing defence landscape is the opening of a whole new arena of defence diplomacy and relations that now comes wrapped up with the global commitment package.

Translated into everyday language, this means a massive expansion of politico-military activity into the fields of conflict prevention, confidence and security-building measures, numerous types of peacekeeping and policing, all kinds of support for training up local defence forces, intensive joint exercises and training with foreign defence forces and a variety of responses working with foreign partners at both the civil and military levels to track international terrorists and forestall their plans. These are the new kit components of the global security game — the software, the platforms, the cables and connections of global military involvement.

Consciously or not, Japan is stepping into the centre of this new scene and thus into a wholly new pattern of defence and security-related activities and commitments, and in doing so will no doubt bring its usual ingenuity and innovative skills to the scene.

Of course there remain those who yearn nostalgically for the old days when defence and security just meant looking after the home patch and leaving the rest of the world to sort itself out. Such views persist in both Japan and in Britain as the two peoples peer from their islands at the stormy international vista. But as the armed forces, expert strategists and political masters in both countries have realized, such a world is now gone and it will never return.

29 NOVEMBER 2017

Governments Must Plan Today
For Tomorrow's Energy Needs

Electric power — or lack of it — is once again in the news. It is not just the millions of East Coast Americans and Canadians who have suffered with monster blackouts. Power cuts have become drearily regular in France, Japan, China, Spain, Italy, not to mention in struggling Iraq. And shortages are widely forecast to hit Britain as well this coming winter, especially if it is a really cold one.

Yet oddly enough, all these problems seem to have different immediate causes in different countries. In the United States the problem has been lack of investment in a modern transmission system to bear the colossal loads. Spending money on reliable transmission grids is viewed as unprofitable by the American power companies.

In France the problem is dried-up mountain reservoirs, combined with over-reliance on aging nuclear power stations that are notoriously thirsty, which means that France will soon have to import more daily electric power from neighbours, thus putting further strains on them as well. In Japan the specific problem of power shortages this summer lies with the assurance of safety at nuclear power stations.

In China, it is more a question of rapid economic growth outstripping supply capacity.

In Britain the issue is also capacity shortage, and in particular the squeeze on the margin of spare or reserve capacity. Again, as in America,

this is of no particular interest to individual privatized power companies with their eyes glued to their balance sheets.

Therefore it gets ignored — until a very cold day, or a very hot one, takes the whole system dangerously near the ceiling of available supplies from the generating stations, and cuts result. Iraq is obviously a different matter again — with sabotage and deliberate disruption of what was anyway a rickety and outdated power system leading to appalling lack of both electricity and water (which needs electricity to be pumped).

So is it just coincidence that this most vital and basic of needs should have suddenly become so unreliable for so many millions of people in so many different parts of the globe? Or is there some common underlying causation making the organization and delivery of power increasingly problematic in advanced or semi advanced societies? The answer is that, yes, there is indeed a common background cause — and one about which governments and policymakers need to be constantly reminded.

Safe and secure electricity supplies demand vastly long-term planning and investment, far further ahead — say 20 years — than anything for which normal market calculations and investment decisions can possibly allow. In a world of deregulated and privatized electricity generators and distributors, it therefore becomes a public or collective decision to see that somehow these longer-term commitments are made in the public interest.

This does not mean that the state needs to own and operate whole electricity industries, as was the case in the communist model, or in many other socialized systems, or in Britain before the Thatcher era. But it does mean that governments should skilfully define certain longer-term obligations and legislate to ensure the companies involved meet them.

Thus in the case of Britain there needs to be a service obligation on generators and the transmission system to keep building enough new capacity to maintain at least a 15-percent margin in case of unusual or emergency conditions.

This in turn requires not only incentives and profits large enough to build new stations (which may mean higher prices to consumers) but something else as well — namely the prospect of reliable fuel and energy supplies for years ahead.

This is the obligation that no government can escape. Britain used to depend on home-produced coal for its power, but that turned out to be hopelessly unreliable politically, as miners went on strike and paralyzed the country, quite aside from the problem of sulphur emissions from coal poisoning the atmosphere. Now it relies on oil-fired and gas-fired stations, together with some nuclear capacity and a small section of "renewables" (hydro-electric power and wind power). Secure oil supplies require global strategic planning and global security (as unending Middle East turbulence daily reminds us). It may also involve making controversial deals with unsavoury regimes, as Japan is finding out in Iran.

The same goes for gas supplies. Secure gas flows require entering into contracts decades ahead. Long pipelines are needed to carry natural gas, often from politically dangerous regions such as Algeria or Central Asia, and elaborate security measures are necessary to protect them. Meanwhile, nuclear power requires immense long-term provisions to cope with safety, waste processing and eventual decommissioning of stations.

Development of renewables, such as offshore wind farms, requires expenditure far beyond the horizons of any investor. Such matters must all involve unavoidable government commitments based on wise, bold and far-sighted policy decisions in the name of the public. International treaties must be signed, long-term guarantees given; even wars must be fought (as currently) to make the world safe for tomorrow's electricity-based societies.

Yet these are just the kind of government decisions that win no votes, and of which the benefits may not appear for decades, while nevertheless bearing painfully on today's taxpayers and consumers. They are the kind of decisions politicians would much prefer not to make and for which no amount of wind power (when the wind blows), sun power or wave power, and no amount of conservation in energy use, can make up.

Instead of spending so much time trying to micro-regulate people's daily lives in ways that are no longer necessary, modern governments should be concentrating their attention on these difficult areas.

Unless they bravely grasp these long-term issues, all the conditions for interruptions and blackouts will be increasingly in place — and it is not just New Yorkers but half the world that will be walking home in the dark.

184

Can The U.N. Handle Iraq?

Everyone wants the United Nations to play a greater role in Iraq — the Americans included.

But is the U.N., as presently structured, capable of taking on such a role? Could it ever have the powers of cohesion and the muscle to address the ugly terrorism and guerrilla warfare that is plaguing Iraq's recovery? And does it even want to get more involved after the horrific murder of its top personnel in Baghdad?

The interests of all those currently within the American-led coalition, as well as the interests of some countries still pondering their contribution, would clearly be served by a higher U.N. profile. The Americans feel they are already carrying too much of the burden, and are reluctant to commit more troops, which would increase the targets available to forces resisting the U.S. occupation.

The British, too, although cautiously sending another 3,000 soldiers to the Basra region, are now stretching their armed forces to breaking point and would dearly like to see other countries, encouraged by greater U.N. involvement, take a bigger share.

Japan would draw some comfort from a stronger U.N. mandate as well. This might reassure the many doubters and would certainly save Tokyo from making an inglorious decision to not send troops on the grounds that some of them might be killed (it would be hard to think

of a worse start to Japan's new higher profile role in international affairs if such a decision were to be made).

The Poles, who are facing strong opposition at home to their already large force commitment, would also be helped by a bigger U.N. presence. So would the Czechs, who have also had second thoughts as the security situation in Iraq deteriorates.

France and Germany — the "old Europe" brigade — are playing a different game. It is hard to see what they are really after.

With one breath they say they want the U.N. to take centre stage, and that the new draft resolution, which reasserts the U.N.'s vital role in restoring "representative governance" — but leaves the Americans still very much in overall charge — does not go far enough. Their line is that the U.N. should somehow run the whole show in Iraq, with the American-led coalition providing military security.

But in the next breath they say they want no part in anything that implies validation of the American-led invasion. Their one clear motive seems to be to make the Americans eat humble pie and admit they were wrong to try changing Iraq by force. As the Americans will never go this far the scene is set for a stalemate, with the French vetoing any compromise resolution at the U.N.

Even if all were agreed on the terms of a U.N. takeover, and extra troops from nations such as India, Pakistan and Turkey were sent to Iraq, are more foreign troops the answer to the wave of terrorism there? Large parts of Iraq are reasonably peaceful and beginning to pull their local communities together. It is in the deadly region to the north of Baghdad and around Tikrit that terrorists are rampant.

There the need is for intelligence operators, local police expertise and Iraqi forces who really know the ground in detail. The same applies when it comes to curbing the incipient civil war between different Shiite sects and between Shiite and Sunni Muslims, of which the monstrous killing of moderate Ayatollah Mohammed Bakr al-Hakim, plus 70 others, in the heart of the holy city of Najaf, is the bloodiest example so far.

The best people to tackle these growing threats are the Iraqis themselves. The Americans made a huge mistake in disbanding the Iraqi Army and are now trying to undo the damage by re-enrolling all but the most senior officers. They — the reorganized Iraqi military themselves

– are the ones who should serve Iraq's new governing council by tracking down on terrorist activity and violent gang rivalries, and thus allow their own government to emerge under a new democratic constitution.

There remains the most basic question of all — does the U.N. have the capacity or the moral authority to preside in Iraq? If the U.N. was a genuine coalition of democracies, dedicated to the overthrow of global terrorism, the answer would be "yes." But the present organization is far from that. Many of its members are either fake democracies or open dictatorships. It cannot even reach a consensus on the true seriousness of the global terrorist threat.

U.N. Secretary General Kofi Annan has spoken about the need for a fundamental reassessment" of how the U.N. works. But that will be for tomorrow, and the problem in Iraq is for today. Putting the U.N. at the head of the whole Iraq operation would solve nothing immediately. It would place on the U.N. administration, and on U.N. forces, tasks well beyond their present capacity to handle. And the chances of the Security Council agreeing a clear remit are anyway minimal.

The best way forward for this unhappy but potentially rich and well-endowed nation will be found not at the U.N. headquarters in New York but on the ground among the citizens of Iraq themselves, their police and their re-constituted security forces.

If the Iraqi people, the majority of whom are delighted to see Saddam Hussein out of power, want their country to hold together, recover and prosper, it will. If they do not, then no amount of outside military force or blessings from the U.N. will save them from bloody civil war and disintegration.

31 AUGUST 2016

Energy and Climate Policy
– Some Unintended Consequences

For anyone attracted to unintended consequences, contrary results, unexpected or perverse outcomes and counter-intuitive conclusion energy policy is the place to study.

All round the world governments are finding that moves in one direction – for example towards energy reliability, energy affordability and cleaner energy – are having frustratingly opposite results from those intended.

A current case in point is the plan by the UK to re-start and renew its civil nuclear power fleet. This, it is worth noting, goes in flatly in the opposite direction to Germany, which is closing theirs down, along with Austria and Switzerland. It also diverges from France which in the past had a superb and massive civil nuclear sector but now has doubts about its renewal, but is broadly in line with China, Russia and South Korea and the oil-rich United Arab Emirates. The German decision, taken on green grounds has, incidentally had particularly perverse results – to which we shall come in a moment.

The UK policy thinking was that a revived civil nuclear power sector, starting with one giant new plant, would combine security of base-load supply with an unending output of low carbon electricity. A decision was reached to allow the French, with Chinese financial support, to build a brand new two- reactor plant on an already established site at Hinkley Point in Somerset.

This sounded a splendid idea but someone forgot about the costs – costs to the consumer, costs to industry and jobs in high energy prices, costs of reducing a tonne of carbon emissions, as opposed to alternative methods. All these have turned out to be gargantuan, demanding immense extra payments from both the government and from the electricity consumer direct, both to construct such a huge plant and to purchase its costly electricity for decades ahead.

The consequence appears to confront UK policy-makers with a terrible choice. Either go ahead and build something which will be a heavy and prolonged burden on British businesses and households even if it is built on time and to budget, and operates successfully, which neither if its immediate predecessors (in Finland and France) have come anywhere near doing. Or, cancel the project at the last minute, damage the UK's whole civil nuclear 'renaissance' strategy, deny China the golden entrée it was hoping to get to Western civil nuclear power construction (and operation), possibly with hostile outcomes in terms of trade relations and China's extensive UK investment plans.

One way it will be goodbye to cheaper electricity and a large risk with an unproven nuclear design. Future nuclear power technology, in the form of much smaller modular and factory-assembled reactors, will be deterred as the Hinkley giant sucks in all available resources.

The other way long-term carbon budget targets may be thwarted and much more gas have to be imported for longer from overseas (both via pipeline and shipped LNG). Even old coal-fired stations may have to be kept open to keep the lights on, although expensive methods for carbon capture and storage of coal- burning might become more attractive. The whole momentum of the UK's nuclear 'new build' will be undermined. The French, (or some of them), as well as the Chinese, will be deeply offended. Billions would have to be paid out by the British in compensation for work already undertaken.

So either way the high and worthy ambitions for both energy and climate policy, as well as for good relations with important neighbours at a time of Brexit, are bound to be thwarted or reversed. It would plainly have been far better never to have embarked on the project in the first place. And it will take diplomatic genius to find a way through the tangle.

Or take the German case, where under strong Green political pressure

the abolition of the whole nuclear power sector has been ordained. With subsidised renewable solar power and wind power building up rapidly the gas-fired generating sector has seen profits evaporate and their plants are closing down. The only other competitive power source is coal. Coal-fired electricity has duly been filling the gap, some of it using lignite (brown) imported coal, the most carbon-intensive of all, and of course the diametrically opposite of what was hoped for – a perfect example of good intentions paving the way to bad outcomes. Germany's unilateral decision to cut out nuclear also throws the whole EU energy and climate strategy into greater disarray.

Finally, there is the classic example in Japan of policy perversity. For deeply understandable reasons the Japanese are uneasy about the re-expansion of nuclear power after Fukushima. But this means that Japan continues to drink in oceans of oil and gas, thus keeping the world oil and gas price higher than it would otherwise be. Not only does Japan thereby emit much more carbon than it should, but global fossil fuel production is encouraged while smaller, poorer and less developed economies struggling to pay more for their fuel imports, are denied the cheap power they need to escape poverty. These are plainly the opposite results to those which sensible and sensitive climate policy demands.

It is easy to point out all the errors and contradictions, and there are many more than can be listed here, but what is the constructive way to prevent them? The answer is to go about energy policy changes and climate aims much more slowly and with much more care than some of the zealots have been demanding. Like the world's ecosystem, the world's energy system is a delicate and interwoven web. Intervene in it heavily in one country and quite unforeseen and damaging consequences can occur on the other side of the planet.

So the greatest subtlety and caution are required, in the closest possible harmony with technology and world markets, and of course in the closest degree of international collaboration (of the practical and not just rhetorical kind) that can be secured. A good helping of humility and honesty about what Governments can actually achieve would also not come amiss.

As the veteran and wily French statesman Talleyrand kept reminding his young diplomat listeners about how to handle public policy - 'Above all, not too much zeal' !

2 OCTOBER 2017

People Power – The New Version.

Until a few weeks ago expert analysts and columnists were explaining that the Europe had escaped the populist 'infection'.

Marine Le Pen had been defeated in France, Angela Merkel would get safely re-elected in Germany and Europe could go forward to more integration on the lines proposed by the ever-ambitious Jean-Claude Junker, the European commission President, despite the UK going its separate way.

But that was yesterday. Today the scene looks quite different. In Germany there has been a dramatic rise in populist feeling reflected in the success of the Alternative für Deutschland party. This has many elements, some of them extreme right wing and distasteful, some of them plain anti-immigration, but all basically reflecting a new demand for the crowd and the minorities to have their voice in a world where there feel too much is dictated to them from the top.

But that is only part of the story. Now we have ugly scenes in Catalonia as the vast majority press for secession from Spain – an unwise alternative but certainly reflecting deep felt anger against the over-dominated centre.

Meanwhile, populist and separatist feelings across Europe have been given new impetus in areas such as Flanders, Bavaria, Silesia, Transylvania, Corsica, the Tyrol and of course still in Scotland. In

the Balkans, where fragmenting national and identity rivalries led to hideous bloodshed two decade ago, they continue to smoulder on. Most of these may be historic sentiments but they have undoubtedly been given new life in the digital age.

The hope that populism has been put back in its box was always an illusion. Technology has done something which traditional politicians and political analysts find it very hard to absorb – namely it has empowered the crowd as never before.

That is not to say that it has empowered the masses in the old bogus socialist sense, allowing dictators to "interpret" the will of the people and the proletariat as they wished and to their own personal and aggrandisement. The old so-called 'democratic' socialist nations of eastern Europe and the absurdly misnamed Democratic People's Republic of Korea, are examples of that kind of empowerment which of course is no empowerment at all.

No, we are confronted with an entirely different phenomenon and one which the political establishments have been very slow to recognise. The underlying forces are stronger than ever in pushing a new kind of populism which endows every individual and every network participant, at the terminal end of three and a half billion connections, with unprecedented knowledge power, opinion power and organizational power.

This is the new situation which has baffled Mrs Merkel in Germany and seriously reduced her authority and power and will do so further. It explains how Mrs May, the British Prime Minister, got things so terribly wrong in the recent General Election, as her advisors failed to understand the determination of millions of young people, using their mobiles and the iPads, to express their own views. Everywhere it intensifies feelings of local identity which then rapidly become inflamed into antagonism against 'them', meaning the establishment, the elite, the centre, those above.

Does this mean we are moving into an age of anarchy? Not necessarily. What it does mean is that those who provide the framework in which debate and democracy take place are going to have to adopt new methods and new mindsets in order to retain authority and give the kind of leadership and reassurance that people want.

The demand now is not for more laws and regulations, let alone patronising lectures or party lines from a government that claims to know better. It often doesn't. Instead the hunger is for more wisdom about the way a hyper-complex world works and the right mixture of a government guidance, support and sensitivity to local feelings.

This is not just a Western world phenomenon. Some of it may be evident in Japan's forthcoming election. Even party-dominated and centralist China is clearly not unaffected by this trend. At the 19th Party congress there was much talk about 'moulding together' the private sector and the state in a new transnationalist China, free of the old ideologies.

No government, no administration, no political party can afford to neglect these new forces to which the digital age has given birth. The power is now in the network and the network is driven by the billions of individuals who connected into it every day, every hour, every minute.

As the old centre falls apart new legitimacy and consent for new kinds of central authority has to be generated. One headline requirement for this is going to be new methods for sharing at all levels not just wealth but the benefits of new growth, at present going only to those who have savings and wealth already, while those on average wages languish. That kind of capitalism will no longer suffice.

But there may now be an even bigger challenge for governments. The old state monopolies may have been curbed, but the new global communications monopolies of the age have taken centre stage. The dominant names are familiar – Google, Amazon, Facebook, Instagram and a host of others. Governments and governed must get on the same side in seeing that while they provide benefits they do not coerce or restrict people into unwelcome patterns of life and behaviour, or promote darker forces of destruction, as they have clearly done in the chaotic Middle East.

Populism of one kind or another is here to stay. The politicians cannot avoid it or wish it away. It will always come back. And to keep their countries and societies together, as well as to stay in power, they will have both to adjust their methods radically and make new alliances with the people at all levels.

26 DECEMBER 2017

A Year of Ignorance

One of the silliest and least informative headlines carried in UK newspapers in 2017 compared alleged rates of economic growth throughout Europe, noting that the UK, after lagging and wobbling following the Brexit decision shock, had now caught up with Germany at 1.9 percent.

Why was it so silly? For three reasons of ascending force and obviousness.

First, comparisons like this depend on where you start from.

Second, overall rates of growth in a complex modern economy are notoriously difficult to measure, and depend on unrepresentative samples, guess work and huge value judgments as to what constitutes GDP in the first place. How, for example, do you measure increased output in art, entertainment, better environment, smoother trains, quicker book printing, nicer nail varnishing services, more tolerance in a society? Nobody really knows.

Third, and far the biggest, although least discussed, reason is that economic growth, however assessed, has become a deeply flawed measure of the health, welfare, dynamic vigour, balance and contentment of a society or nation.

Conventional economic analysis concentrates on the cash value of activities and the measurable flow of investment, wages and interest, savings

and consumption and enterprise, all driven by competition and with the banks oiling the wheels of finance and the state providing, and charging for, the necessary infrastructure of public services, law and security. At the centre of this stage is placed the utterly unconvincing and unreal figure of rational economic man, who in real life does not of course exist.

That leaves out the real determinants of economic progress which lie at its very foundations – in the home, the household, the human impulses to share and co-operate, in the whole world of social relations and sense of fairness, in the surrounding environment and in the routine, but essential, dealings and requirements of daily life, on which everything else depends. Most of these activities in a society may be unpaid, but neither man nor women – rational or otherwise – gets through the day without them.

These are precisely the 'core' qualities that determine a country's strength, or weakness. They are what decides whether an economy pulls together or slows down to torpor and stagnation levels and falls apart.

Yet these are the considerations and measurements that almost all economists for the last century (with some brave exceptions) have completely ignored.

Focussing on market efficiency and better physical infrastructure may boost the all-absorbing growth rate figure, at least superficially. But that kind of growth, narrowly defined, may come with more social divisions, not less, with instability, de-motivation, and with new dangers of the whole market system catching fire and blowing up, as it nearly did back in 2008.

So where is the progress and national strength in that? Economic analysis which just looks at markets and flows of income is starting half way down the track. The real drivers of national progress begin by treating people not just as consumers but as citizens, with all the needs, ambitions and attitudes which reinforce citizenship and a feeling of common purpose.

Will the economists now begin taking a wider view of what constitutes real and balanced growth in differing societies? The question is of high relevance to Japan. As a visitor one arrives with a mass of 'expert' Western briefing stating that the Japanese economy has been stagnating for a decade or so.

Yet this is a society that has been, and continues to be, highly creative

and socially innovative, lively and open in debate, remarkably cohesive and properly concerned both that there should be a role for all, in the home and the workplace, and that the environment should be fully respected, regardless of what impact this approach has on official data, on measures of GDP growth or productivity levels (another immeasurable in real life) and all the rest.

If this is 'stagnation' then there is something seriously and deeply wrong with the way things are assessed.

The chances of getting any real change in mainline economic thinking are slim. But there is a way out of the trap.

An illuminating book by Oxford economist Kate Raworth reminds us that in the 21st century global networks are doing what economists and policy-makers should be doing but are not. Networks driven by vast digital power grow of their own accord, linking up real interests and concerns across the planet and by-passing blinkered economic theories and misguided government measures which derive from them.

Networks influence behaviour, she explains. They tap into norms and values such as duty, respect and care, and they distribute both power and wealth in ways that have never happened before.(Paradoxically they also concentrate it in giant world-wide monopolies, but that's another story).

State policies cannot deliver all these aims. But ensuring that new wealth is far more evenly shared is one central goal that governments can push towards. Those of us who in the 20th century used to believe that, with markets unleashed, wealth would 'trickle down' now need to revise our mindsets since that is plainly not happening. Radical re-design of monetary policy to share wealth much more widely is clearly essential.

So architects, and comparison-makers, of national economic growth and industrial strategies beware. Not only is national output much harder to define in the digital age. Not only is the future (and even the present) shape of industry completely unpredictable.

But sticking to the old and narrow economic perspectives and definitions may be the wrong national target and the wrong strategy. Competing with rivals becomes pointless. More so-called 'growth' may just mean more social tension, a less balanced society and a worse life for many.

You have been warned.

29 JANUARY 2018

Russia's Eurasian Dilemmas

For those who like to split the world between East and West, Europe and Asia, and to identify clear dividing lines between the two, there was always a major problem. Which side of the line did Russia fall? Was it an Asian power or a European power? Was its culture basically western or did it adhere to an alternative, and more Asian, model, with different viewpoints and different philosophies?

If anything, the puzzle is now growing greater. While China seeks more and more links, physical and economic, with 'The West', and especially with the European continent, and while Japan has long been committed to many, if not all, Western patterns, Russia seems to hang awkwardly half in and half out of Europe, governing itself on principles which fit neither the Chinese model, nor Western democratic values, and leaving those trying to deal with this huge country puzzled and uneasy.

It is often forgotten that Russia, although with the biggest landmass of all and many highly talented people, is nowadays in global terms a dwarf economy, two-thirds the size of Italy's, less than half of Britain's, a ninth the size of China's and fourteen times smaller than the USA.

Its income per head is a seventh of America's, about to be overtaken by China and of course far, far beneath Japan's

The amazing thing is how such a small economy, with a shrinking

population and so poorly run, manages to have such an impact on the world.

For example, the USA seems to be in a permanent frenzy about Russia. People in Washington talk as if there was a new Cold War. Meanwhile Russia is conducting a vicious war in Syria, although to what end is not all that clear. It has caused violent mayhem in Ukraine, grabbed back the Crimea - as well as chunks of Georgia, is busy doing its best to destabilize Central Europe and the Balkans and developing new forms of hybrid and maskarova warfare.

It has forced the whole of NATO onto the alert, threatened Europe's energy links and of course allowed, or maybe encouraged, a wild west Botnet of cyber-hacking and false and fake news, through a maze of criminal syndicates.

This Russia of Putin Mark Two will not of course last for ever, even with arranged elections. The oil and gas revenues on which it floats will steadily drain away - like the Aral Sea - and leave a lot of Russia high and dry, regardless of any temporary oil production deals with the Saudis.

Gas sales to Western Europe will fall, and so will oil and gas prices, as American shale exports compete and renewables replace hydrocarbons. The danger in all this for a weakened Russia is that in the longer run, as the future Eurasia merges together, it will simply be shunned and by-passed.

In a way the Russian dilemma attracts sympathy, although Mr. Putin is hardly a sympathetic figure. The British people certainly feel a real warmth for the Russian people, for their heroism and their endurance. The country is rottenly led but its people are seen as friends. That distinction has always been clear.

But for the moment that is not how Putin and his ruling clique appear to see things. So there is little choice for the West and the democracies but to approach this once great country, still heavily armed with nuclear weapons, with caution and uncertainty about which way it is going to jump next, who it will try to bite next and what it really wants to be.

Responding to Russia becomes not just a question of adopting firm NATO military postures on the ground in Eastern Europe and the Baltic states (who feel especially threatened). The battle has to be just as much in the narrative as on the physical front line. And here the West

is much better placed than it was during the Cold War. There is no coherent ideology uniting the Russians, as in Communist times.

The way to break down this wall of surly hostility is to do the opposite of what some Cold War warriors recommend. Far from trying to isolate Russia or throw up new barriers the best course is to expand trade and dialogue in every possible way. Trade and Commerce are great pipelines of truth and awareness.

The aim should also be to strengthen already good cultural relations through all possible channels. Russian exchange scholars and Russian students should be welcome, suitably checked of course. There is also already excellent scientific and space co-operation with Russia, which should be further built on.

At the same time there must be zero tolerance for Russian criminality, wherever it occurs, including of course in London - as a recent TV drama called MacMafia has been reminding British audiences vividly.

The whole international community should also keep pressing Russia all the time for full adherence to the disarmament treaties and processes.

As for sanctions, let these be focused on identified miscreants, fraudsters and rogues, such as the notorious murderers of Magnitsky. More general sanctions make less sense and never work well. Often they just halt trade and have the reverse effects.

It is in nobody's interest that Russia should continue to be the odd one out. The contemporary world is changing shape and has to be managed in new ways. If Russia wants to play a strong part in the rise of Eurasia and the connectivity of the globe it will have to change its direction and decide how to become a good ally, not a spoiler, of both East and West.

Is India the New Trump Card?

Who or what is the Quad? It has no website and is rarely mentioned in the media. Yet this alliance of four nations (for that is what it is), could be the decisive group in shaping the stability, security and progress of the whole Indo-Pacific region, and therefore of the whole world.

The four nations involved are the USA, Australia, India and Japan. The association and common interests of these four powerful democracies has been discussed in vague terms in the past but is now assuming a new significance. President Donald Trump clearly sees the Quad idea as a key part of America's unfolding Asia policy, and this explains his Administration's increasingly strong focus on US-Indian relations in particular.

The big thought behind it is this. China's remarkable growth and dynamism is to be admired, but an Asia dominated entirely by an ambitious China, pushing outwards with its Belt and Road through central Asia and with its newly-constructed South China Sea islands, is much less welcome. A China that is prospering is plainly good for its neighbours and the global economy. After all China is Japan's second biggest export market, and Australia's number one export market as well. That's fine, but no-one wants to be completely rolled over by the Chinese giant. Trade -yes, but not if it leads to domination.

A secure and stable Asia therefore needs to have a good counter-balance to China, and a coordinated security strategy, including close defence cooperation, is just what the big four 'Quad' could deliver. This could be especially so in the maritime sphere, where Chinese assertiveness, bordering on aggression, makes other Asian governments very uncomfortable.

This leads the latest US thinking to the view that India, now the world's fifth largest industrial power, must be befriended and supported as never before and why all bridges to India must be strengthened. One of these bridges is seen as lying via Britain and the Commonwealth network of nations, of which India is far the largest and Australia one of the richest. This explains, among other things, why US leaders have shown growing interest in the modern Commonwealth, and why they have talked about opening in Washington a new branch of the Royal Commonwealth Society.

Of course there are snags and challenges, as with any grand strategy.

India may be becoming the cornerstone of Trump's strategic vision but it is still excluded from the Asia-Pacific Economic Cooperation forum (APEC). This will have to be overcome - hopefully with the support of all India's allies in friends.

Then there is the Pakistan problem. Not only are Indo-Pakistan relations as bad as ever, but American relations, too, are far from friendly with Pakistan. The country is viewed as weak on terrorism and, almost worse still, seems to favour China these days over its Western allies. Somehow the historic tensions between these two quarrelling neighbours, India and Pakistan, must be de-escalated. Here, too, since they are both Commonwealth members, Britain and the other Commonwealth members might play a calming and constructive part, despite the extreme sensitivities involved.

Another problem is the puzzling decision of America to withdraw from the Trans-Pacific Partnership, so painfully negotiated, which has scarcely helped regional togetherness. Clearly the new US focus on Indo-Pacific ties is intended to be some kind of compensating alternative to this curious and self-harming move, which leaves such a vacuum in American influence on the trade side. Maybe the Quad initiative is seen by the Trump Administration as a chance for better success.

Whatever the motives one can discern in all this a new global security pattern emerging. Historians may like to compare it to the great game between the powers of the 19th and 20th centuries. But there is a big difference from the alliances of the past and the diplomacy which sustained them. The cyber age and the growth of mass and continuous connectivity are pulling peoples and interests together across national boundaries as never before, even where governments seem to be disagreeing and pulling them apart.

Attempts to build power blocs and alliances in the future will have to take full account of this trend. And here, too, the Commonwealth model of cooperation coming from the people and the grass roots may prove better than the heavier hand of US diplomacy – which has had a poor run over recent decades, whether in Asia or the Middle East. When the fifty-three leaders of Commonwealth countries, covering almost a third of humankind, meet in London in a few weeks' time the subject of future Asian security, and how best to contribute to it, should certainly be on the agenda.

But meanwhile, the Quad concept, if developed carefully, may well be the best hope for a peaceful balance in Asia, keeping in check the great power rivalry of the kind which destroyed Europe in the past and opening the way for Asian economic cooperation and trade expansion all round.

But much work, wisdom and respect for Asian values will be needed, especially in Washington, to make it a reality and make it effective.

Taking the SCO Seriously

Western liberals have hitherto been somewhat dismissive of the Shanghai Cooperation Organisation.

First it is seen as a rather weak structure, lacking a firm central system of coordination and direction, like, for instance, the European Commission at the head of the European Union, or even the looser NATO.

Second, in as far as it has common aims, they have been seen as broadly anti-Western and anti-American, and therefore to be regarded with suspicion.

On the first point the Western experts could not be more wrong. India and Pakistan are now both members (despite their endless mutual hostility), and an invitation is out to Iran also to become a full member.

The 'team' now includes not just China, Russia and the 'stans' of Central Asia, but the whole Indian sub-continent, and with countries like Turkey also showing interest. The SCO thus becomes an assembly embracing almost half the human race in a gigantic network.

Networks develop their own agendas. Heavy top-down and centralising control is out of place. In this case it is clear that, despite numerous lingering disputes, the member states - especially China - see the SCO forum as increasingly useful in managing and promoting common aims relating to security, crime control, legal procedures, environmental and

health standards, and possibly finance and trade, and in growing effective agencies to pursue these goals on a cooperative basis.

On the second point the Western suspicions have more substance. Unquestionably there is a shared belief, or vision, held by all SCO members, that the age of American domination, and of West-dominated global institutions, is coming to an end and that new global institutions should be developed with a much stronger Asian influence (and possibly African and Latin-American as well), at least in parallel with the Western order, and in some areas in defiant competition.

As long as the SCO just appeared to be no more than a cover for purely Chinese ambitions to take a much bigger world role, Western wariness and disinterest were understandable. If the SCO agenda was simply to further Chinese goals, such as those expressed in recent speeches by Xi Xinping, via, for instance, the multiplication of Belt and Road initiatives and a general desire to keep American warships out of what are regarded as Chinese sovereign waters, then it made sense to give it little extra attention.

But if now, for instance, we are going to see not just China but half the entire world line up to support Iran, as the Americans get set to toughen sanctions and cut it off, despite European protests, that should surely make President Trump and his advisors think again before rushing to throw out the nuclear deal (the JCPOA) with Iran.

But there is an even deeper, longer-term and more strategic reason for taking an enlarged SCO much more seriously. This is rooted in the increasingly hyper-connected nature of today's global issues. Whatever governments may publicly say or attempt to do, markets, interests, cultures and learning are interweaving at an unstoppable pace. Connection is replacing clash. For example, in the new globalisation not only are products assembled in a chain which runs through a dozen countries, East and West, but linked actual stages in the production process may be separated out between different economies and societies.

Furthermore, not just in trade and investment matters, but in key fields such as defeat of international crime, terrorism, drug trading and people trafficking, the interest of all responsible governments becomes to follow, and work with, the trends being set by larger forces.

In short, officials and strategic experts should be thinking about

building not walls but gateways between the leading powers of today and tomorrow. This does not ignore, in an unrealistic way, the on-going differences between, for instance, China and the USA, China and Japan, China and Australia, China and Europe and even China and India, using the common platform of the SCO itself to iron out squabbles.

But it does suggest that the coming phase in international affairs should be best viewed as a new period of constructive interaction between the great powers, none of which may in practice have nearly as much real and individual power as they assumed in the past. Space for concessions on both sides could be enlarged.

Contrary to some fiery proclamations on public platforms, the list of areas where cooperation and possibly common action are essential, indeed unavoidable, is growing of its own accord. In Afghanistan, in the Middle East quagmire, in global climate dangers, in open trade flows, in curbing the power of the giant global information corporations, in preventing run-away nuclear proliferation, in reasonable respect for a rules-based world order, the forces pushing East and West together are now stronger than the pressures, real or perceived, which drive them apart. Even the dramas of the North Korean issue and Trump-Kim on-off-on rendezvous, should be seen, and handled in this wider context, not just as a Western 'problem'.

As it develops, the Shanghai Cooperation Organisation offers those Western strategists who are sufficiently alert and far-seeing, a web of linkages and valuable opportunities to contain rivalries and build common ground internationally in face of the world's most dangerous threats.

They should be taken.

18 JUNE 2018

Washington – A Tale Of Two Governments

The world is full of bitterly divided views, vastly amplified by the information revolution. But for sheer canyon-like separation it is hard to beat the current state of affairs in Washington DC, at the governmental heart of what is supposes to be the richest, biggest, most powerful, most influential nation on earth, but somehow just now isn't.

This is a city in argumentative mayhem. No-one seems to agree with anyone about who is really in charge or in what direction America is supposed to be going. If this was just a matter of fast-talking heads attacking each other ceaselessly on every current affairs TV show, that would not be too worrying.

If the turmoil of argument and doubt was just a reflection of the basic structure of the United States constitution, as influenced by Montaigne's ideas on the separation of powers, that, too, would be nothing very different from healthy democratic normality.

But the divisions and disputes today, right now, go far deeper than in either of these instances. They run not just through the public debate but through the very heart of the administrative machine. Quite simply, on one side is the President and a coterie of supporters, plus of course, his tweets and blogs and their staggeringly effective and wide impact, and on the other side is the whole governmental apparatus of mighty departments, agencies, advisory groups, Congress with all its parties

divided and at sixes and sevens, the uneasy liberal media, the think-tanks and all the rest.

No-one, even at the highest administrative levels, and even at areas assumed to be close to the White House, seems to know what the President is going to say or do next. He has just called the young Prime Minister of Canada, Justin Trudeau, weak and false, Canada being America's closets and largest and friendliest neighbour. He has rubbished the communiqué from the G7 meeting in Quebec which his hard-working officials had just signed off. He has agreed things with the half sinister, half buffoon, North Korean leader, Kim-Jong-Un, which few high officials quite understand and for there was which zero preparation (and which could leave close ally Japan in a nasty place!).

He has pulled out of the Trans-Pacific Partnership (TPP) which even his strongest free trade supporters thought was a good idea. He has rejected the painstakingly agreed deal with Iran to halt its nuclear-weapons programme which may hard-line and experienced realists in the administration believed was at least a start in checking further nuclear proliferation in that region.

And now he has opened a trade war, with the target meant to be China but the shots scattering over all and sundry, including his European allies, and making retaliation and damage to American exporters a certain prospect. If there is a single serious economist inside the whole U.S. Federal government machine and its supporting agencies who thinks this is all a good idea it would be hard to track him or her down.

Nor is it just economists and trade advisers who are tearing their hair. China is just the country Mr. Trump needs, to help him pin down the North Koreans to proper de-nuclearisation. Canada is the next-door neighbour who could be most help in reforming NAFTA, (which in the Trump view badly needs repair). The Europeans are the ones America needs for sharing the defence burden and building effective counters to Russia's disrupting hostility – even though Trump was calling for Vladimir Putin to be re-invited to the G7, after Russia's expulsion for breaking all international rules and norms (work that one out).

One moment the other world leaders are all great guys, smart friends with plenty of embraces and hand clasps. The next moment it's a kick in

the teeth for Xi Xinping, for Macron, for Abe, for May, for Merkel, for Trudeau, and who next?

It's no wonder that senior officials and diplomats, whose deepest instinct is to speak with a united voice and be loyal to their President, struggle to keep up with, and explain, the latest twists and turns – or may work on a carefully crafted policy position for years, only to wake up one morning and find the whole position has been overturned and reversed.

And yet stand back outside the Washington frenzy and there is a completely different side to this whole confused story. The Trump appeal endures. Few think he will be denied a second term. The very fact that he seems at war with the gigantic and lumbering apparatus of government increases his attraction and sustains his legitimacy.

The truth is that successful governance and leadership have always been mixture of two things – uplifting vision, with a touch of celebrity theatre, on the one hand, and the hard reality on the other of reconciling endless differences with every interest and every ally through wily politics and statecraft. It has always been a conflict between hope and reality, between high moral ground and harsh realpolitik, which the clever leader weaves together.

People of course want both, but the magic of the information and communication revolution has put the vision and celebrity side right on top and on a separate stage. Wiser heads explain that while the President Trump show goes on to wide applause the real business of government has to grind steadily on beneath the headlines.

In short, it is a tale of two governments in one city – in this case Washington – each depicting the other as out of touch with real, grass roots feelings, everyday life and the necessities of good government,

Meanwhile a restive public peers in on the scene in wonder and people get on with their business. In fact, despite the talk of rust-belts and America being ripped off by its competitors the US economy is flourishing – yet another apparent contradiction.

Indeed, the whole lesson of the Trump era may be that government with a coherent and single voice and message – at least in the democracies – may be a thing of the past. There are just too many billions of conversations going on across the networks all the time disputing everything, challenging everything.

That is the new reality. Either one can block ones ears and retreat into a private world, or live with, and even enjoy at times, the cacophony. It will not go away.

24 SEPTEMBER 2018

Religion and Politics;
Hopes and Disappointments

Believe it or not, I have been writing columns for The Japan Times for more than 30 years. Often I have uttered quite controversial views about the world that a tolerant editor has kindly carried — my hope being to get some reaction from readers and provoke a good debate.

I have to confess almost total failure in this regard. Despite having seen around 500 articles published, the feedback has been minimal — except in one notable case.

This was when I rashly criticized bishops of the Anglican Church for treading too far into politics — I think it was in the early 1990s during a British general election. For some reason this sparked a real furor throughout Japan and a veritable flood of responses. I do not know how many Anglicans there are in Japan, but it seemed a great many, all of them writing to denounce my views and saying that, on the contrary, the views of religious leaders on political issues were most welcome, and a lot more valuable than those of many politicians.

Well, here we go again. The Archbishop of Canterbury, Justin Welby, head of the Anglican Church of 100 million souls, has been plunging boldly into political issues recently, but this time I am going to take a different line. In this totally altered world in which we now live, and in times such as these when all the old verities are under attack, moral bearings have been lost, no one knows whether news is true or false,

uncertainty prevails and ordered government almost everywhere is under challenge, I welcome the voices of all thoughtful people, whatever their status. And if they can couch those views in ways that get reported and spark intelligent debate, so much the better.

Welby is certainly thoughtful, and coming from a business background in the oil industry, also well-informed about practical everyday issues. And he has certainly succeeded in getting his views reported by airing them in left-inclined forums.

But now I am going to sound less enthusiastic about his outspoken and very political views. What a confused, and quite frightened, world needs from spiritual leaders is some really deep analysis of present anxieties and fears, and a really deep understanding and explanation of what is actually happening to people and societies.

Notably, there is the overshadowing and puzzling paradox that in an age of total, intense and continuous communication, along with massive information overload, people feel lonely and disconnected. It is getting ever harder to know what to believe or in which direction life is going or what kind of world our children should be prepared for. All the old debates, between freedom and order, between the state and the individual, collective planning versus the market, have lost their relevance as technology, which knows no right or left in ideological terms, marches forward reshaping everyone's lives. This is where some good unbiased guidance on the near future, and on the everyday struggles of ordinary people in their billions, would be very welcome. How are enough resources going to be 1) generated and 2) shared and spread, to ease daily pressures on every family, provide occupations for all and make the space available for all the natural human instincts of mutual care and concern to come fully into play?

In the new age of microchip dominance there are some fascinating and hopeful possibilities opening up. These include new methods of ensuring that new wealth goes into every pocket, not just those of the "fat cat" few; that reformed capitalism and markets, which now underpin almost every global economic model (even the Chinese) work for all; that democracy can take new shapes and shake off its tarnished image through the agencies of such things as blockchain instant linkages between millions; that every single child on Earth can

get a good and tailored education; that love of one's own country can be successfully woven together with networked cooperation across the planet; and much more besides.

But, alas, instead of lifting our hopes and opening our minds on this new world unfolding, the archbishop chose to drag us back into the left-right arguments and the philosophical quagmires of the 19th and 20th centuries. Capitalism, in his eyes, had lost contact with moral foundations, taxes were to be raised, inequalities flattened by state action, wealth creation (and by implication innovation and enterprise) discouraged, flexible job patterns destroyed, the power of trades unions, which in its old form brought the United Kingdom to its knees back in the 1970s, to be resurrected.

Generally this was the old socialist agenda, which has proved so damaging and hurtful, when a new kind of social democracy is both required and maybe possible in ways not available in the past.

Of course, there are plenty of today's evils to overcome, many of them springing from weakened governments, new giant monopolies defying any nation, fake news, twisted versions of Islam, which should really be a peaceable ally to other religions (how are we going to achieve that?), nuclear weapons, the wild west of cyberspace and the toxic tone of political debate, with courtesy and good manners (the essence of a stable society) swept aside.

So there is plenty for elected politicians and party activists on which to focus. From the spiritual side, and from church and faith leaders, we need the added, and vital, ingredient of perception, wisdom and illumination of the dark scene and a bit of cheer about the hidden future and its possibilities.

On this occasion that was not forthcoming. One lives in hope.

Is it all change for the Auto Makers?

All good things come to an end – or so they so say.

Some sensation-seeking British journalists have just found an undoubtedly good thing which they claim is at an end. This is the massive and long-standing industrial relationship between Japan and Britain, especially in automotive manufacture.

The news that Honda is closing its plant at Swindon, after forty years, that Nissan is to make its new Xtrail model back in Japan rather than at its super-efficient plant in Sunderland, England, has been greeted in anti-Brexit quarters as a clear sign that after all these years Japanese investment has lost faith in Brexit-minded Britain and is heading home.

The news that in other sectors both Panasonic and Sony are shifting their headquarters out of England and to somewhere on the European Continent has given further fuel to this story. Nor has it helped that Hitachi has just suspended involvement in one major British nuclear power project and Toshiba has withdrawn from another, although even the most frenzied opponent of leaving the EU would find it hard to attribute this to Brexit.

One part of the whole picture which is unquestionably true is that Japan's investment in the UK has not only been a major commercial success but also a huge benefit for the transformation of the British economy over some fifty years. Incoming Japanese businesses in the

20th century faced Britain's obstructive trade union practices head on. Ludicrously restrictive work practices, limiting all innovation, were thrown out and poorly trained and embittered workforces rejuvenated with high tech production and top class working conditions – for instance with brand new plants in the Welsh mining valleys.

So even if it was true that the Japanese were now departing, (when in fact it is all a gross exaggeration) this would be the occasion for an enormous thankyou. The Japan investment factor, beginning with Sony Morita's new plant at Bridgend in the early 1970s, played a major part in taking British industry out of its strike-ridden, post-war state into the modern era and preparing it for the wave on wave of new technology revolutions to come. It would be like saying thank you and goodbye to a first class consultant or doctor who had effected a complete cure and could go on their way with the job well done and much gratitude.

But of course this is all just fantasy. There is no general Japanese retreat from Britain. The departures are only a tiny fraction of the dozens of companies and at least 150,000 jobs which they provide.

What may be going on is something entirely different – especially within the automotive sector - something which the average political and economic commentator finds it difficult to grasp. The entire world automotive industry is undergoing a radical refashioning.

Analysts forget, as they rush into print, that traditionally Britain has been extremely good at designing and producing motor vehicles. In the earlier part of the 20th century it led the world. It is true that British car manufacturing was ruined by militant trade unions, bad planning and weak management in the nineteen-fifties, and had to be rescued by foreign investors, Japanese, French and German. But there is no law of nature which decrees against a revival of British ownership in the totally changed conditions of a new era of industrial technology and a new age of automotive design generally.

The opportunities for British-led entrepreneurs to move back in and build a different kind of auto industry, are growing all the time. A revived British-based motor industry would still need to work hand in hand with Japan's recognised world lead in automation and robotisation, and probably with car production in other countries as well.

This is because the assembly of cars and their engines and electronic

component parts is now a completely internationalised network business. There are skills and partnerships to be drawn on from a whole variety of countries, not just Japan, but Korea, Malaysia, Vietnam, Thailand, South Africa, Turkey, Brazil and of course China.

Thanks to Japan's past reforming impact the British car scene is now ripe for moving into this new and different age, both in terms of entirely new enterprises, new products (for instance to meet the electric and hydrogen propulsion future) and new patterns of personal car use in an urbanised world. Millions living in cities are now asking why bother to own a car when you can always take one on demand from a nearby stand, a Zipcar, or call up a vehicle and driver digitally within a minute.

International standards are of course always required in car design and safety features. But these are increasingly settled globally and apply to vehicles destined for every market and running on every country's roads.

Britain plans to have a free trade agreement with the rest of the EU, just as Japan now has, so no border tariff will apply. As the next wave of globalisation beds in, and the actual processes and different stages of production and marketing of a unit such as a car are themselves internationalised, it will matter less and less where the stages occur or who owns the operation at various points, or what new or long dormant name brand or marque is on the product. Large new companies could appear rapidly on the world stage from nowhere, as has already occurred in China.

In this transformed world milieu no industry is escaping disruption. Some new investments may come, some old ones may go. Brexit is just one part of a gigantic readjustment, which the whole of Europe industry is also experiencing and which reverberates in all corners of European politics. Life was always difficult for the international corporate investor in choosing into which country to locate big resources and different parts of the supply chain. It is about to get even more so.

9 APRIL 2019

The Chinese have Landed

It can no longer be pretended or avoided. The Chinese presence in Europe has now reached a significant level – a tipping point where it begins to influence the shape and direction of economic and social progress in the West in ways which require not a blind eye, or the occasional wringing of hands, but a clear and constructive response.

Take first Europe's main ports – the points at which the traded goods arrive and depart which are Europe's lifeblood. China is now heavily invested in key seaports all around the continent. These include Piraeus in Greece, Valencia and Bilbao in Spain, Sines in Portugal, Zeebrugge in the Netherlands, Genoa in Italy, and now, following a much publicised visit of the Chinese leader Xi Xinping to Rome, the ancient key port of Trieste, giving access to the heartlands of Central Europe.

In all it is estimated that China now controls one tenth of European port capacity. At the latest tally it also owns four European airports, large wind farms in nine European countries, a mass of property in the City of London and some highly prominent European enterprises such as Volvo in Sweden and Syngenta in Switzerland.

On top of that a major Chinese company holds a $9 billion stake in Daimler (parent of Mercedes-Benz) and has key role in Britain's civil nuclear renewal programme. It also has direct stakes in British water utilities, banks and power generators.

Admittedly the inward Chinese investment flow has eased in 2017 and 2018 from its staggering 2016 peak of $18 billion. But it will certainly pick up again, and anyway the issue is not so much the inward flow as what happens to the implants once in place. And implants grow.

All his is visible and open for all to see. What is happening beneath the surface, in the way of intelligence penetration, cyber intrusion and acquisitions behind anonymous fronts there can be only dim ideas. Certainly the security services of most European countries are at sixes and sevens about what to do in face of domination by Huawei and other advanced Chinese technology enterprises in the on-coming 5G generation of communications and information linkages.

The European public is left uneasy and confused. For the last few decades it was Japanese investment which was the big factor, depicted and exaggerated by some, particular American commentators, as a threat, but generally coming to be seen as an unqualified asset, especially in the British case. Partly as a result, Japan has come to be regarded, certainly in Britain, as a close and reliable friend and ally on all fronts, not just confined to trade and investment.

But the China presence seems much more complicated, extensive and insidious. There is dim but growing awareness that Chinese initiatives and involvement are expanding in every part of the world, from the Indian sub-continent (notably in Pakistan), to most parts of Africa, to the islands of the Caribbean and to Latin America. Much of this is connected with China's all embracing Belt and Road Initiative, and its several winding new Silk Roads. Suddenly they seem to be reaching everywhere.

Meanwhile, within Asia itself Chinese projects dot the islands of the South Seas, while both Australia and New Zealand, having once welcomed Chinese trade and investment, are now getting very uncomfortable at too much on what once seemed a good thing but is now going far too far and coming far too close.

The European Union leaders have been gathering recently to ask themselves what to do about this fast emerging situation. Across the Atlantic President Trump has already decided. He wants to do a deal with the Chinese giant, and Congress mirrors many, if not all, of his anxieties. It may all come to nothing, but 'America First' is where he

wants to be seen going.

But for Europe it seems much less straightforward. There is a fascinating historical symmetry here between China's own predicament in the nineteenth and early twentieth century – as the Empress Dowager Tzu His (or Cixi) struggled to decide with her advisers what to do about the ever more invasive Western 'barbarians' - and the exact reverse situation which Europe now faces.

But if the situation is reversed the questions arising appear strikingly similar. Are the intruders friend or foe? Should there be cooperation or exclusion? Should the newcomers be ceded special ports (they already have some, see above) and cantonment areas in which to operate? Can insatiable demand for their imports be checked? And is it too late anyway to stop the onward march of totally globalised trade, even if the EU is supposed to be a trade protected area?

There is one fundamental difference with history, however. We now live in a transformed era of almost total connectivity, communication and dialogue. Here is a possibility for all parties to shed ambiguity ad talk openly and frankly. On the European side some kind of common approach, welcoming but selective, has to be crafted. On the Chinese side, bland assertions that overseas investment is all a commercial matter and nothing to do with geo-political strategy or colonising aspirations have to be put aside. The facts to the contrary are too strong to be denied. Everyone knows that China is a state capitalist system with obedience to state and party priorities being the ultimate discipline.

A good bit of statesman-like honesty all round could yet lead to harmony, development prosperity and mutual gain, instead of fear and disruptive hostility. Or is that too much to ask?

Why Normal Times will not Return

There is a school of thought that believes when a few current global problems have been surmounted, normal times will return both to world politics and to world economics.

For example, many believe that when U.S. President Donald Trump finally gets his comeuppance, the old and generous America of Uncle Sam and Pax Americana will return, the U.S.-China trade war will wind down, peace will break out in the Middle East and we will back to business as usual.

Or in Europe, once the British, led by new Prime Minister Boris Johnson, have made a clean break from the European Union, things will settle down in the region, trade patterns will resume as before and Europe's march towards greater integration will continue as before. Relative world stability will resume its reign as people resume their business and some degree of certainty returns.

These complacent views are wrong and are dangerous because they divert efforts from preparing for a quite different world, posing different challenges, especially on the political side, which lies ahead and of which the sinews are already visible.

The prime cause of this upheaval, its destruction of all previous "normals," is the tiny silicon chip and its ever multiplying processing speeds. It is the staggering informational, connecting, organizing,

revealing, coordinating yet fragmenting impact of this still accelerating technology that has placed power in mass hands, to an unprecedented degree, and drastically weakened old political hierarchies in both democracies and autocracies alike.

But those who hope that this process leads on to a new era of democratic unity and stability, with tyrants toppled and privileged networks exposed, are in for a big disappointment. The dispersal of power to the masses, and the crumbling of respect for and trust in past ruling classes, opens the path not to a more liberalized order but to a cacophony of rivalries, disputes and grievances, amplified as never before and making governing far harder than ever before.

The late British Prime Minister Margaret Thatcher once observed that there was no such thing as society and she was much criticized for it. But of course she was right in the sense that society is not some beautiful and coherent body of views but a broken mosaic of a thousand differing and shifting viewpoints.

The great British historian G.M. Trevelyan argued that politics is the outcome, not the cause, of social change. In the West, this new scale of social chaos is already playing back into politics and governance, multiplying political parties, generating angry demands for the recognition of endless varieties of identity, interest and local cause, and making decisive leadership and guidance more difficult than ever, just when it is needed most.

In the loop of sequence and consequence, this creates new frustrations and disappointments, leading in turn to widening outrage and still more political instability.

This rage is intensified as other mounting effects of new technology and the communications revolution cut in. Notable among these are the ways in which modern globalization, the child of the chip, first disrupted blue-collar employment in the West and now invades white-collar and middle-class security.

Services may have taken over from manufacturing in Western economies, but if many services can now be better, and far more cheaply and swiftly, performed by individuals from Asian, African and Latin American sources, that destroys white-collar careers and is already doing so. Then along comes robotic artificial intelligence and machine

learning, again chip enabled, which automates a huge range, although not all, of service jobs, creating a deep sense of unfairness and injustice, and producing yet further demands on already weak governments to "do something" to protect people's security and living standards.

All this is a recipe for turmoil out of which the need for new kinds of political management ("politics" meaning literally the affairs of the citizens) are emerging. The young in the West are now said to crave strong leaders, and care much less about endless and fruitless democratic argument and old ideological conflicts. Both younger and older generations advocate "direct action" and taking to the streets.

Faith in the capacities of the political class to deliver on the new great issues of global warming, or gender equality or even the more mundane issues of good housing and health care for all grows steadily weaker.

Either way the missing ingredients now are trust and respect. These are the glue without which societies cannot cohere and without which common loyalties cannot be sustained.

But note that this is presented as very much a Western state of affairs. Neither Japan — nor China, although in a very different way — seem to suffer so much from the anti-establishment, anti-elitism with which the West is now infected in the hyper-information age.

Is there some quality of respect and loyalty here, toward the state, toward family and parents, toward community, arising out of a different philosophical tradition, for which the West can now learn? For example, should belief in competition, so central to Western economic theory, be tempered by a greater sense of obligation, which is so strong in Japanese business life?

To paraphrase the great British statesman George Canning, could the new Asian world be called upon to redress the balance of the old West?

Almost all the supporting pillars of Western certainty and continuity are now under challenge. Even the measures by which progress is judged are in question, as the economists' old friends, like gross domestic product, are derided as poor guides to the true welfare and health of a society. Other intangibles may now matter more, and other forms of capitalism may bring more politically manageable outcomes.

From the East, with its economic and now increasing technological predominance, with its giant cities and super-modern social and

physical infrastructures, come the simple lessons that family respect and obligation, some deference to elders and dutiful support for law and authority, may fill the moral vacuum.

How authority is also to be properly and soberly held to account, how freedom (but not license) is to be exercised, how free speech (but not abuse or slander or fakery) is to be upheld, how human rights are to be balanced with responsibilities, how leaders are also to be true servants — these are now the conundrums of Western life and culture.

And until they begin to be resolved, there will be no return to normal times, either within nations or geopolitically.

28 OCTOBER 2019

Beautiful Harmony in an Angry World

Lucky Japan with its new imperial era of beautiful harmony. How the Europeans wish they had some of the same elixir. Of course Japan has an unlucky side, too, when it comes to the ravages of nature, with terrible typhoons, tsunamis and earthquakes visiting with seemingly unfair frequency.

But perhaps it is these dreadful visitations that make for the harmony, or at least the unifying resilience of the Japanese people in the face of nature's fearsome challenges. At any rate, the disuniting populist clamour, digitally surcharged, that has paralyzed the United Kingdom (over Brexit but also other issues) and filled the streets of Europe with protest, sometimes verging on violence, and brought politics to the boil of bitterness, seems so far to have bypassed Japanese society.

And populism is not just a European disease. In the United States it has produced an erratic presidency. In the Middle East it has brought unrestrained tribalism and war (now taking a new downward turn in northern Syria). In Iraq, Chile, Venezuela, Lebanon, Hong Kong, Sudan, the mobs are on the streets with increasing frequency. This is indeed, to borrow the heading from one recent Times editorial, "an angry world" that conventional politics seems sadly unable to address.

So what or where is the way forward out of this turmoil? As with any disease or debilitating condition, to begin finding answers and cures one

has to understand causes. And although politicians and commentators have been reluctant to acknowledge the roots of chaos they are in fact quite easy to identify.

Of course, since the dawn of history there have been oppressed and angry peoples ready to rise up, from the slave rebellions against the Roman empire to revolutionary France, to Britain's million-strong 19th century Chartists (who nearly overthrew the throne) and to the hideous, weaponized 20th-century populism of the Nazi and communist eras, which almost destroyed civilization.

The difference now — the enabling, magnifying, hyper-contagious new factor — is the tiny microchip: a computer on a chip. It is this that has empowered protest, enabled organized rebellion, spread grievance, filled the entire planet with rumour and fear — often based on fake information — and opened up for viewing all the glaring inequalities of life on a scale and with a transparent visibility never matched before in history.

The sceptic might argue that the computer age has been around for 40 year or more, so why has it taken until the last decade or so to light the fuse of outrage and angry protest so widely? Why suddenly has the tone of public discourse changed, with every argument polarized, every debate driven to extreme positions and extreme language, with the middle ground area of moderation and compromise crushed out of existence? Why suddenly have respect for, and trust in, political hierarchies and institutions collapsed like a house of playing cards?

The answer lies in the laws governing the upward spiral of communications technology. Revolutions start slowly. The speed of microchip processing started some decades ago, like a geometrical progression. Double anything every year and soon quite modest numbers turn into colossal figures, heading off into infinity. As speed has risen, along with access in every corner of the planet, cost has fallen to near-zero.

It has taken the iPhone and the iPad to place in the hands of two-thirds or more of the human race the access to knowledge, the power to link up, the means to challenge, the technology to defy and disagree, to bring the cacophony of opinion and demand to its present pitch. And ahead lies much more, as value-free algorithms take over, as

quantum computing delivers unimaginable speeds and as blockchain brings everyone into everything.

Such a world is bound to be confused, bound to be fluid and disordered, bound to breed disappointed expectations, bound to look for new focal points to fill the empty spaces left by collapsed faiths and doctrines.

Contrary to centuries of Western philosophy, about the sacred importance of the individual, human beings yearn to be associated, to be in families, communities, societies and to have a common cause or national story to which to be loyal.

But stories need a storyteller whose wisdom commands respect and admiration and followers. Absent such a figure, or such a story, the whole pyramid of trust and cohesion crumbles all the way down. Smaller nationalities break away from bigger ones (as Scotland threatens to do from the U.K. or Catalonia from Spain). Smaller communities pull away from more central institutions; traditional local leaders lose respect; family patriarchs, matriarchs and parents lose control; children break away into a moral wilderness of knife and drug gangs.

In Europe, and certainly in the U.K., it is all happening before our eyes. The internet, which was going to bring citizen liberation, has ushered in forces of social disintegration. For the younger generation in particular a sense of purpose and national direction has been lost in ceaseless argument and disillusion. Possibly the cause of saving the planet and its species from climate destruction can fill the gap, but even there doubts prevail.

Repair and restoration are possible, once the algorithms have been curbed and the communications leviathan harnessed and pinned down. Roles and purposes are out there to be described, but they will need ten times more élan, imagination and historical perspective than anything now forthcoming.

So step forward the new articulate leaders of wisdom, foresight and true understanding now urgently required. With their intervention and guidance, a fragmenting and disputatious world can be calmed and a bit of that Japanese harmony shared and regained.

But without them — not a chance.

5 NOVEMBER 2019

A New Parliament will Decide

They said it could not be done. There was no way, claimed an army of experts, columnists and opinion-formers, that a new withdrawal deal could be worked out between the United Kingdom and the rest of the European Union. It was quite impossible to solve the complex problems of Ireland's division, with the republic in the south staying in the EU and the north staying as part of the U.K.

Well, they were all wrong. A new deal was worked out, as I predicted on Sept. 20, paving the way for both orderly British withdrawal and new trade agreements with the U.K.'s other world partners, such as Japan, China and America, as well as a new type of relationship with the rest of Europe.

In the jargon, this was "a soft Brexit." The EU leaders and officials in Brussels agreed to it, the Irish government in Dublin agreed to it, business groups in Northern Ireland agreed to it and even the argumentative House of Commons at Westminster gave it majority approval. All was set for formal U.K. departure on Oct. 31.

But there the happy agreement stopped and the problems began. Having agreed to the new deal in principle, MPs refused to push through the legislation to make it happen. A prospect opened up of never-ending quarrels, amendments and delaying tactics that would postpone Brexit until kingdom come.

Utterly frustrated, British Prime Minister Boris Johnson took the final gamble. If this House of Commons, as at present composed, would not guarantee to pass the necessary legislation, then another House of Common would have to be summoned. In other words there would have to be a general election. The Oct. 31 departure would have to be delayed (with EU consent). It would be a case not of people against Parliament, but of people against this Parliament and in favour of a new one.

Here at last Johnson got some agreement, with the small political parties leading the demand for an election, and the main Labour opposition reluctantly lifting their veto. It will take place on Dec. 12.

And what will be the outcome? Here again experts and analysts all round are pessimistic. The conventional wisdom is that the new Parliament could be as paralyzed and unhelpful as the old one, with no clear majority for anything or anyone.

Their argument is that Johnson will fail to get the decisive win he needs. His votes, they argue, will be sucked away on two sides — by the demagogic Nigel Farage and his kamikaze supporters, who want a crash exit from the EU and dislike the deal Johnson has so skilfully negotiated, and on the other side by the resentful Conservatives who never wanted to leave and will defect to the centrist Liberal Democrats, whose policy is to reverse everything and go back into the EU.

The result, they say, will be more indecision, with the U.K. failing once again to meet the exit deadline — this time Jan. 31 — and yet more and more delay — to the despair of industry and business, the general public and the wider world.

But are these dark and negative views right? This column, having already defeated conventional wisdom once, is prepared to remain defiant. So the prediction here is that the prevailing wisdom will be wrong again. Far from losing votes, Johnson will stand out clearly for the one thing everyone really wants — a soft and orderly withdrawal from the EU that keeps an open border in Ireland and a good long transition period in which the whole economy can gradually adjust while new trade relations across a changing world are hammered out.

Far from taking Conservative votes, the Farage farrago will crumble.

Farage and his close chum, U.S. President Donald Trump, will be seen as the faintly clownish, although dangerous, populists they are. As for the Liberals who want to reverse history, they, too, will lose their backward-looking appeal for most people. Instead Johnson will emerge with a solid majority and press on successfully with his already agreed and negotiated deal.

Johnson's enemies keep depicting him and his supporters as on the political right. In fact he is very much a middle road, so-called One-nation Conservative, committed to social reform, top-quality public services and education, wider ownership, an active and caring state working with private enterprise, a green environment and a balanced welcome for immigrants.

Above all, he is bent on taking his party, and the nation away from harsh ideologies and into the totally new era that technology is shaping for us. His main opponents, the Labour Party, will be offering a brew of Leninist socialism, the kind that claims to be speaking for the people but in practice crushes the people, a right-wing, top-down socialism that brings not freedom but state oppression, and the misery that follows it. The British find this sort of recipe repulsive.

Instead, the bottom line outcome is plain — a moderate and modern government harnessing the best of good administration with the best of market enterprise.

A new policy stance will emerge, friendly to European neighbours but not too much so, friendly to the United States but not to the point of subservience, generous in decentralizing powers to the regions and the smaller nations within the U.K., but keeping it all united in a single U.K. market economy and kingdom, albeit under a new constitutional structure.

Above all, this will be a Britain that marches not just with the old West but with the rising East, the Asia of the future, where all the market growth is going to be — especially with its old friend Japan, with the vast Commonwealth network, with advancing Africa and with Latin America. There will be much work and many struggles ahead, but this is the path that is opening up.

Call it unattainable, impossible, absurd optimism? But that is what they called the Johnson Brexit deal. So now just wait and see.

CONCLUSION

The Japan Affair

There is an argument in some quarters that for the UK in the 21st century a choice has to be made between America and China.

But the argument is wrong. It does not reflect the new international realities of the digital age and the modern network world.

In today's world, and even more tomorrow's, the choices are going to be numerous and shifting, requiring huge agility and diplomatic skill to manage and manoeuvre. In the fresh light of post-Brexitdom the UK's hopes and possibilities can now unfold.

Old ties will need reburnishing and new links busily built up across the entire globe. The thinking which sees just China and America as the two dominant superpowers belongs to a past age of empires, although it still permeates much of the dated rhetoric from leading voices heard in Washington and Beijing.

Instead the task is now to handle a thousand different connections, a mosaic of cultures, a myriad of viewpoints and concerns – and to do so tirelessly, adroitly and with subtlety and tact.

For Britain this is the big question – how to move on from the assumptions of a 'safe' Western world of fixed alliances and relationships to a far more complex and fluid global order. For Japan a slightly different 'big' question is whether to cling to its position as an outpost of the West, or whether to play centre stage in the new Asia, with both

its power and its perils, or whether it, too, now moves into the new global reality which encompasses us all, like it or not.

Or perhaps for both nations there is, after all, a new sort of Third Way. This would be a third way not between Western doctrines of capitalism and socialism, as has been attempted from time to time, with zero success. Instead it would be the beginnings of a unity and weaving together of Western values (which are British values) and Eastern philosophies, of ancient cultures from either end of the planet, of a kind which has never yet existed and was believed never could exist.

'East is east and West is west, and never the twain shall meet', said Rudyard Kipling, but adding that there could be no border 'when two strong men stand face to face'.

He was right then, in the fading pre-digital, disconnected, distance-dividing, suspicious world of the past. But in this era of hyper-connectivity and globotronics replace 'strong men' with strong technologies, whether facing in competition or cooperation, and can any borders in this sphere now stand?

That is both the glory and the danger of the age we are now entering, and it requires entirely new approaches.

Here's one suggestion to help changes on their way. Why not shift UK-Japan relations up a whole gear? Already, outside the purview of officialdom or of media interest something of this kind is happening, driven forwards by the constant automatic advance of networks and the still little understood but unstoppable laws of the digital age.

In areas of technology, defence, security, culture, research, innovation, the two island states are becoming steadily bound together. A little bit of recognition, a little bit (but not too much) of strategic push at government and ministerial levels, could make this a wonderfully strong platform for both nations in a very dangerous and uncertain world.

It would not be the only positive feature of a post Brexit world, of course. Many other alliances will be needed. But the friendship and basic good will are there, the common interests in the world are there, and now the opportunities are there.

Speaking for ourselves, will our UK policy-makers, media figures, columnists, intelligentsia, strategists, masterminds at the top of the Foreign and Commonwealth Office, those in the Cabinet Office, those

surrounding and with the ear of Britain's new Prime Minster with his big Parliamentary majority – will all or at least most of them have the nous, the perception, the finger-tip understanding to look where we are going or could go?

Let's hope that this is the still better story which the next few decades will be able to illuminate.